HISTORIC PHOTOS OF
FORT LAUDERDALE

TEXT AND CAPTIONS BY SUSAN GILLIS

TURNER
PUBLISHING COMPANY
NASHVILLE, TENNESSEE PADUCAH, KENTUCKY

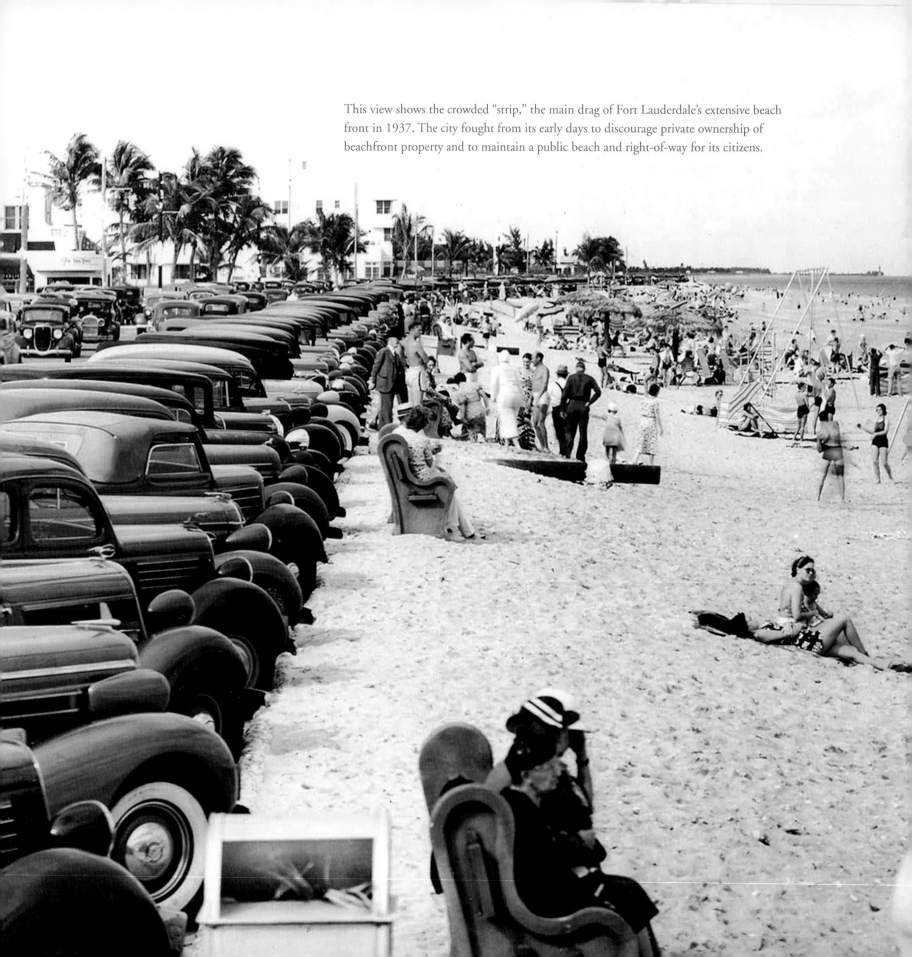

This view shows the crowded "strip," the main drag of Fort Lauderdale's extensive beach front in 1937. The city fought from its early days to discourage private ownership of beachfront property and to maintain a public beach and right-of-way for its citizens.

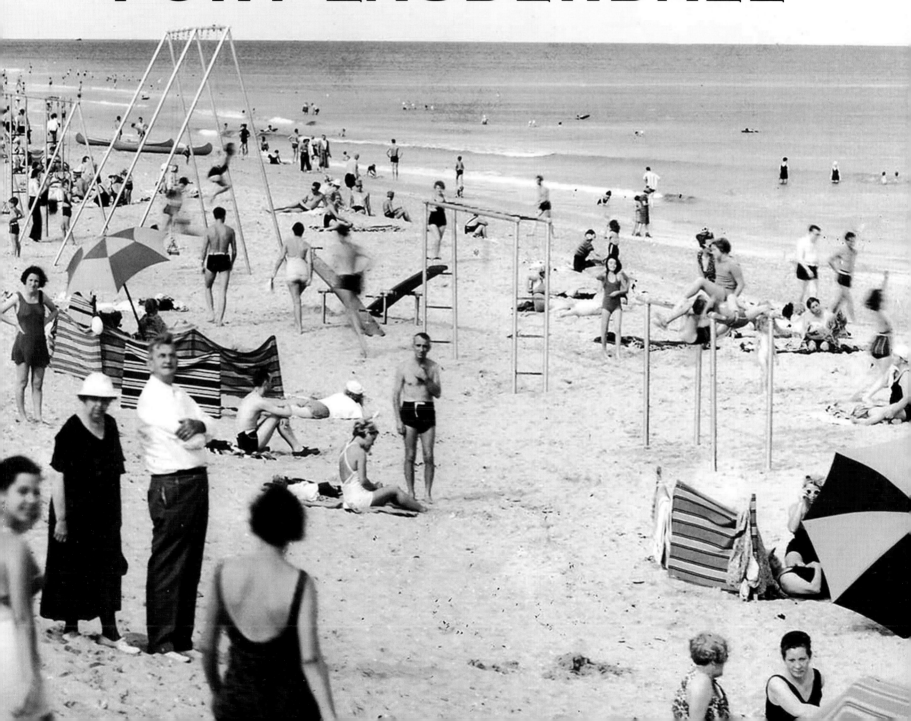

HISTORIC PHOTOS OF
FORT LAUDERDALE

Turner Publishing Company
200 4th Avenue North • Suite 950 412 Broadway • P.O. Box 3101
Nashville, Tennessee 37219 Paducah, Kentucky 42002-3101
(615) 255-2665 (270) 443-0121

www.turnerpublishing.com

Historic Photos of Fort Lauderdale

Copyright © 2007 Turner Publishing Company

Library of Congress Control Number: 2007933775

ISBN-13:978-1-59652-411-8

Printed in the United States of America

07 08 09 10 11 12 13 14—0 9 8 7 6 5 4 3 2 1

CONTENTS

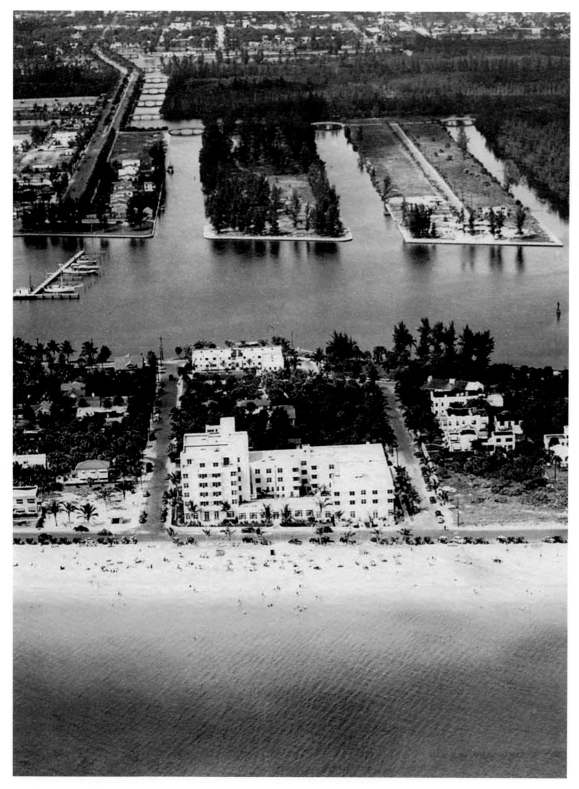

In 1937, the construction of the Lauderdale Beach Hotel, shown at the center of the photo, signaled a new era of tourism for Fort Lauderdale. At far left, the floating hotel Amphitrite can be seen on the old Las Olas Causeway in this photo taken about 1939. Notice the undeveloped Nurmi Isles in the background.

Acknowledgments

This volume, *Historic Photos of Fort Lauderdale,* is the result of the cooperation and efforts of many individuals, organizations, and corporations. It is with great thanks that we acknowledge the valuable contribution of the following for their generous support:

Broward County Historical Commission
Fort Lauderdale Historical Society
State Library and Archives of Florida

The author would like to thank Ms. Denyse Cunningham of the Broward County Historical Commission for her invaluable assistance with this project. This volume would not have been possible without the extensive research collections of the Historical Commission and the Fort Lauderdale Historical Society.

PREFACE

No one knows for sure the origins of New River's name. The Rio Novo first appeared on Spanish maps by the seventeenth century. For thousands of years, people have called the picturesque New River home. The ancient Tequesta Indians of South Florida once plied its waters in their dugouts; they had all left South Florida by the end of the eighteenth century.

In the 1790s, new pioneers arrived along New River and a small settlement began to grow up there. Bahamians who survived by farming and wrecking (salvaging) were joined by Americans when Florida became a territory in 1821. The Seminole Indians, originally from tribes whites collectively called "Creeks," had made their way from Georgia and the Carolinas into South Florida by this time as well—and conflict soon ensued.

In December of 1835, the Second Seminole War broke out. In January, the family of local justice of the peace William Cooley was killed by a group of Indians while Cooley and others were away salvaging a shipwreck. In March of 1838 Major William Lauderdale and his Tennessee Volunteers, with Robert Anderson and Company D, 3rd U.S. Artillery, came to New River. They established an encampment at the forks of the river and named it Fort Lauderdale, in honor of the ranking officer. There were three Fort Lauderdales during the war years; the third and most permanent was located at the beach where Bahia Mar is now.

The years after the Second and Third Seminole Wars were quiet ones on New River. A few intrepid souls called the wilderness home. In 1893 a stageline was established on the new Dade County Road, which stretched from Lantana (now Palm Beach County) to Lemon City (now North Miami). Ohioan Frank Stranahan came to New River to operate a ferry and overnight camp for the stage. He decided to open a store as well, a welcome center for trade with the local Indians. Instead of "New River," he named it "Fort Lauderdale" in honor of events that seemed, even then, a part of the distant past. From this humble origin a new town grew. By 1896, Henry Flagler's Florida East Coast Railway began through service to Miami and "civilization" began in earnest. The tropical wilderness would never be the same.

It is here, at the turn of the century, that our story begins. The images in this book are divided into four sections. The first chapter, spanning the 1890s through the 1910s, examines the growth of a new community from outpost to river-port town. Stranahan's trading post, the coming of the railway, and the establishment of the Everglades drainage canals all came within a few short years and resulted in the 1911 incorporation of the town of Fort Lauderdale.

The 1920s and '30s were the eras of "boom and bust" for South Floridians. Fort Lauderdale was at the very heart of the 1920s land boom, and urbanization began in earnest. Tourism and real estate were in; farming was relegated to the hinterlands of the county. Two killer hurricanes, one in 1926 and one in 1928, put the final cap on the boom times, but Fort Lauderdale residents rebuilt their community and kept going through belt-tightening times, confident that the lure of the beach and climate would continue to attract the almighty tourist dollar.

Chapter three examines the 1940s and '50s through war and peace. Fort Lauderdale played host to a number of military installations and citizens supported the war effort with bond drives, blackouts, and rationing. The winter of 1945–46 was the best tourist season for the city up to that time. The ensuing years saw another boom for the area as thousands of former servicemen returned, this time with their families, to settle in the land they had grown fond of during the war.

During the 1960s and 1970s, Fort Lauderdale became Florida's "fastest-growing city." New developments filled the city limits while high-rise co-ops and condominiums began to grow up along the skyline. Fort Lauderdale earned its hard-to-shake sobriquet *Where the Boys Are*, for its Spring Break crowds. National issues like civil rights and the Cold War had a direct impact on local citizens; life was changing in what was once a small, Southern town. By the end of the 1970s, Fort Lauderdale had almost reached build-out, hemmed in by other growing municipalities within the county, but it continued to serve as the social, political, and governmental center of Broward County—and still is today.

—*Susan Gillis, Author*

The goal in publishing this work is to provide broader access to a set of extraordinary photographs. The aim is to inspire, provide perspective, and evoke insight that might assist officials and citizens, who together are responsible for determining Fort Lauderdale's future. In addition, the book seeks to preserve the past with respect and reverence.

With the exception of cropping where necessary and touching up imperfections wrought by time, no other changes have been made. The focus and clarity of many images is limited to the technology of the day and the skill of the photographer who captured them.

—*Todd Bottorff, Publisher*

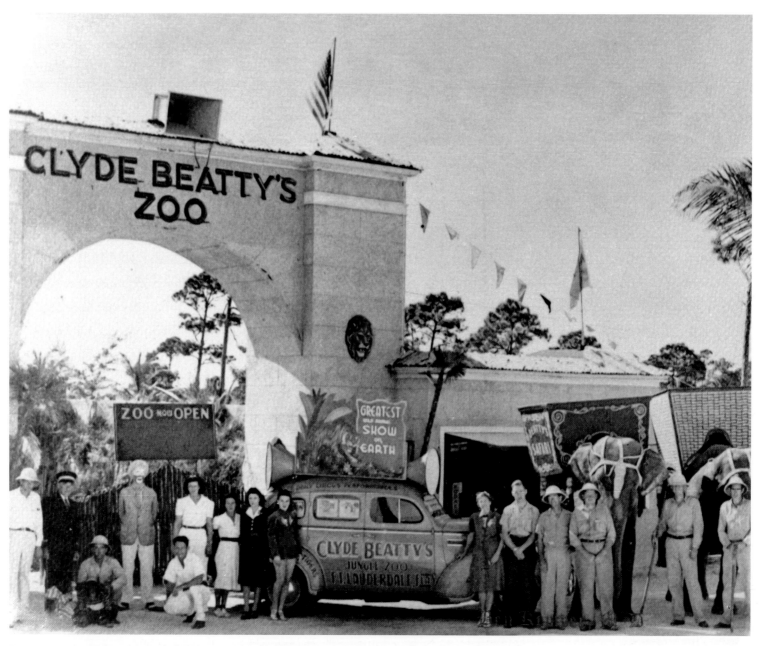

In 1939, circus entrepreneur Clyde Beatty acquired an attraction called the McKillop-Hutton Lion Farm, located on East Sunrise Boulevard. There, he established a unique local attraction, the Clyde Beatty Zoo. It was forced to close by 1945 as development marched north—neighbors complained that the roaring lions made sleeping difficult.

A New Town

(1890–1919)

Fort Lauderdale is named for a Seminole War–era fortification originally constructed at the forks of New River in 1838. The modern community, however, can trace its origins to the establishment in 1893 of a trading post and overnight camp to serve the new stage line along what was then the Dade County Road. Proprietor Frank Stranahan befriended the local Seminole Indians and named his store "Fort Lauderdale" in honor of a bygone era. Within a few years, the Florida East Coast Railway was completed to Miami and the history of the river town changed forever. New pioneers and supplies came readily to the idyllic farming community.

In 1906, Governor Napoleon Bonaparte Broward chose Fort Lauderdale as the place to begin his Everglades Drainage Project, a series of canals to create farmland from Everglades swamp. The North New River Canal, completed in 1912, brought a new era to Fort Lauderdale, as farmers from as far away as Lake Okeechobee shipped their produce by barge to be packed and sent north via the train. Little Fort Lauderdale became the "winter vegetable shipping capital of the South," and a land boom ensued. In 1911, the town was incorporated, with about three hundred residents. A "downtown" grew up where rail and river met, adjacent the Florida East Coast Railway station at New River on Brickell, also known as Southwest First Avenue. A devastating fire destroyed most of the downtown in 1912, but determined citizens quickly recovered.

The year 1915 was pivotal in local history. The Dixie Highway—Florida's first "interstate highway"—was completed through the county, and Broward County was carved out of Dade County to the south and Palm Beach County to the north. The new county seat was Fort Lauderdale, and a new court house, school board, and other county functions were naturally centered there.

By the late 1910s, the frontier community had become a city. Electricity and phone service brought Fort Lauderdale into the twentieth century, and cultural amenities such as schools, theaters, and a library abounded. Several film makers, including the famous D. W. Griffith, were drawn to the community for its natural "South Sea" beauty, and the city became, however briefly, a film capital. The stage was literally set for one of Fort Lauderdale's most exciting eras.

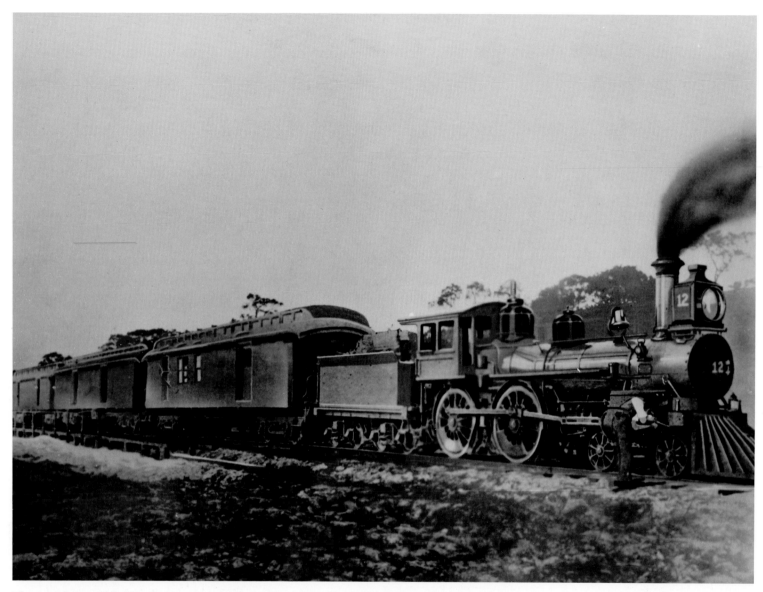

The completion of the Florida East Coast Railway (FEC) from West Palm Beach to Miami was a pivotal event in the history of South Florida. It brought settlers and supplies and provided a much-needed transportation route for agricultural products such as winter vegetables. The first passenger train arrived in the little settlement of Fort Lauderdale on February 11, 1896. In April, through service began to Miami, and South Florida was a wilderness no more.

Henry Flagler was the entrepreneur behind the Florida East Coast Railway and arguably one of the most influential men in Florida's history. Flagler engaged New Smyrna grower and associate Philemon Bryan to oversee the construction of the railway from Cypress Creek (Pompano) to New River (Fort Lauderdale). In April 1895, Flagler wrote to his friend Julia Tuttle, "not that I expect to build up a town at New River, but I think it is good farming land."

By 1899, the young community had enough children to request a school from what was then the Dade County school system. The schoolhouse was built with materials provided by local builder Ed King, father of several of the students. It was located south of New River on what is today Andrews Avenue, at about Southwest Fifth Street. Many of the students arrived at the school by boat, the major form of transport at the time.

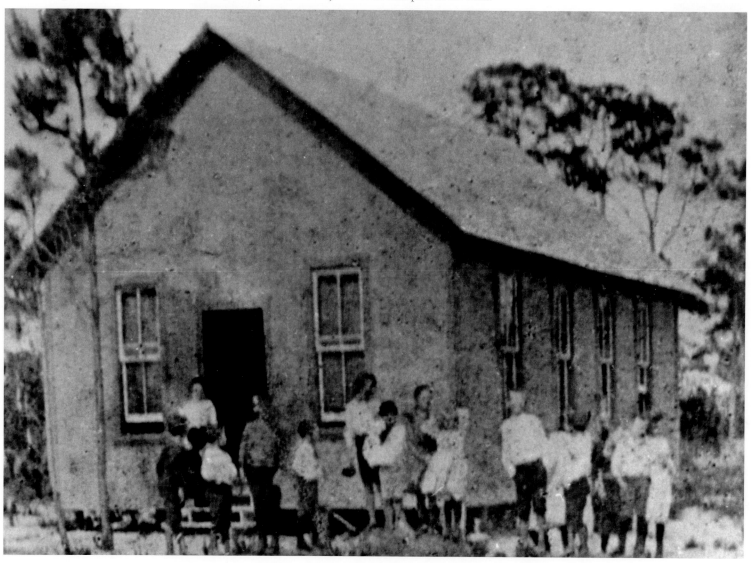

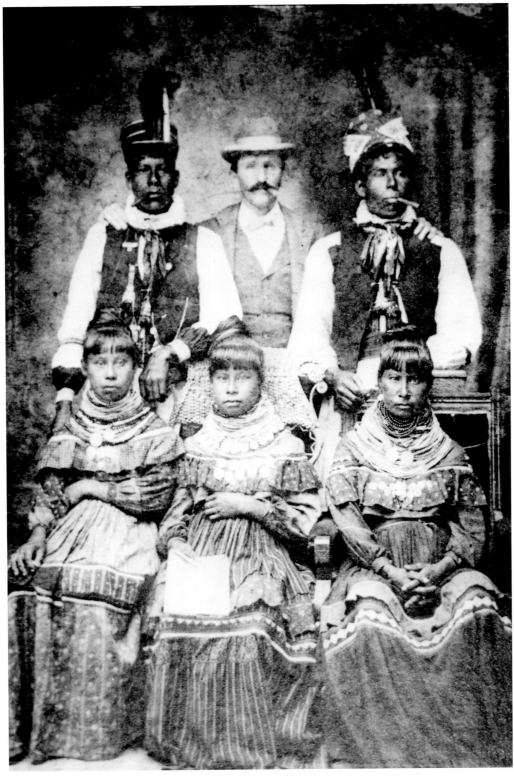

The local Seminole Indians were befriended by Frank Stranahan who arrived in 1893 to run the New River ferry and an overnight camp for the new Dade County stage line. In this image a man identified as Frank's brother Will, freelance journalist and amateur anthropologist, poses with two Seminole men (Charlie Tiger and Charlie Billie) and three women (Nittarkee, Otta hee, and Follee Tikee) for a Miami photographer in 1904.

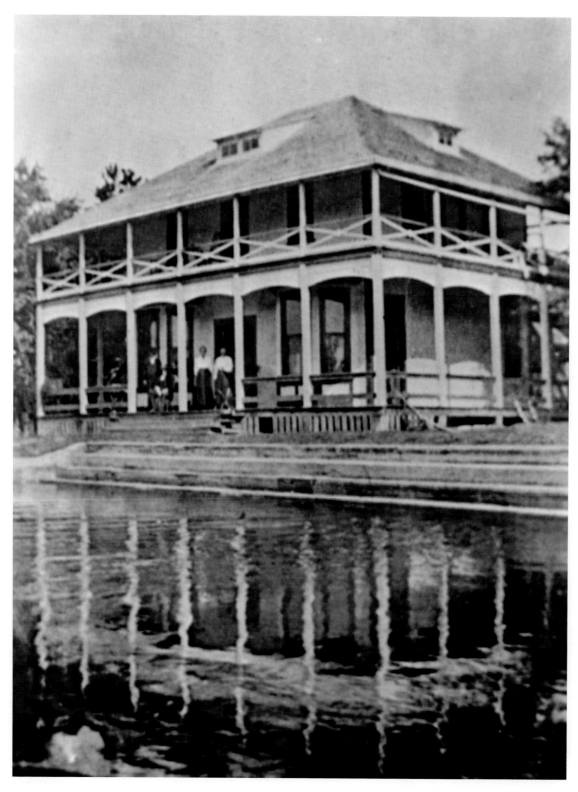

Camp operator Frank Stranahan built a store and established a lively trade with the local Indians. The camp and store soon became the center of a new community called "Fort Lauderdale." The old "trading post" was replaced in 1901 with this two-story structure which still stands on New River above the Federal Highway tunnel. This image shows Frank with his bride, Ivy Cromartie Stranahan, Fort Lauderdale's first schoolteacher, in front of the house about 1913.

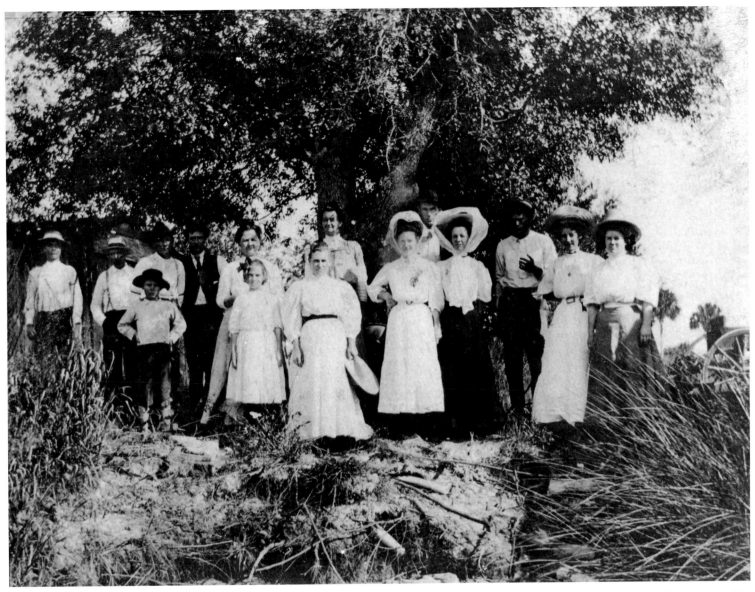

Few of us can imagine the challenges that faced the settlers of the young community of Fort Lauderdale at the turn of the century. The sometimes oppressive heat and numerous pests would have daunted many pioneers, but the warm winter climate, endless waterways, and tropical scenery attracted others. Here, several of the townsfolk gather for a picnic, in fashionable regalia, on New River about 1909.

Fort Lauderdale was a river town, and the principal means of travel at the beginning of the twentieth century was by boat. To "get out of town," one went by rail. The site where New River and the Florida East Coast Railway met became the new center of the growing town. Here, the Marshall brothers, pioneer growers along the south fork of New River, pose in their rowboat near the FEC bridge about 1905.

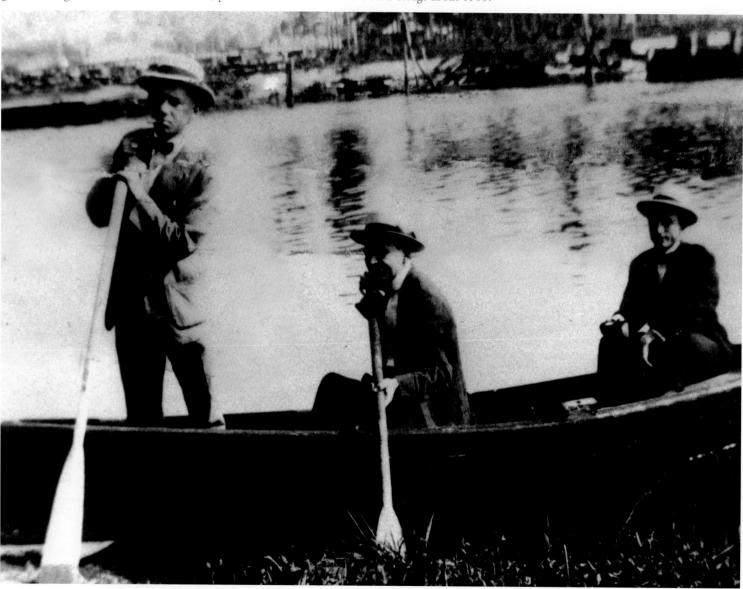

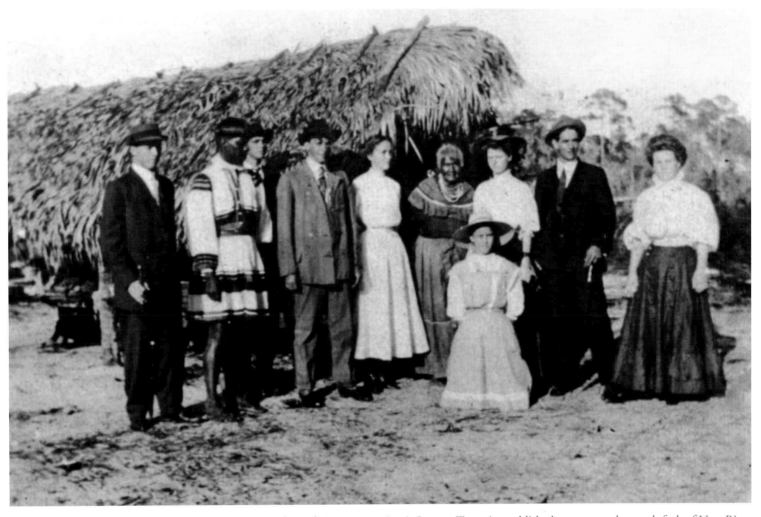

Seminole medicine woman Annie Jumper Tommie established a camp on the north fork of New River shortly after 1900, near what is today Broward Boulevard. As the community of Fort Lauderdale grew, the camp became a natural tourist attraction for travelers and curious locals. Fort Lauderdale residents Frank Dupont and Eva Tommie Meadows (far right) pose with members of Annie's family about 1909.

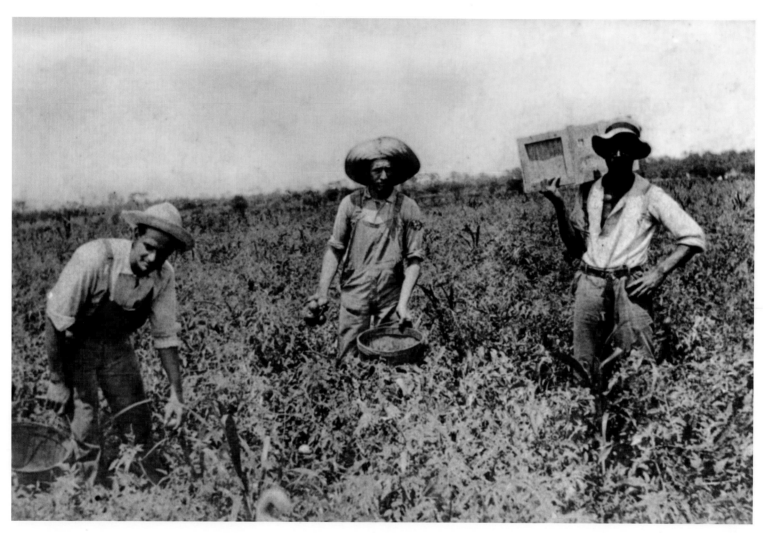

Early settlers were drawn to the Fort Lauderdale area by the excellent farmland and year-round growing season. Many crops proved unsuitable because of ravenous tropical pests or difficulty in shipping. Tomatoes, however, were relatively easy to grow and survived the long trip north without refrigeration. Here, three pickers harvest Fort Lauderdale's most popular crop about 1909. The gentleman at center is identified as "Johnie Parker."

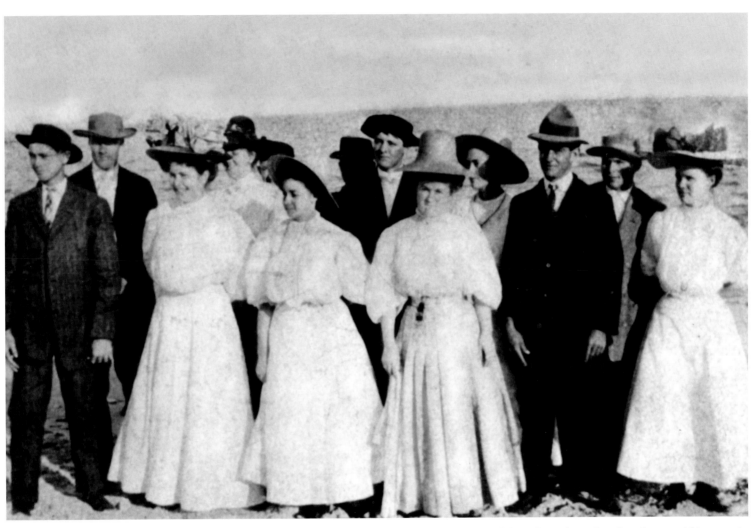

Fort Lauderdale's beautiful beaches were not the principal draw for early settlers that they would become in ensuing years. Before the first causeway was built, a trip to the beach involved a trip by boat, but holidays such as Christmas and the Fourth of July were often celebrated with a "fish fry" and picnic at "Las Olas Beach." In this photo, a group of well dressed revelers pose for such an occasion around 1909.

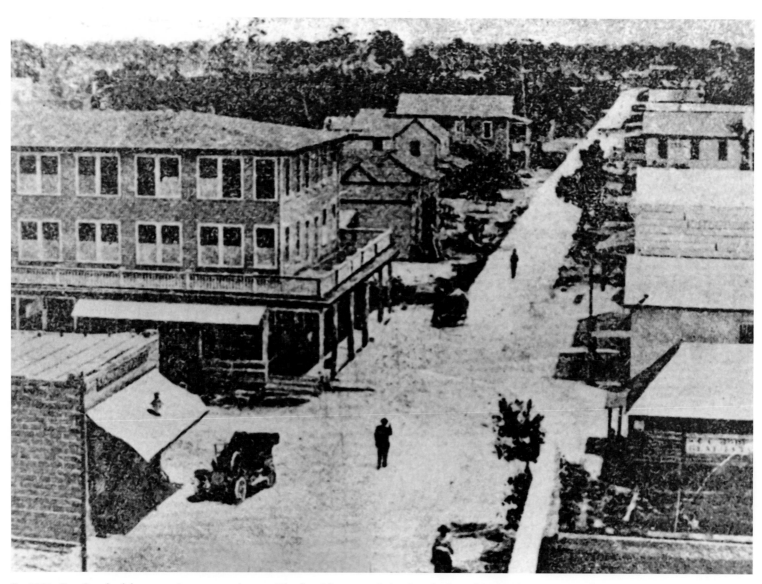

By 1911, Fort Lauderdale was an incorporated town. The first "downtown" developed where the Florida East Coast Railway met New River—the crossroads of transportation at the time. This scene depicts Fort Lauderdale's first "main street," Brickell Avenue (Southwest First Avenue) about 1911. At left stand the Everglades Grocery and the Osceola Hotel. To the right, at the bottom of the frame, is C. G. Rodes' real estate office, the pool hall, and the Lyric Theater.

In 1915, Broward County was created from Palm Beach County to the north and Dade County to the south. The new county courthouse was located in what had been Fort Lauderdale's second schoolhouse, constructed in 1910 south of New River on Andrews Avenue. In 1928 it was replaced by a new courthouse built on Southeast Third Avenue, site of the present courthouse complex.

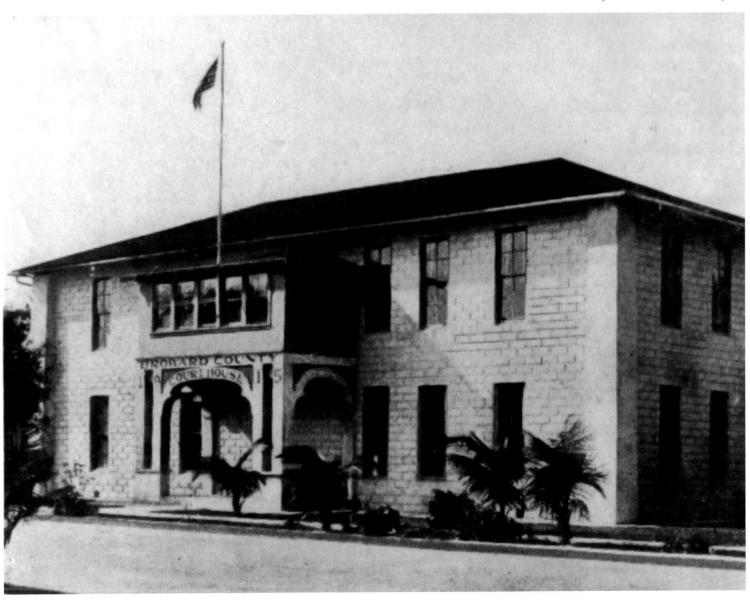

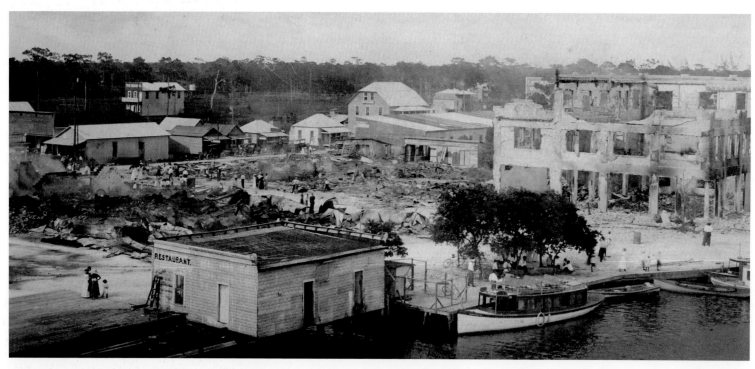

Fort Lauderdale's downtown was virtually destroyed by fire on June 1, 1912. The town council responded by establishing a volunteer fire department and initiating water and sewer service for the newly incorporated community. This view shows Brickell Avenue, looking toward the northeast, from a vantage above New River—probably atop the Florida East Coast Railway bridge.

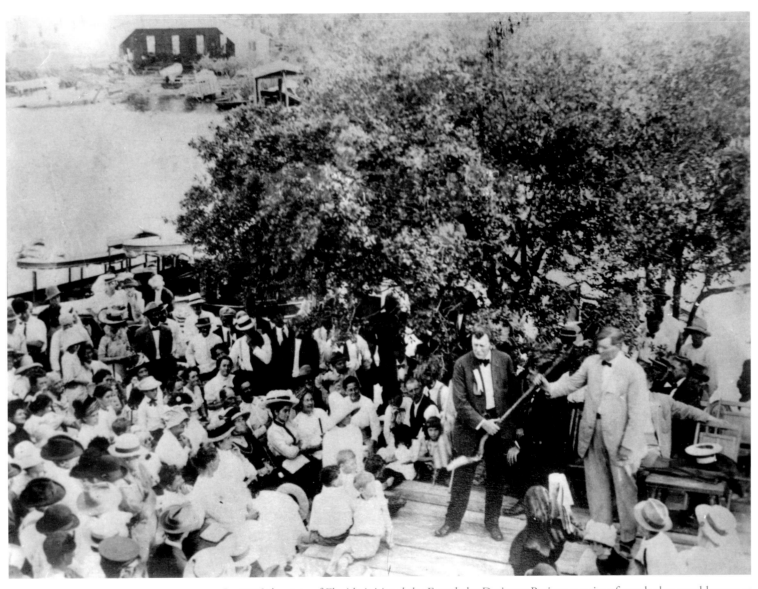

In 1906 the state of Florida initiated the Everglades Drainage Project, a series of canals that would connect the two coasts and drain the glades for farmland. The first such waterway was the North New River Canal, which today links New River with Lake Okeechobee. Governor Albert Gilchrist, in the black suit, presents a shovel to Fort Lauderdale Mayor William Marshall at the ceremony recognizing the completion of the North New River Canal, April 26, 1912.

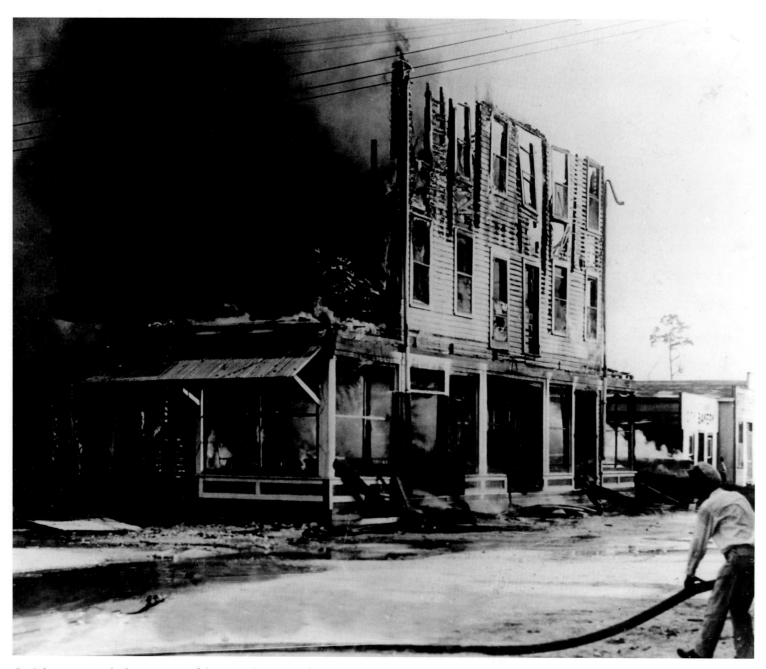

On July 17, 1913, the last survivor of the 1912 downtown fire ironically succumbed to fire itself. The Osceola Hotel was a three-story, wood-frame structure originally constructed as a warehouse and later converted to a hostelry to house the many new investors and settlers coming to the area. This north-facing view shows the new fire department in action on Brickell Avenue.

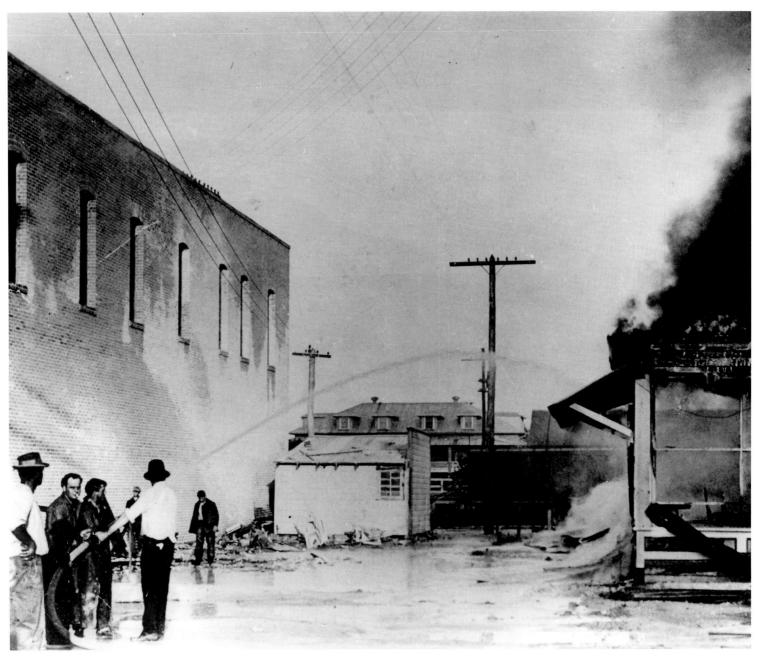

This view of the Osceola Hotel fire features the nascent fire department, at left, in a shot taken from the south and east corner of the inn. At left are the concrete-block walls of the newly constructed Oliver Building, which stood until the 1990s. In the center background is the roof of one of the city's first hostelries, New River Inn. Built around 1905, today it is the home of the Fort Lauderdale Historical Society.

The British-born "Commodore" A. H. Brook arrived in Fort Lauderdale in 1919 and immediately became one of its principal boosters and a renowned activist. He made his home in the historic neighborhood of Sailboat Bend, located on New River just west of downtown. This photograph shows the fine river view from his home, Brookside, with his sailboat, *Klyo,* moored at center.

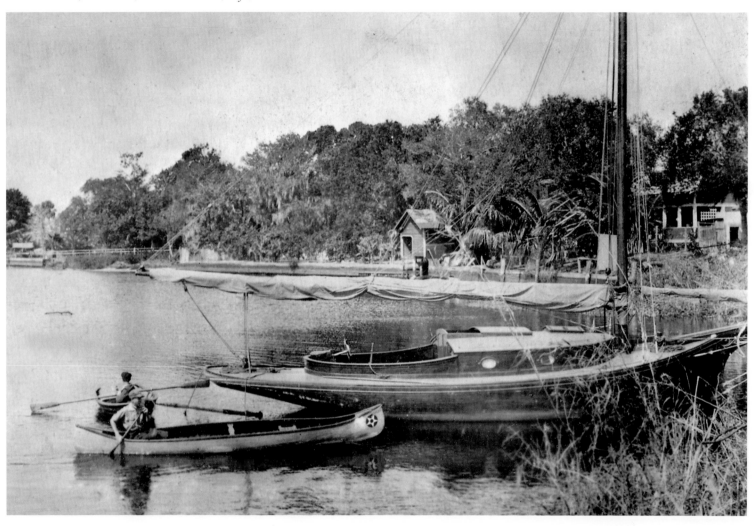

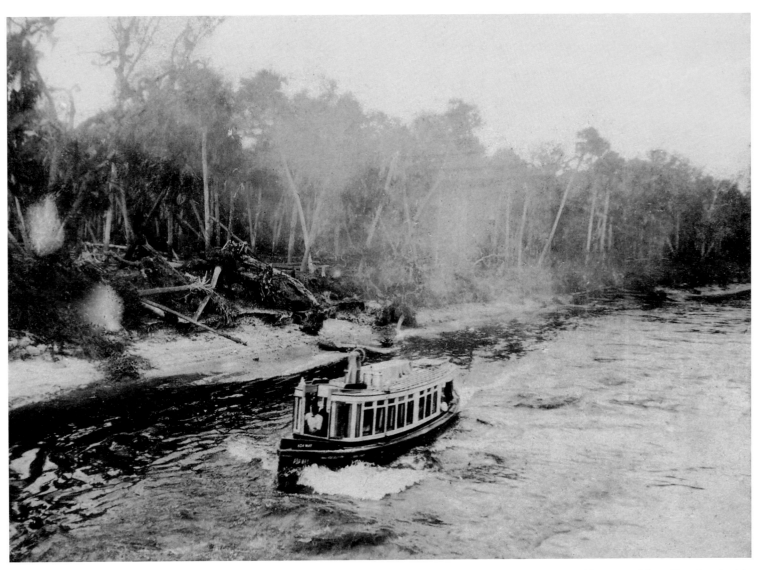

With the completion of the North New River Canal in 1912, it was possible to travel from Fort Lauderdale to Fort Myers inland by water. South Florida enjoyed its very own "steamboat" era as boats brought prospective land buyers and growers' crops back and forth from Lake Okeechobee to the railhead at Fort Lauderdale. Pioneer Ivan Austin photographed this scene along the canal in 1913.

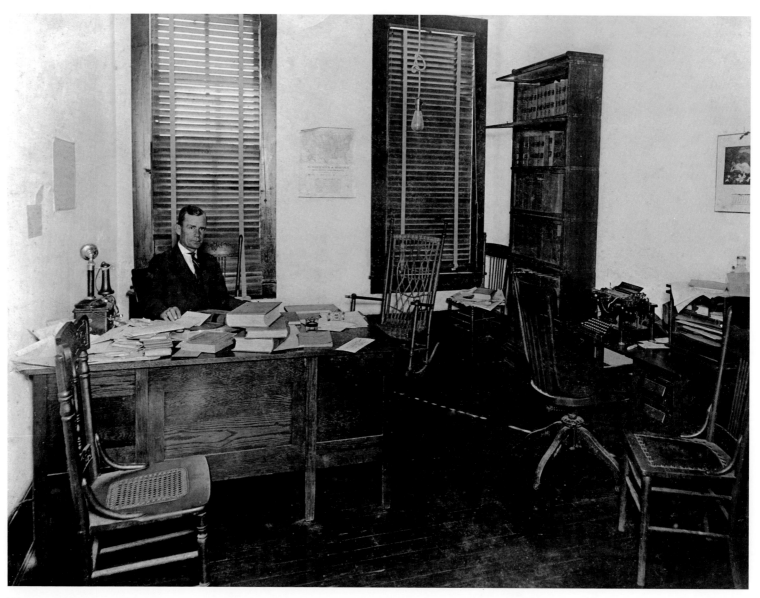

This rare interior view shows the new county's prosecuting attorney Gregers A. Frost in his courthouse office in 1915. County commission meetings were often held in this office in the first days of county government. The frontier town of Fort Lauderdale had acquired telephone and electric service by this time, evidenced by the phone and light bulb to the left and right of attorney Frost.

The creation of Broward County in 1915 resulted in the establishment of the Broward County Public Schools, which had previously been part of the Dade County public school system. Today, Broward County has one of the largest school systems in the country. The first superintendent of schools was James Malcolm Holding, who served in that capacity until 1919, when he resigned to pursue his agricultural interests.

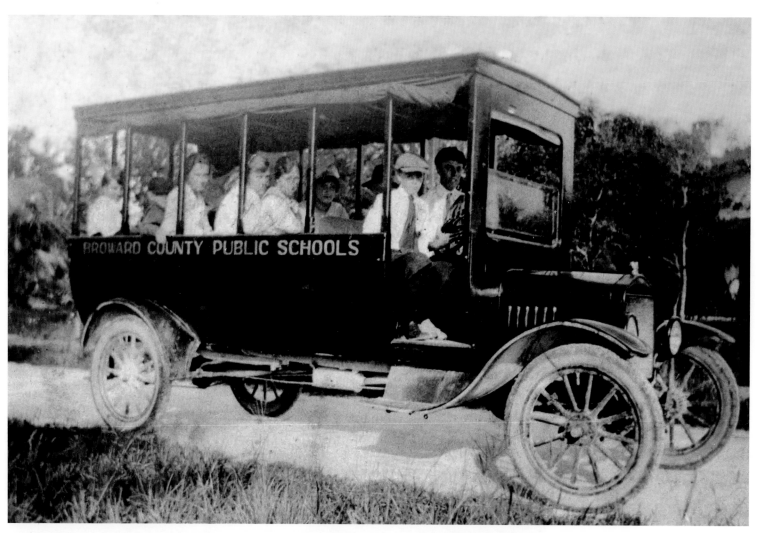

The new county school system was far-flung indeed. From Deerfield to Dania, open-sided buses like the one shown here transported teenage students to the only high school in the sixty-eight miles between West Palm Beach and Miami. The Central School, now known as Fort Lauderdale High, was the pride of the new county, graduating its first class in May 1915.

"Tom Thumb" weddings, in which children acted out a formal wedding ceremony, were often performed by charities as fund-raisers and entertainment at the turn of the century. In this image, two children portray a "Tom Thumb" couple, complete with baby in carriage. They are patriotically arrayed for a parade in downtown Fort Lauderdale in the 1910s. Notice the saw palmettos, once prevalent throughout the local landscape, in the background.

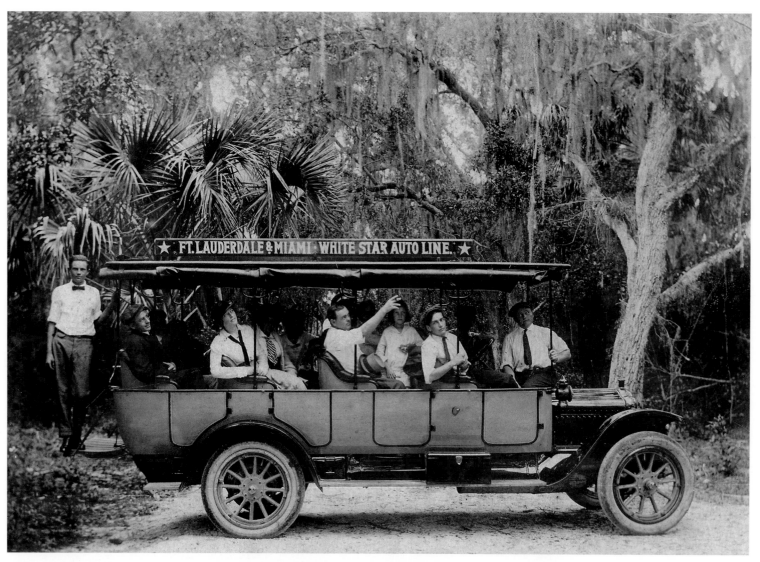

On June 15, 1915, the White Star bus line began operations between Palm Beach and Miami. The open-sided buses, named for the manufacturer (White) were actually owned by Fort Lauderdalians. Two buses each made a complete run once a day. The White Star Line was later sold to the Greyhound Bus company. Here, travelers enjoy a beautiful tropical vista along the roadway—a far cry from today's interstate.

Famous director D. W. Griffith oversees a location shot on New River in 1919. Pioneer camera artist "Billy" Blitzer stands at left. Fort Lauderdale briefly became a movie capital during the late 1910s and early 1920s, as its unspoiled tropical scenery attracted directors.

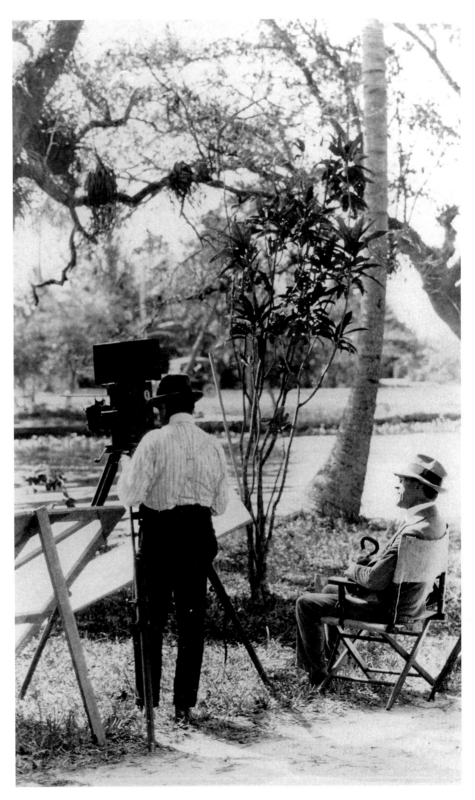

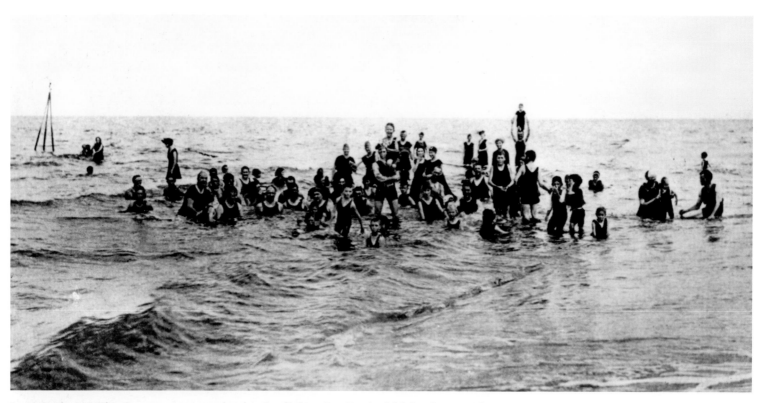

In 1917, the Las Olas Causeway was completed, at last linking Fort Lauderdale's beach area with downtown. A trip to the beach no longer relied on an available boat; it was much easier to hitch a ride on someone's "flivver." The beach and causeway encouraged an important industry in Fort Lauderdale: tourism. This photo features a joyful crowd, late 1910s.

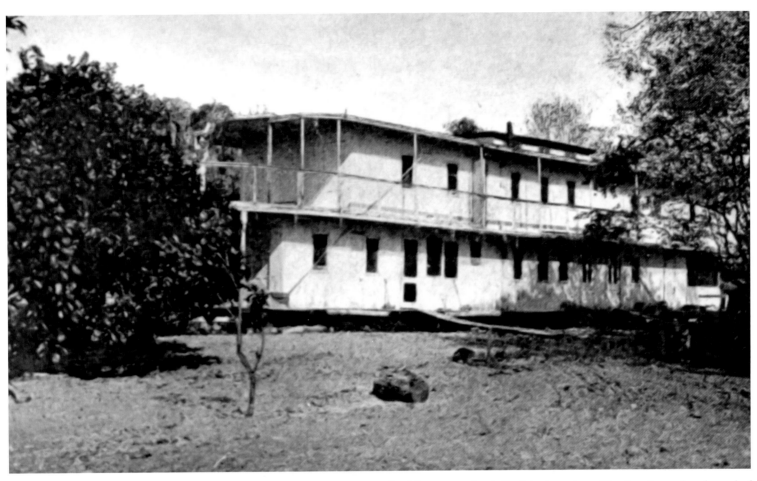

One of the local "attractions" of the era was the shell of the houseboat *Wanderer,* located at the end of Southwest Fifteenth Street in what is now the Shady Banks neighborhood. Originally owned by millionaire naturalist C. B. Cory, it later belonged to famed actor Joe Jefferson, and was notable for the notorious happenings that once took place on board. It was destroyed by the 1926 hurricane.

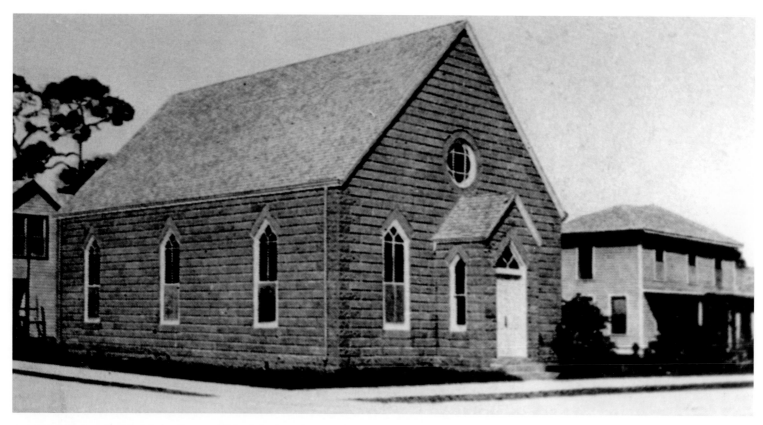

In 1903, Fort Lauderdale Methodists established the first church when they began meetings at the old schoolhouse. By 1905 they had constructed this concrete-block structure on the corner of Southwest Sixth Street and Andrews Avenue. In those days, it served as the early home of a number of other denominations as well. It was completely demolished by the hurricane of 1926.

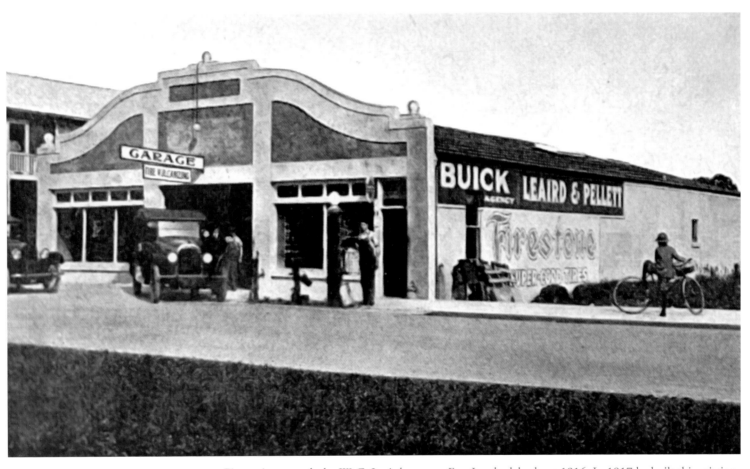

Pioneering auto dealer W. C. Leaird came to Fort Lauderdale about 1916. In 1917 he built this mission-style garage, featuring a distinctive curvilinear gable, on Andrews Avenue just south of today's Southeast Second Street. Leaird was also the town's Ford dealer. Leaird and Pellett sold their business to the Green Motor Company in the early 1920s.

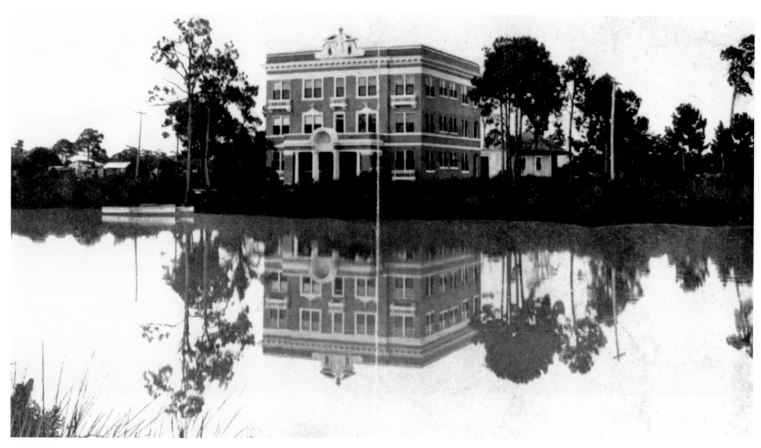

One of New River's best known landmarks for many years was the Dresden Apartments, constructed around 1917. The building stood at 220 Southeast River Drive, on the grounds of the current county courthouse, and was demolished in 1967 after years of decline.

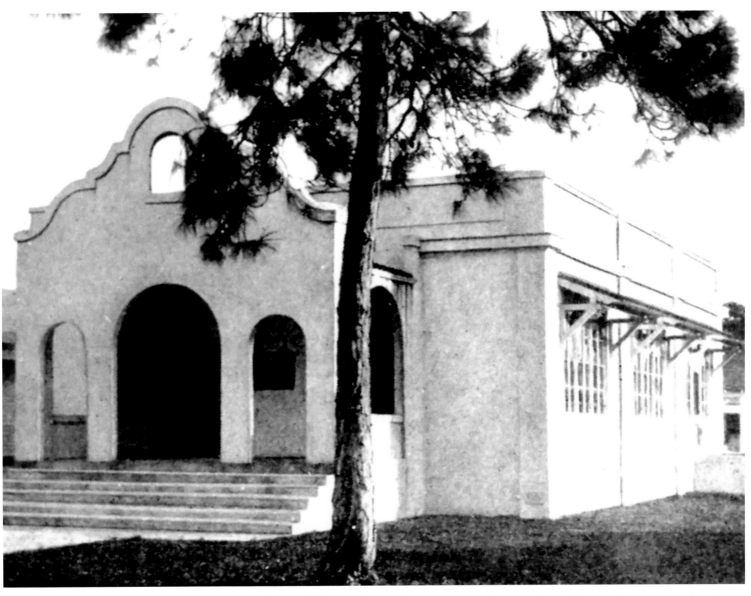

South Florida's first professional architect, August Geiger, designed this mission-style building for the Christian Science Church in 1916. It stood on the south side of New River just to the north of the current county courthouse and jail complex. Later, the building housed the city's public library and the Broward County Historical Commission. It was demolished in the 1990s.

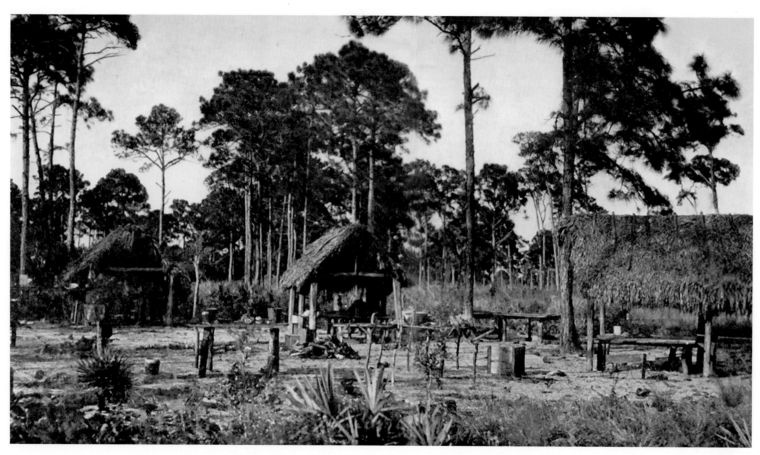

This wide-angle view shows Annie Jumper Tommie's compound located on what is now Broward Boulevard just east of I-95. Notice the native pines and saw palmettos which once constituted the natural "landscaping" of Fort Lauderdale. The structures known as "chickees," made of cypress logs and palm thatch roofs, represented one of the Seminoles' creative adaptations to the South Florida climate.

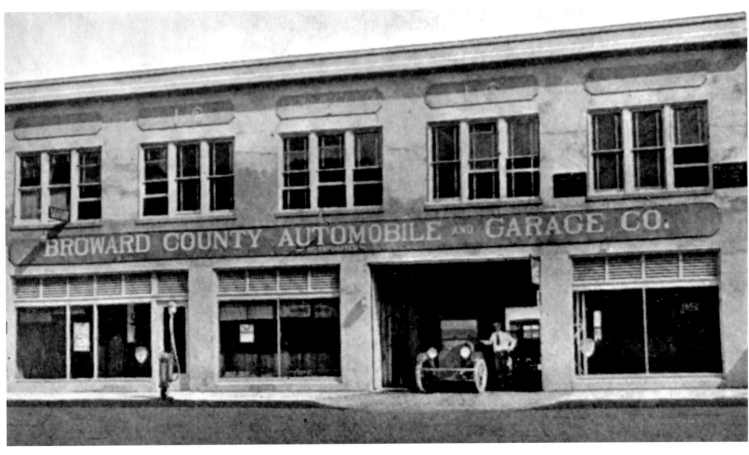

The opening of the Dixie Highway through the county in 1915 brought the automobile to a new prominence in Fort Lauderdale. Garages and service stations popped up throughout town to service "tin lizzies" and more refined vehicles. The Broward County Automobile and Garage Company was located on the bottom floor of the 1916 Wheeler Building, on the east side of Brickell (Southwest First) Avenue and New River Drive—today's Riverwalk.

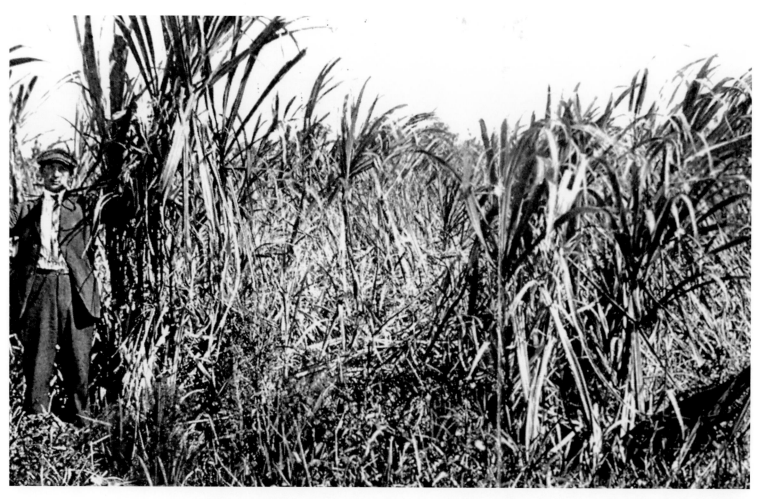

The completion of the Everglades drainage canal system in 1912 opened up vast tracts of land for cultivation. Farmers experimented and found many types of crops could be grown in the rich soils and warm climate of the region. Sugar cane, shown growing in the fields of Davie about 1917, west of Fort Lauderdale, was one such crop, but it did not become an economic success until after World War II.

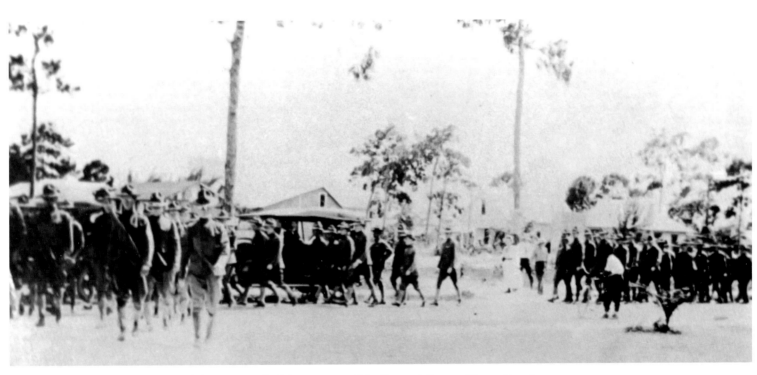

In 1917, Mayor Will Reed organized the Fort Lauderdale company of the Broward County Home Guard, a precursor to the National Guard. The men were equipped with Springfield rifles and U.S. military standard uniforms of the era. The Fort Lauderdale *Sentinel* of November 23, 1917, joked the men would "be ready to repel any attempted German invasion of the east marsh tomato fields." Here, the guard drills near Fort Lauderdale High School.

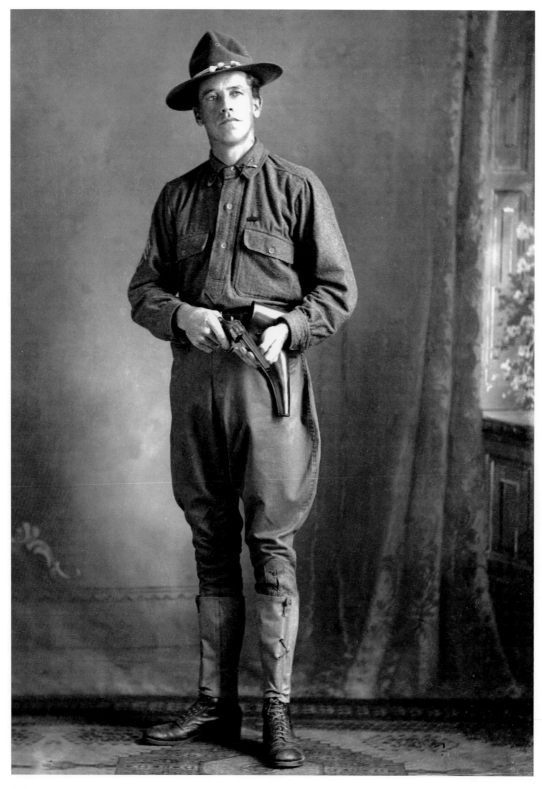

Norwegian-born Sigurd Dillevig was a pattern maker at a Chicago foundry when a local firm selling Florida lands lured him to South Florida in 1912. Dillevig owned the town's only "marine ways," or marine railway, located on the point between the forks of New River. He also served in the Fort Lauderdale Home Guard, as can be seen in this photo from about 1917.

Arteyee Tiger Osceola, wife of John Osceola, shows off the Seminole woman's fashionable attire around 1917. She wears a blouse/cape and tiered skirt featuring colorful strips of fabrics pieced together. On her blouse are silver ornaments made from stamped metal coins, an art form no longer practiced. Around her neck, she wears strands of beads given to every Seminole woman on special occasions.

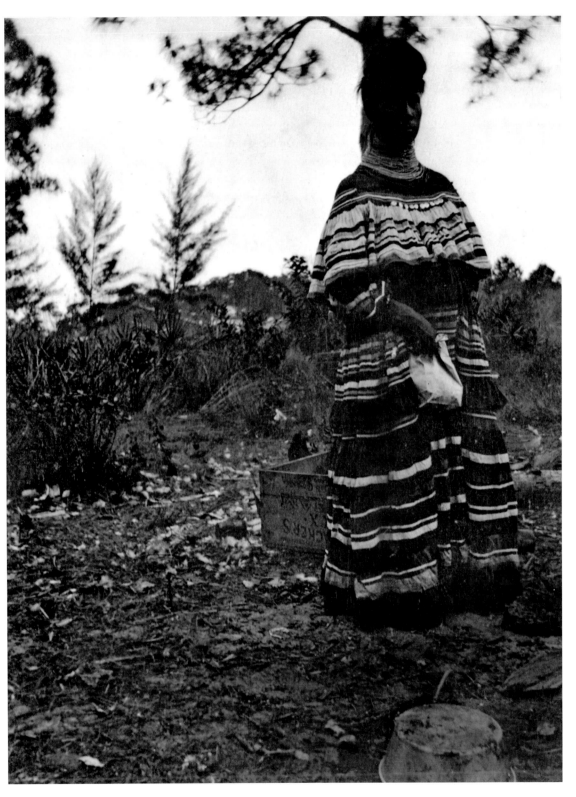

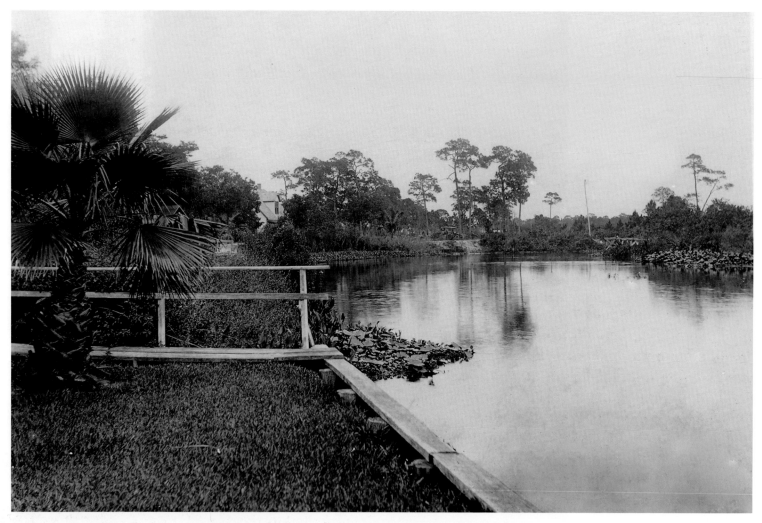

Sam and Ethel Williams moved with their daughter Oleta to a small wooden house on the north fork of New River in 1916. Located in the rustic area then called the "west side"—today the neighborhood of Sailboat Bend—the house had no well or cistern when the Williams moved there. The draw of their suburban location is clear in this photo, showing the pristine north fork of New River, looking down river (east) about 1917.

Boom and Bust

(1920–1939)

By the early 1920s the canal system that had made Fort Lauderdale a popular river port was largely unnavigable, silted up by agricultural runoff. But local residents were generally unconcerned because the city had a new economic focus—real estate and tourism. An era of prosperity at the end of World War I, added to the arrival of the Age of the Automobile, made Florida in the 1920s the subject of a new "gold rush." The gold was the golden sand of South Florida's beaches, and Fort Lauderdale was situated ideally at the very center of the action.

The big draw was land. New developments arose all over the city. Within a year, choice downtown lots sold for up to 5,000 percent of the original asking price.

Unfortunately, the boom was about to go bust. South Florida's only rail line at the time placed an embargo on building supplies, to expedite much-needed repair of the tracks. Bad publicity from northern newspapers and disgruntled summer visitors added to the slowdown. Finally, two of the worst hurricanes ever to hit the area—one in 1926, followed by another in 1928—caused mass destruction and loss of life. Florida's land boom was at an end, and the Great Depression came to Fort Lauderdale years before it struck the rest of the nation.

Despite the belt-tightening to come, a number of important public projects were completed in the late 1920s. The Fort Lauderdale Casino Pool and Fort Lauderdale Golf and Country Club served as new tourist draws. In 1928, residents' long-time dream of a deepwater port was realized with the opening of Port Everglades.

However, hard times were inevitable for the local citizens and the city itself. The people simply did not have enough money to pay taxes—the revenue the city relied upon to operate. Agencies like the Federal Emergency Relief Administration (FERA) provided aid in the form of training and employment. Former Mayor Thomas Manuel, who served during the difficult era recalled, "the main thing I remember is that people never gave up, we had a great belief in the future because we knew that as long as we had the sun and the ocean that people were going to come here … and they did."

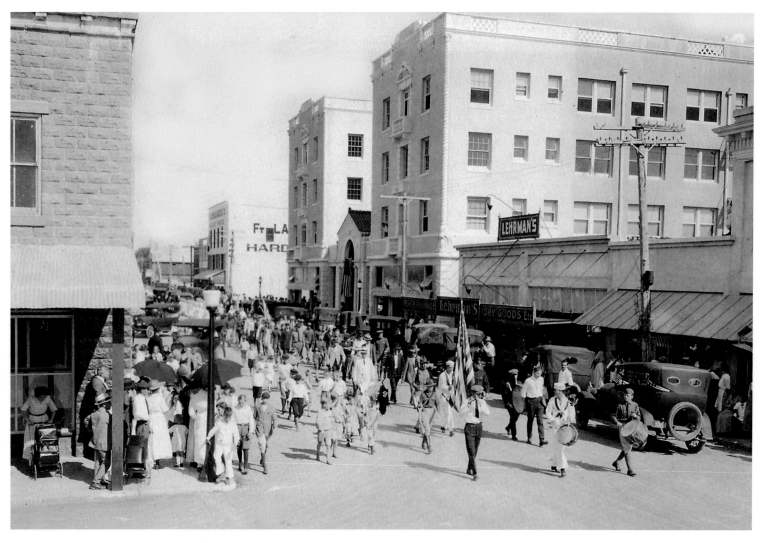

This view of North Andrews Avenue, facing north from the New River bridge, shows a patriotic parade around 1920. The new decade signaled truly a new era—agriculture and shipping no longer reigned supreme. Tourism and real estate became the new focus of the local economy. The Mediterranean-style Broward Hotel rises majestically in the center of the photo.

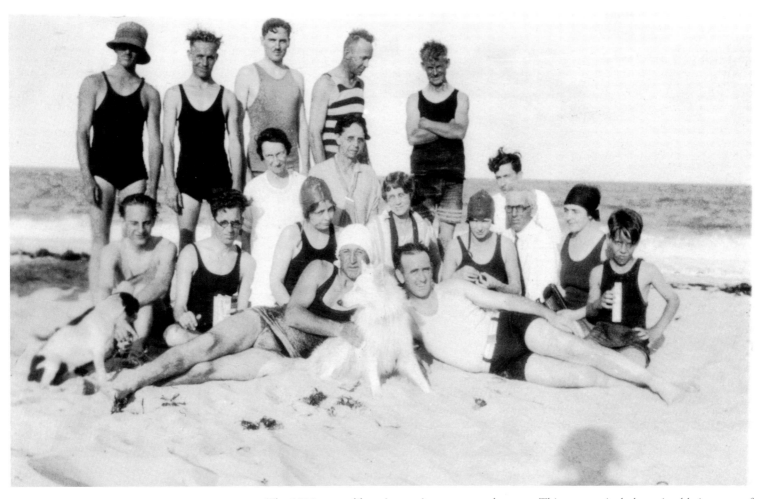

The 1920s was a liberating era in more ways than one. This was particularly noticeable in terms of fashion; women's clothing became dramatically less restrictive and more revealing. During the 1910s, Fort Lauderdale's female beach-goers would have been properly clad with sleeved dresses complete with knickers and stockings. The "modern" men and women in this image wear tank suits in an almost unisex style.

The Bryans were one of the first families to come to the new town of Fort Lauderdale in the 1890s and played a pivotal role in the entrepreneurial life of the community. In this image, the third generation of Fort Lauderdale Bryans "hang" with friends outside Reed Bryan's home on New River in 1921. Left to right are: Thomas Charlton; Robert Young; future mayor Reed Bryan Jr.; and James Bryan.

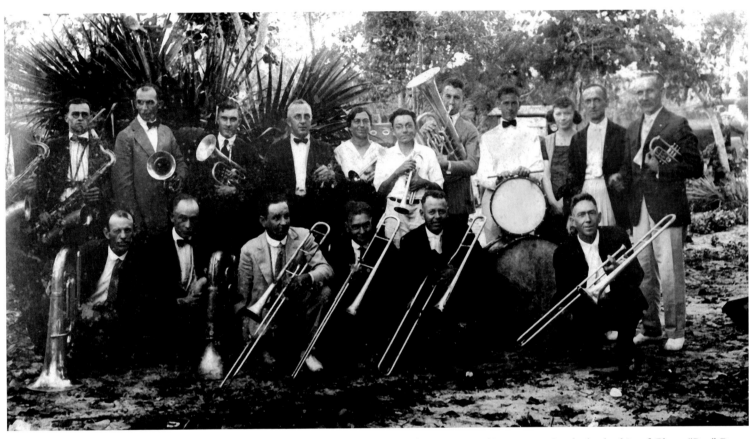

Fort Lauderdale's first municipal band was organized in 1913 under the leadership of Glenn "Pop" Bates. The band provided a much-needed cultural respite for hard-working citizens, with concerts held on the riverfront on Brickell Avenue every Saturday night. Bates' wife, son, and two brothers played in the band, despite brother Beryl's missing arm. (He's third from the left, front row.) This photo shows band members from the 1920–21 season.

One of Fort Lauderdale's most recognizable characters in the 1910s and 1920s was "Shirttail Charlie," a Seminole Indian who panhandled on the streets for a living. A legend grew that Shirttail had murdered his wife and been condemned to wear a woman's dress as punishment. The truth was he simply continued to wear the "big shirt" style, which was slowly being replaced by trousers and jackets among Seminole men.

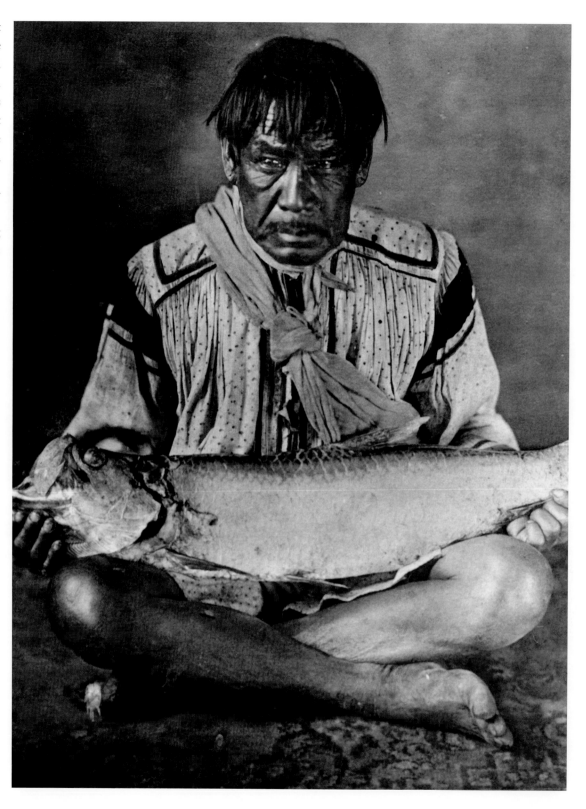

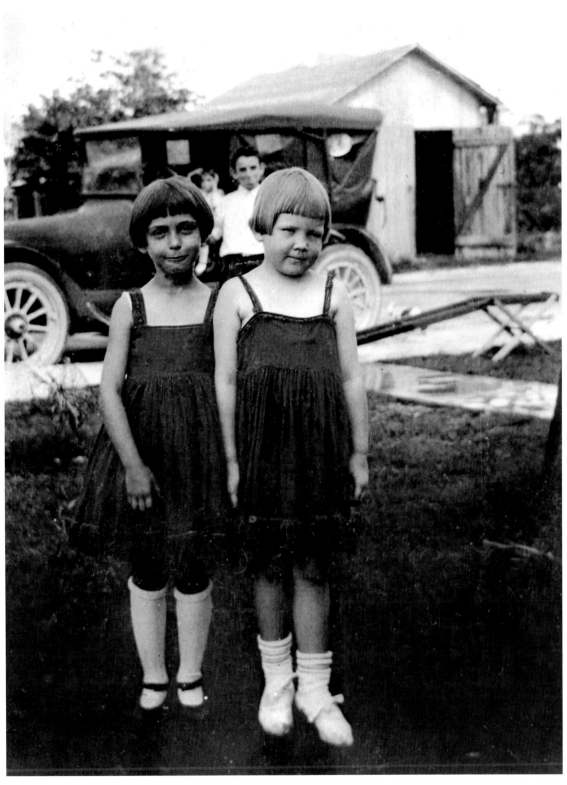

Max and Rosa Lehrman came to Fort Lauderdale in 1918, one of just a handful of Jewish families in those early years. Max was the well-known owner of Lehrman's Department store on South Andrews Avenue. This photo shows young Nellie Lehrman with friend Antoinette Sullivan posing on what is probably the lawn outside the Lehrman home, located on Southeast Second Avenue, just north of Las Olas Boulevard, in 1920.

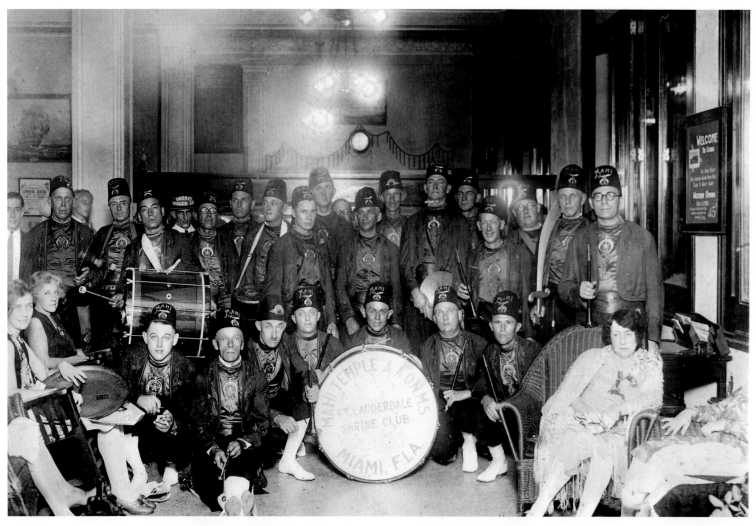

On February 26, 1927, a group of Masons met to establish a local Shrine Club in Fort Lauderdale. Their charter was issued under the auspices of the Mahi Temple in Miami in May of that year. In July 1928, the club was granted permission to form an "Oriental Band." Here, band members, in regalia, are shown posing with their wives, who played a significant "supporting role" in all of the band's performances.

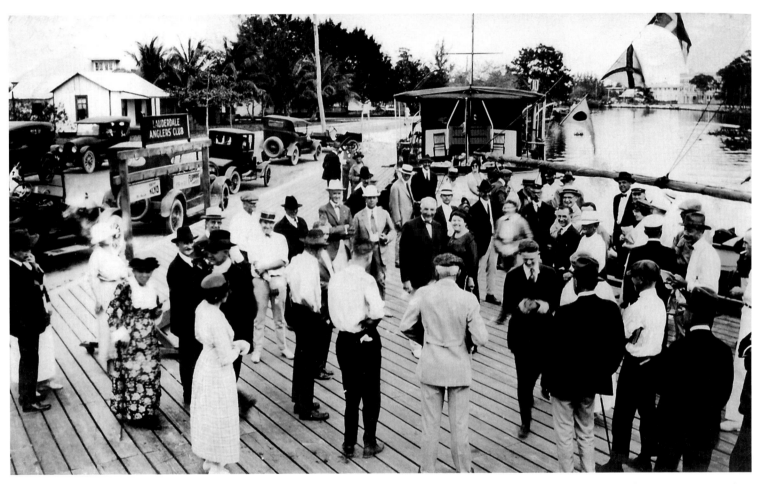

In 1921, local boosters Commodore Brook and Tom Stilwell "rescued" president-elect Warren G. Harding as he was traveling down the Intracoastal Waterway and met a grounded dredge mysteriously blocking the way. It was all part of an effort to promote the young city. Harding was a willing participant, even playing a round of golf. He is the dapper man in the black suit at center, posing with locals on the docks near the Andrews Avenue bridge.

Eccentric millionaire Hugh Taylor Birch purchased about three miles of Fort Lauderdale beachfront property in the late 1890s, long before any residences or hotels were constructed there. Much of the estate was eventually sold off, but a portion remains as two of the least-developed and most-treasured parts of Fort Lauderdale real estate today, Birch State Park and Bonnet House Museum and Gardens. Here, curious visitors stroll through the coconut palms in the tropical paradise of the Birch lands in the early 1920s.

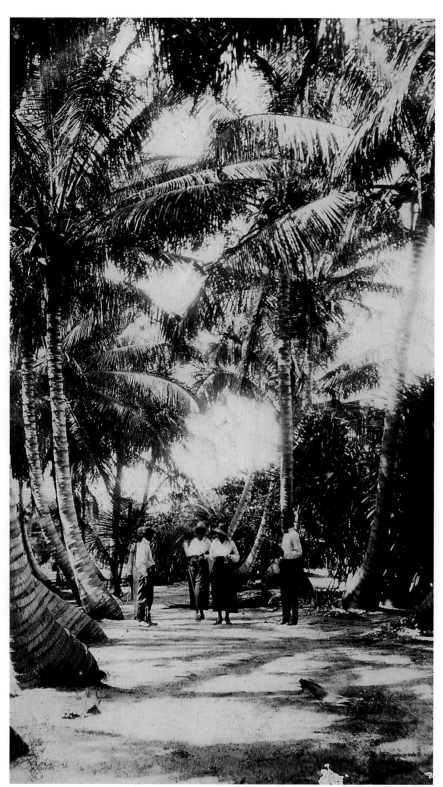

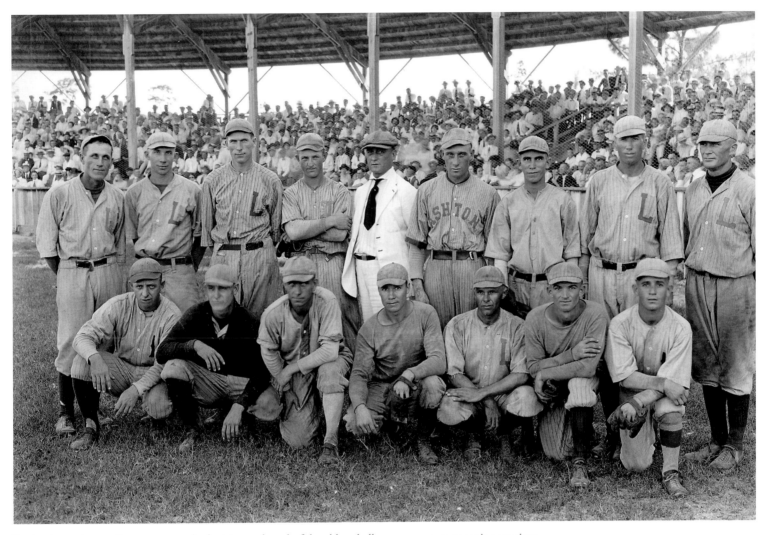

In the days when radio was new and television unheard of, local baseball games were an engaging pastime in small-town America. Everyone turned out for the games of the Fort Lauderdale town team, shown here in 1921. They played teams from various neighboring communities, but "Beat Miami" was their rallying cry. Games were played on Stranahan Field, a site at the southwest corner of Federal Highway and Broward Boulevard.

Early in the 1920s, Fort Lauderdale's town baseball team—now called the Tarpons—began hiring players, just as other teams in the league did. Some, like Les "Sugar" Sweetland, went on to play in the big leagues. By now, every store in town would close at game time. In 1924, the Tarpons won the East Coast League pennant, which survives in the collections of the Fort Lauderdale Historical Society.

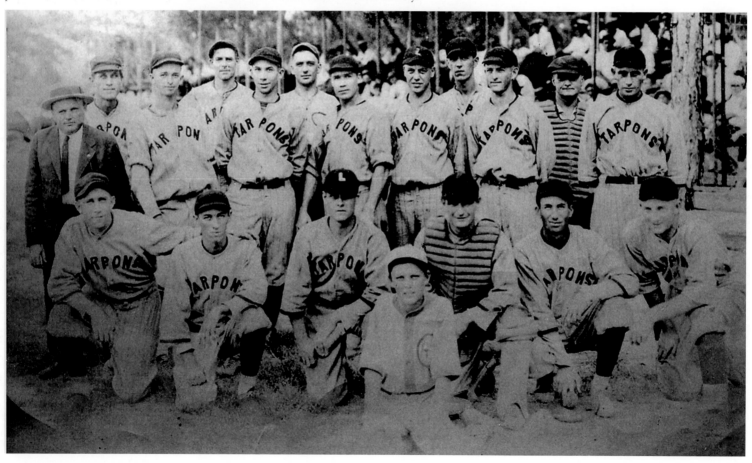

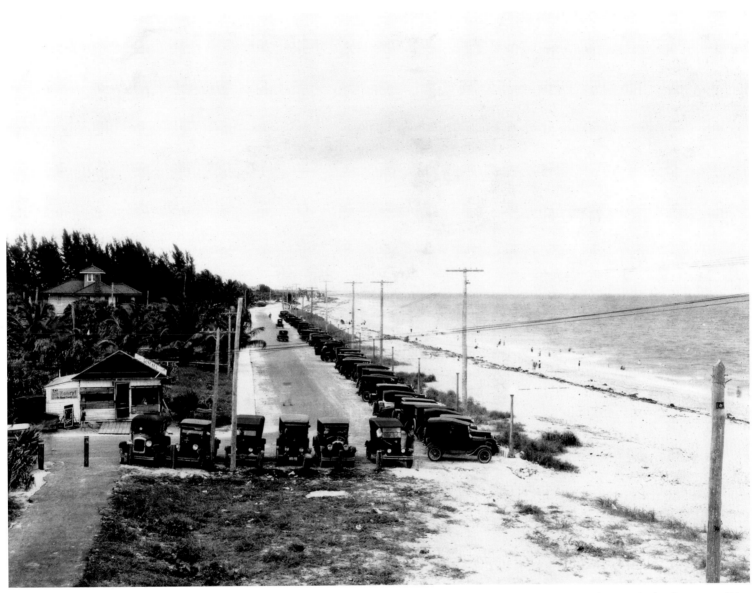

The completion of the 1917 Las Olas Causeway resulted in the slow but steady development of Fort Lauderdale's now-famous beachfront. The cars lining what was then known as Las Olas Beach are a testament to its new-found popularity and the growing tourism industry. The north-facing view was photographed from the roof of the first Fort Lauderdale beach casino in 1925.

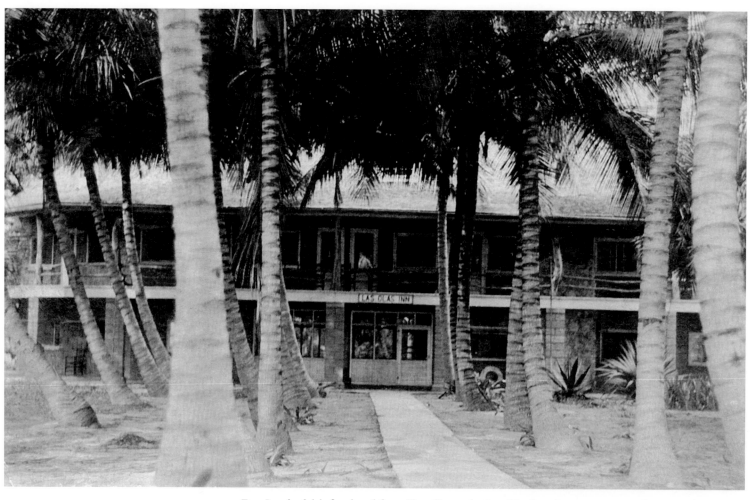

Fort Lauderdale's first beachfront "hotel" was the Las Olas Inn. It was constructed in 1902 by pioneer builder Ed King, the first building in town made from hollow concrete-blocks—today the standard for South Florida structures. By the 1920s, it had become a unique tropical getaway for sportsmen and tourists. This view shows the eastern facade in the mid-1920s.

Pioneer Jimmy Vreeland, son of a one-time keeper of the House of Refuge—a rescue station and shelter for shipwrecked sailors, operated by the U.S. Life-Saving Service, the forerunner of the Coast Guard—became Fort Lauderdale's first charter boat captain. "Cap" Vreeland and his *Kingfisher* boats operated out of his private dock off Las Olas Boulevard, just east of the present causeway. This image features happy visitors with their catch on Vreeland's dock in the mid-1920s. Notice the grouper at upper left with mackerel in mouth.

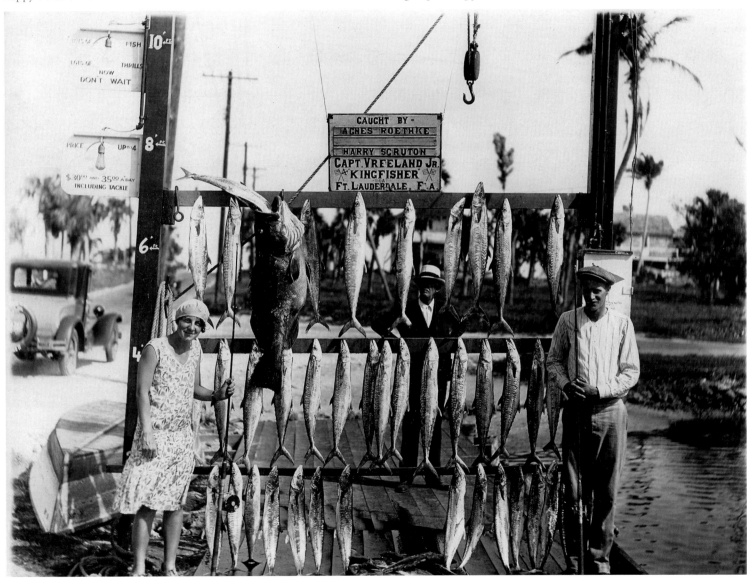

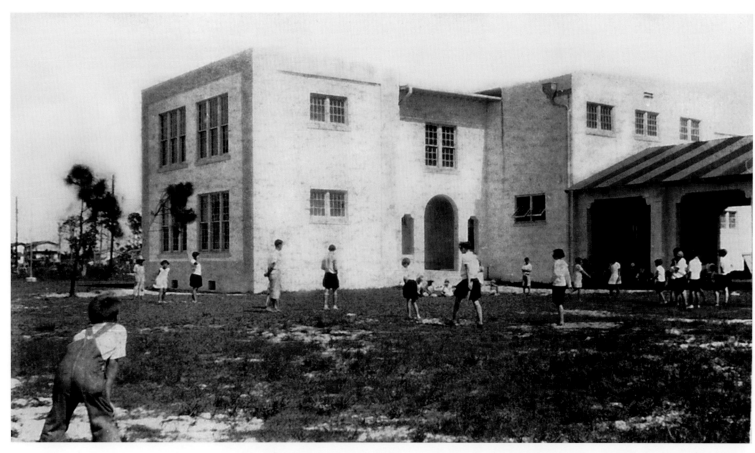

One of four grade schools which once served as "feeders" for Fort Lauderdale's Central School (now Fort Lauderdale High), Westside School opened in 1923 on West Las Olas Boulevard. One of the principal views from the school was a Seminole camp, located adjacent to it on the north fork of New River. The building and adjacent properties later served for many years as Broward County School Board headquarters. The old school is under restoration in 2007 for new use as a cultural facility.

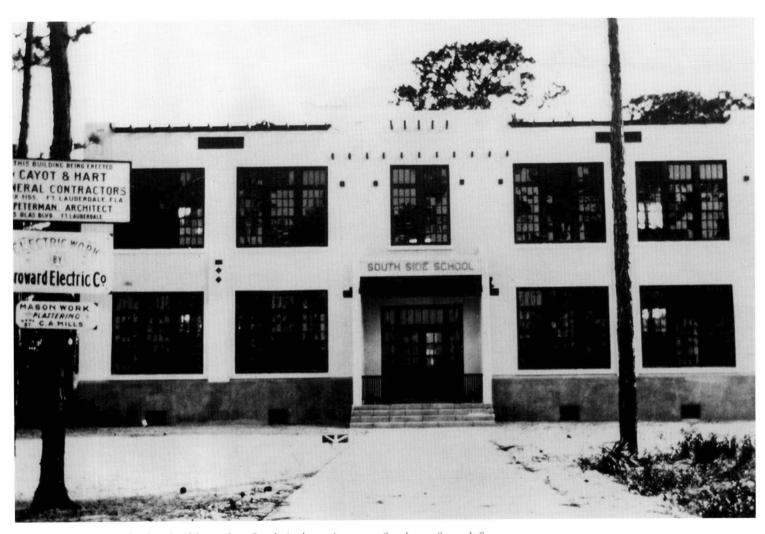

The mission-style Southside School located on South Andrews Avenue at Southwest Seventh Street was designed by local architect John Peterman and opened in 1922. To meet the needs of the growing population, extensive additions and a separate classroom complex were added in the late 1940s. In 1967, the school closed its doors. It sat derelict until 2006, when the city took on the admirable project of restoring it for use as a community center.

Maypole dances were popular public entertainments held on the first of May at schools throughout America in the early twentieth century. In this photo, well-dressed students, probably likely from Central (later called Fort Lauderdale) High School, stand ready for the maypole dance in the early 1920s.

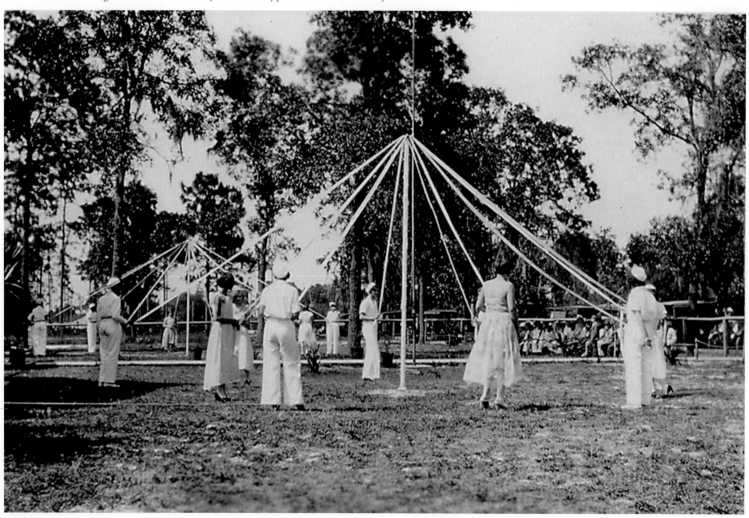

Fishing was a pleasurable and inexpensive pastime for locals as well as tourists in the 1920s. Fish of all varieties were extremely plentiful in the river, canals, and nearby Everglades, as well as the ocean. In this photo, "Dad" Sullivan poses with George Gillespie and Mary Louise Sullivan with a nice catch of mackerels in the mid-1920s.

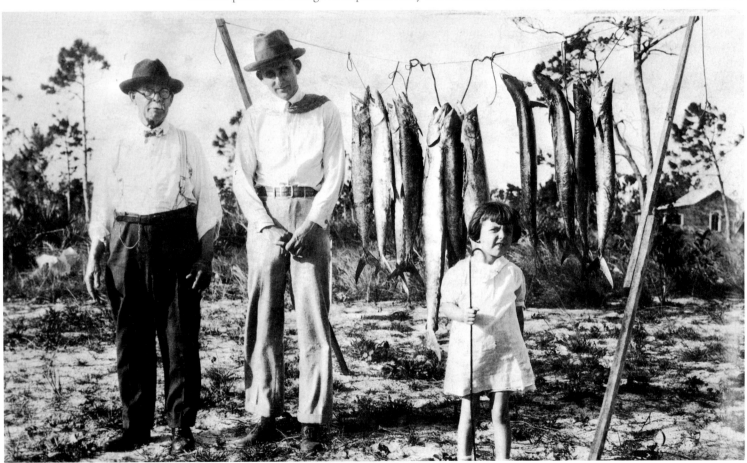

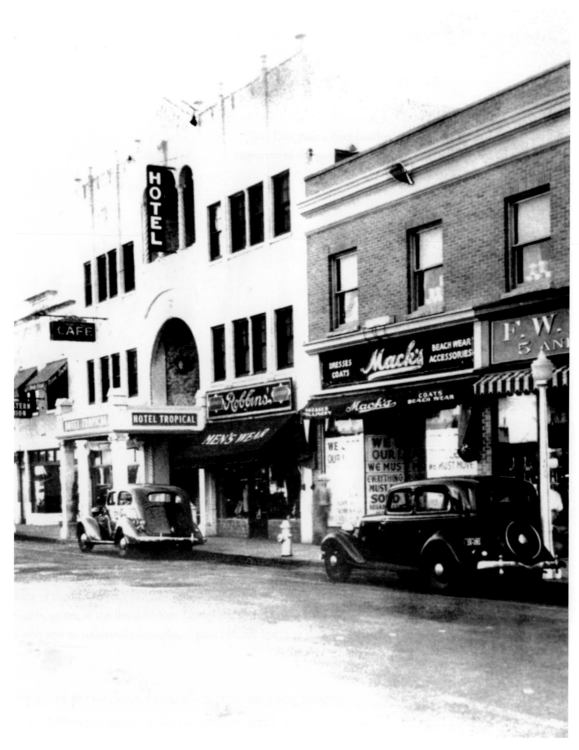

The handsome Tropical Arcade constructed in the popular Mediterranean Revival style opened in 1926 on South Andrews Avenue. The building housed many commercial establishments, as well as the Hotel Tropical which was located on the second floor and primarily served business travelers. The arcade was demolished in the 1970s and today is the site of the Museum of Art.

Fort Lauderdale's volunteer fire department poses just outside the station's 1921 location, on what is today Southwest Second Street at Andrews Avenue. The building at left housed the town's first newspaper, the Fort Lauderdale *Sentinel*. The empty lots in the background belie the amazing growth of Andrews Avenue within the five years to come. The sign at right points to the road to the Everglades and a Seminole Indian camp attraction.

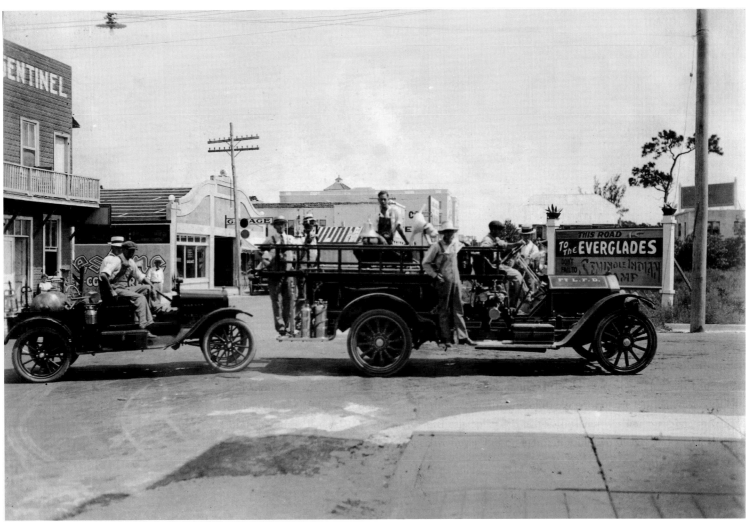

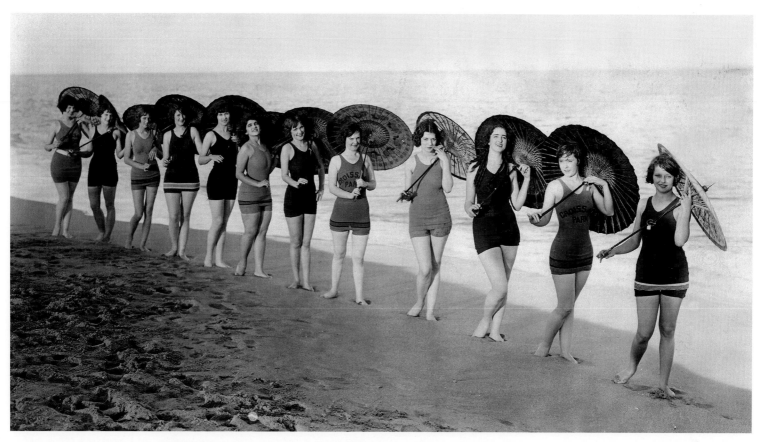

In 1925, at the height of the Florida land boom, Chicago salesman Frank Croissant came to Fort
Lauderdale offering land for sale south of New River. Among the promotions for the new development of
Croissant Park was a beauty contest; the swimsuit competition is shown here.

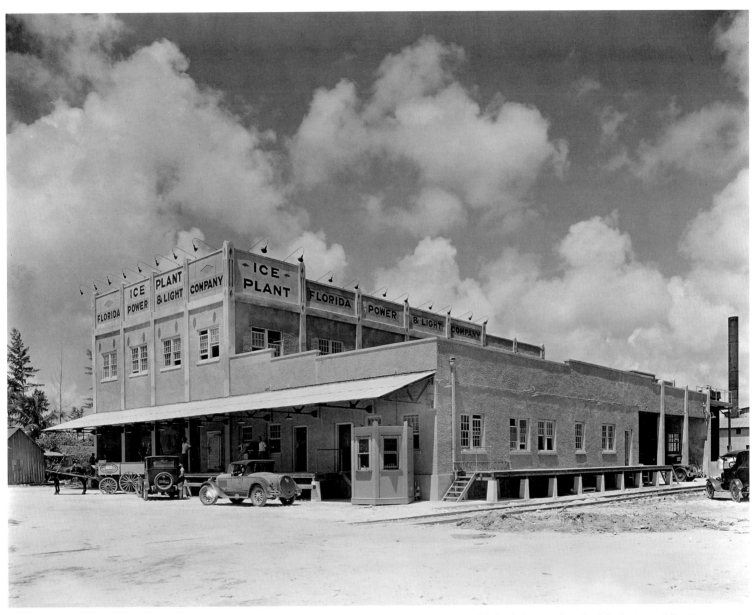

In 1913, pioneer entrepreneur Tom Bryan established the Fort Lauderdale Light and Ice Company in a building on Northwest Second Avenue. The power system was necessary to generate the ice; excess electricity could be sold to the public. By 1925, the "ice plant," was bought out by the young company Florida Power & Light, today South Florida's principal electric utility. This scene shows the FPL plant on September 7, 1926.

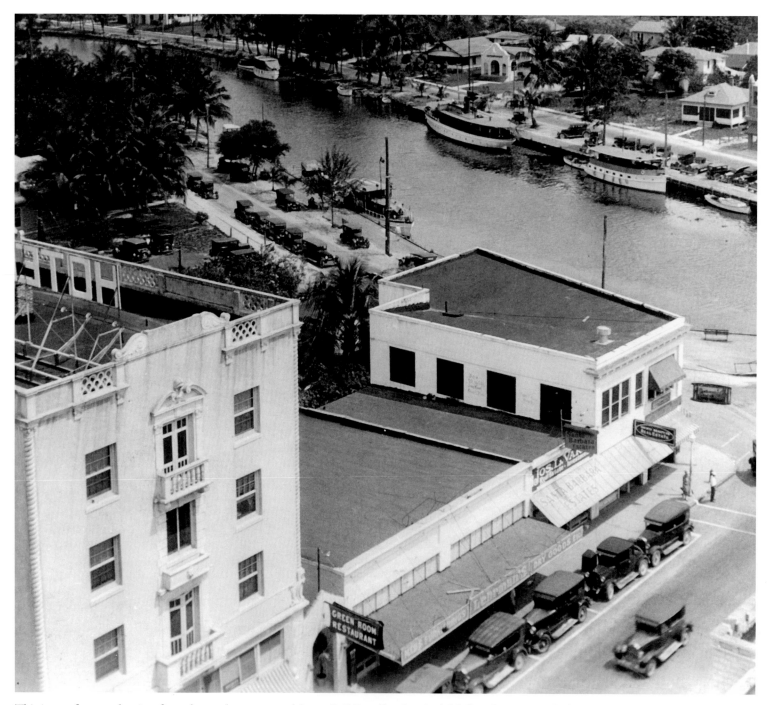

This image features the view from the newly constructed Sweet Building, Fort Lauderdale's first skyscraper, which opened in 1926. In the foreground, the Broward Hotel, Lehrman's Department Store, and the Witham Building are visible on Andrews Avenue. The road at the north side of the river, shown at center, is today Riverwalk. South New River Drive, in the background, is now the site of the county courthouse complex.

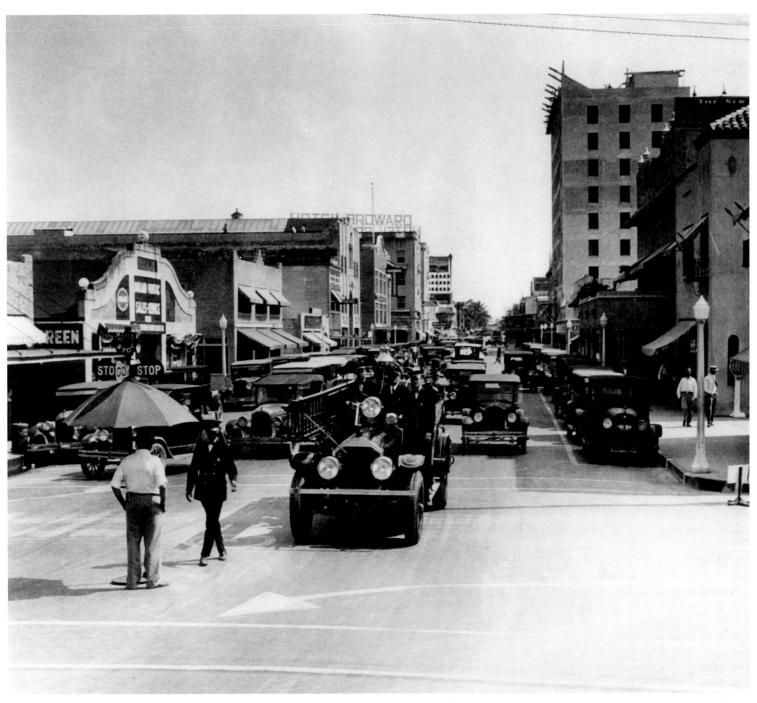

Andrews Avenue had supplanted Brickell as the city's main street by the mid-1920s. This view shows the proliferation of new commercial structures that arose within a few years during the height of the Florida land boom. Notice the one-way traffic and the city's first skyscraper, the Sweet Building, under construction in the background at right.

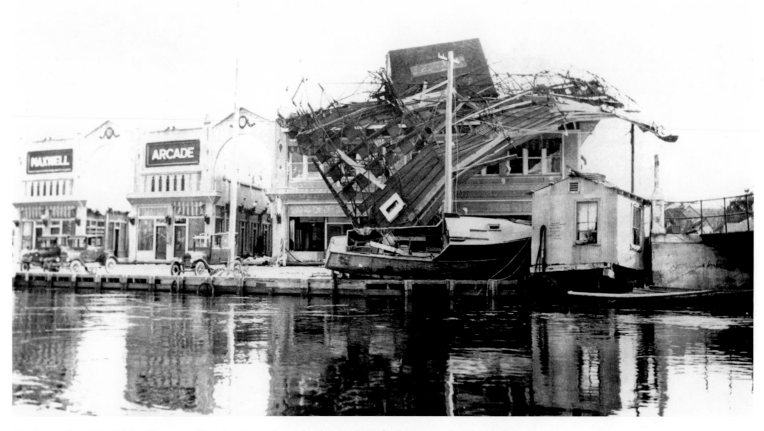

On September 18, 1926, a Category Four hurricane brought the crushing final blow to the Florida boom. The devastation in Fort Lauderdale was spectacular indeed. This view of the Maxwell Arcade shows the damage to an electric sign reportedly built at the amazing cost of $150,000. The building, however, survives today on the southeast side of the Andrews Avenue bridge.

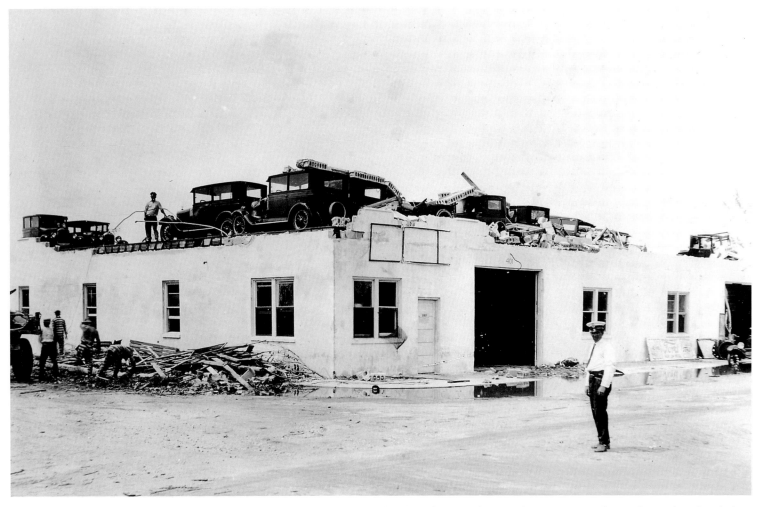

The 1926 storm affected South Floridians from southern Dade County to as far north as Lake Okeechobee, causing at least 240 deaths and $159 million in damages—well over a billion dollars in today's terms. This image shows the Ford garage in Fort Lauderdale, which lost its entire second floor. The dramatic photo by Hollywood photographer H. G. Higby was used in a number of contemporary publications documenting the storm damage.

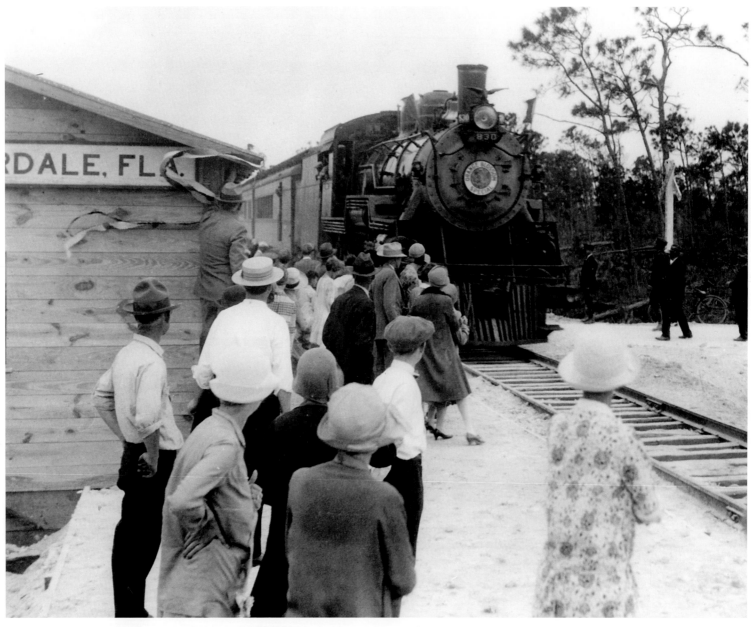

Until 1927 only one rail line extended into South Florida, Henry Flagler's FEC Railway. On January 8, 1927, locals at Fort Lauderdale greet the much-anticipated arrival of the "Orange Blossom Special," the new train of the Seaboard Air Line Railway. One of the attendees was Dorothy Walker Bush (in the floral dress at right), mother of future president George H. W. Bush.

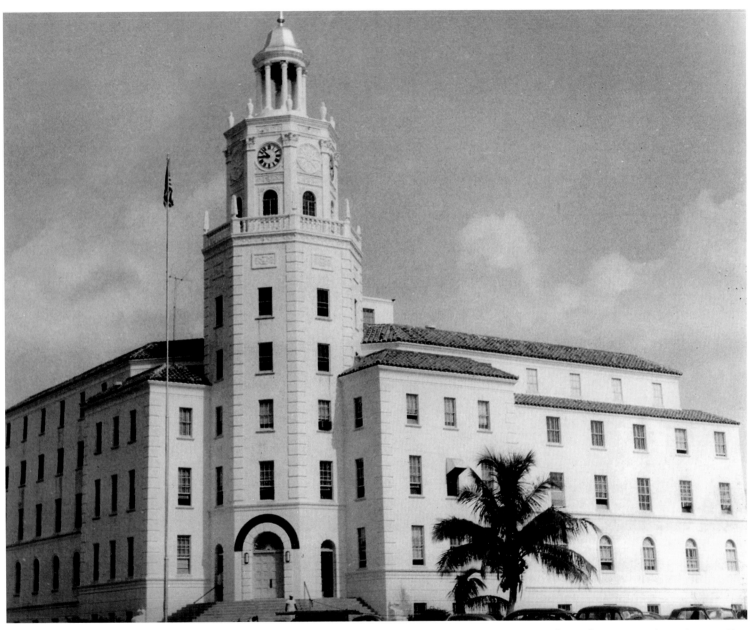

By the late 1920s, Broward County had outgrown the small courthouse on Andrews Avenue. Fort Lauderdale architect John Peterman designed this handsome Mediterranean Revival building, which opened in 1928 at the northwest corner of Southeast Third Avenue and Southeast Sixth Street. By the 1950s, the building underwent a series of renovations which eliminated the bell tower and other traces of the original facade. Today the original structure has been completely replaced by the current courthouse.

Merle Fogg, Fort Lauderdale's first pilot, was a popular and personable young man who came to the area during the boom to fly the seaplane of Fort Lauderdale Light and Ice Company founder, Tom Bryan. Working with photographers like R. B. Hoit, shown here on April 1, 1928, Fogg provided the first quality aerial photographs of the Fort Lauderdale area.

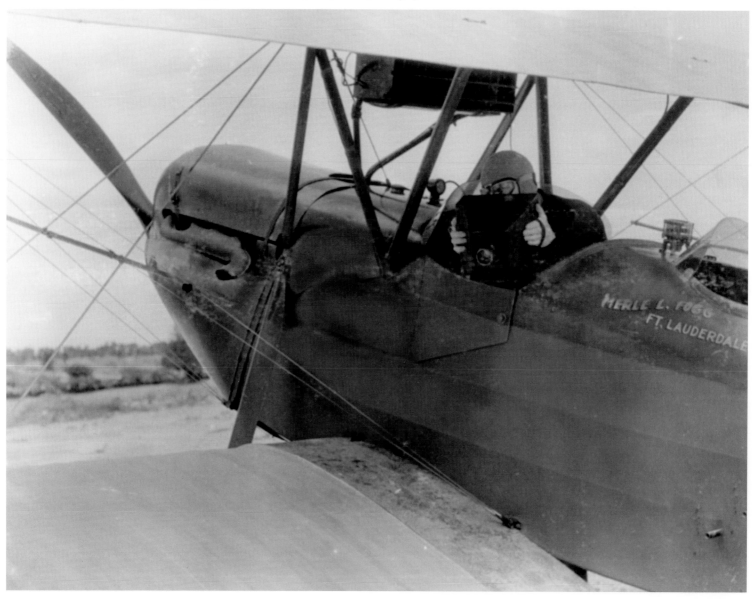

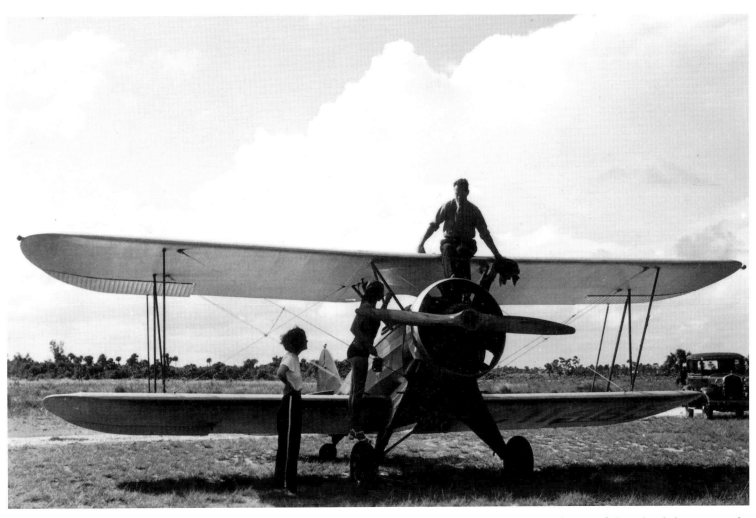

Merle Fogg was killed in a plane crash on May 1, 1928. When city fathers decided to convert the Southside Golf Course into an airfield, it was named in his honor. Merle Fogg Field was dedicated in 1929. The modest field became the Fort Lauderdale Naval Air Station during World War II; today, it is the Fort Lauderdale Hollywood International Airport.

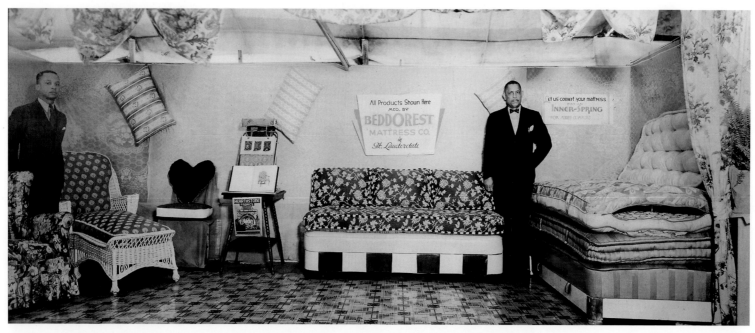

By the 1930s, Fort Lauderdale's African American community had established a separate business district west of the FEC tracks and north of Broward Boulevard. One of the success stories of the era was "T. S." Cobb, owner of the Bedd-O-Rest Company, which manufactured mattresses, sofas, and draperies. Here, Cobb and an unidentified employee pose in their booth at the county fair in 1935.

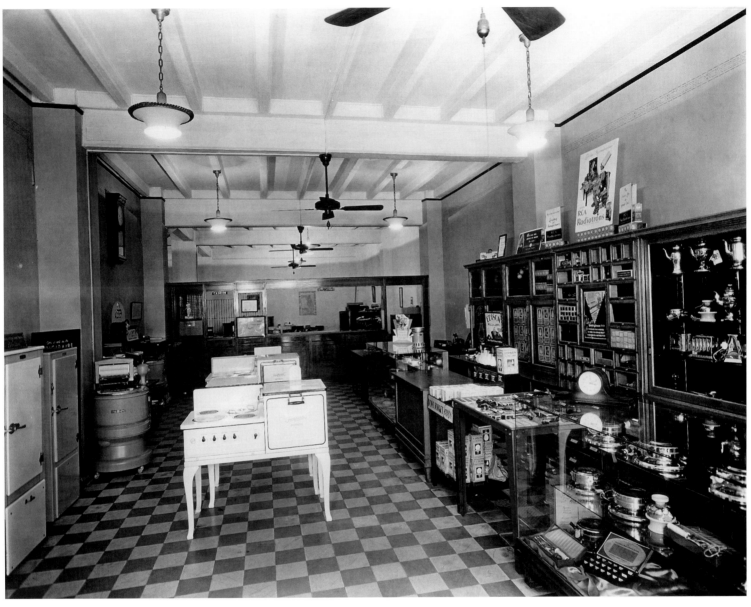

Despite the advent of the Great Depression, new technology held the same appeal for Fort Lauderdale residents in the 1930s as it does today. In this wonderful shot of the interior of the Florida Power & Light Company office, dated 1931, fine, new electrical appliances such as the latest washing machine, stove, and other gadgets lure the prospective buyer. Edison light bulbs fill two shelves and a table display.

Helen Shapiro Ullian and husband Alfred owned Ullian's Cut Rate drug and sundry store, according to the 1933 Fort Lauderdale directory. The store was located on the corner of Andrews Avenue and Northeast New River Drive, the former home of Alfred Beck's well-known drugstore. Here, Helen and her husband's cousin Aaron Gordon pose outside the store in 1933.

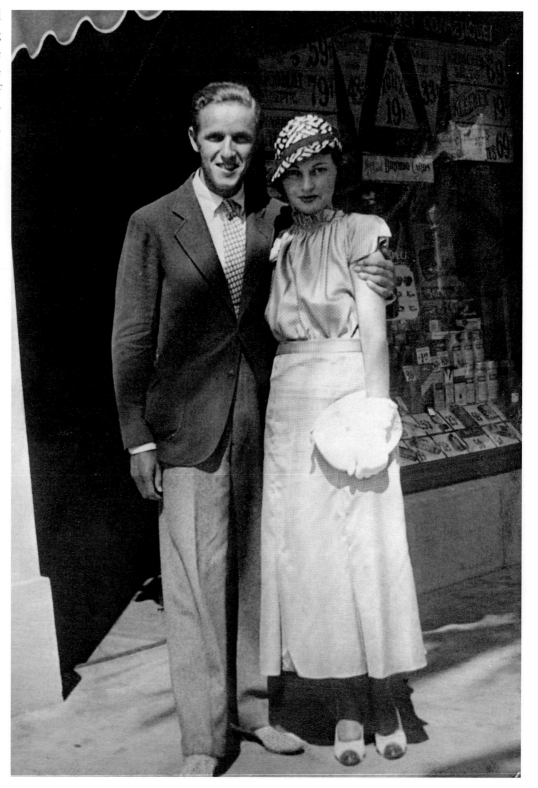

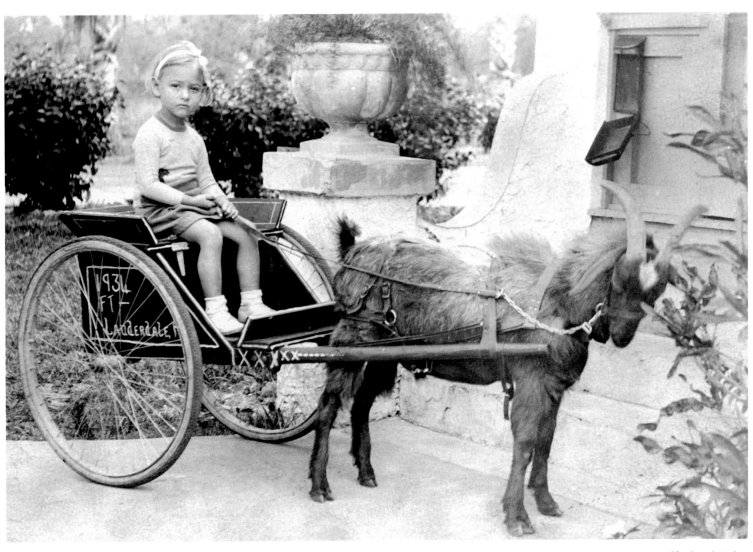

The Ullian family first came to Fort Lauderdale in the late 1920s. Second-generation Alfred and Helen Shapiro Ullian resided at the southeast corner of Southeast Sixth Street and Andrews Avenue during the 1930s. In this charming photo, their daughter Norma poses on a goat cart outside what is probably the family home in 1934.

The 1930s proved to be hard times for the local Seminoles. The Everglades drainage canals had forever altered their water-reliant lifestyle, and jobs were in short supply for all citizens. Many Seminoles continued to make their home in the wilds of the Everglades. In this photo taken for Indian agent James Glenn in 1935, a woman hangs hog meat to dry at a typical Seminole camp.

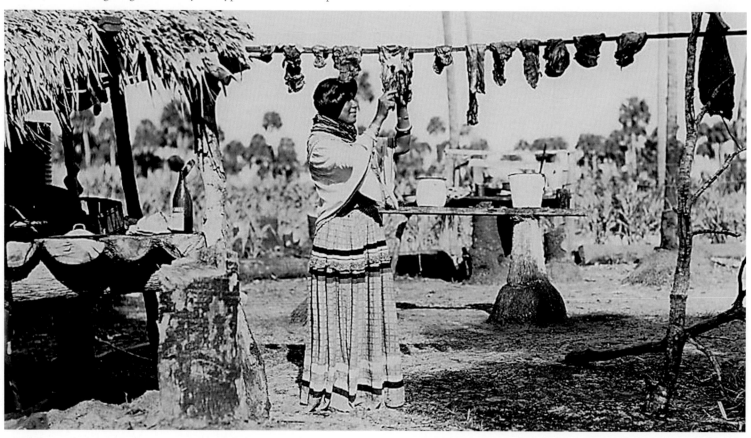

Fort Lauderdale's first "airport," named for aviator Merle Fogg, was basically a field on the site of the former city golf course. It was little used in the early 1930s due to a lack of facilities. In 1934, the city made a commitment to construct two runways. Here, Federal Emergency Relief Agency workers clear land for the new runways in 1935.

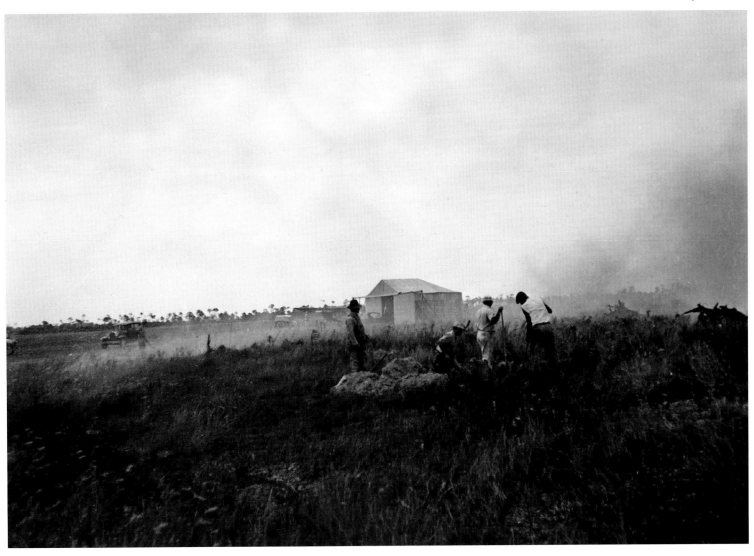

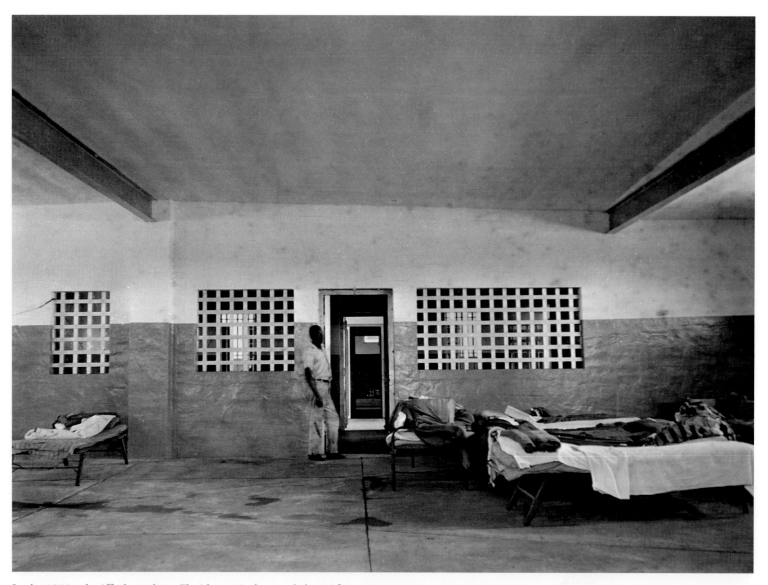

In the 1930s, sheriffs throughout Florida routinely rounded up African Americans on vagrancy charges during harvest time; they were forced to work off the fine in the fields. Sheriff Walter Clark and his brother Deputy Sheriff Robert Clark were paid by local farmers for the use of the prison labor. Home for the "workers" was the Broward County Prison Camp, located on Northeast Thirteenth Street at Seventeenth Avenue; a typical dorm room is shown in 1935.

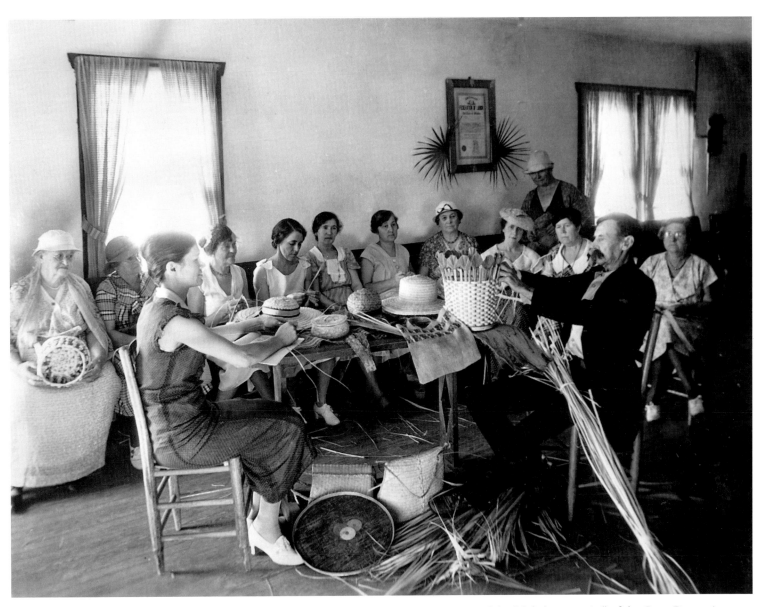

The Federal Emergency Relief Agency (FERA), one of the "alphabet agencies" of the Great Depression, was organized to provide relief to the unemployed in America. A key goal was to train women with marketable skills to allow them to supplement their income. In this photo, Fort Lauderdale women learn to make basketry using local materials in 1935.

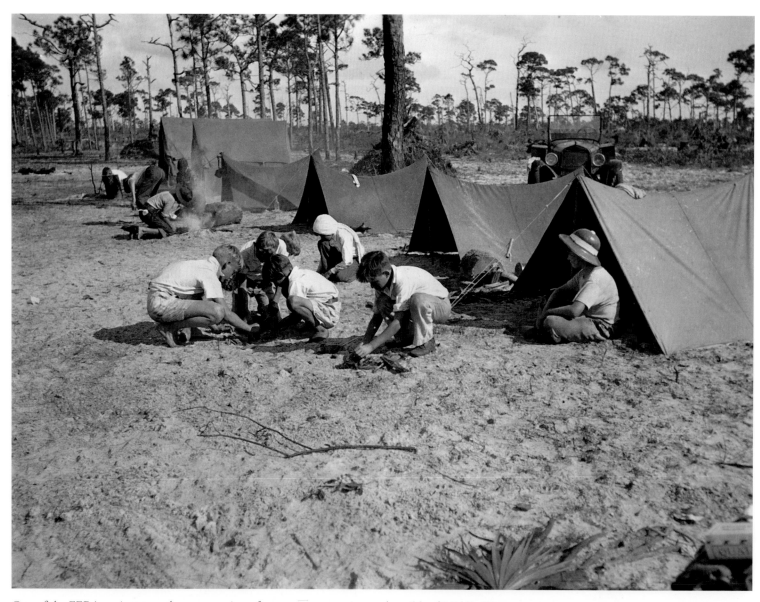

One of the FERA projects was the construction of a scouting camp site on the wilds of Middle River, at the northern limits of Fort Lauderdale. Here, local boy scouts conduct a fire-making contest at the camp in 1935. Notice the native pines—long gone now—in the background.

This Broward County prison building was constructed with FERA labor in 1934. The building, located just west of Federal Highway on Northeast Thirteenth Street, survived until about 1950. Today it is the site of Sunrise Middle School.

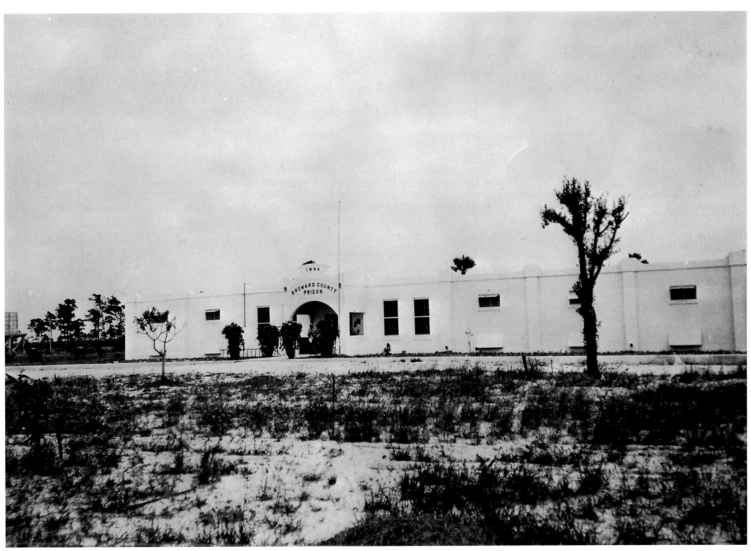

The Federal Emergency Relief Agency taught urban women to be self-sufficient during the Depression era. In the Fort Lauderdale area, four canning kitchens trained local women in food preservation techniques. Here, women prepare tomatoes for canning at one of the four FERA-funded canning kitchens in the Fort Lauderdale area in 1935. Tomatoes had long been one of Broward County's most popular crops, easily grown and easily transported to northern markets. The Dania area, for example, was known as the "tomato capital" until well into the 1950s. Salt-water intrusion into local soils finally ended local tomato production.

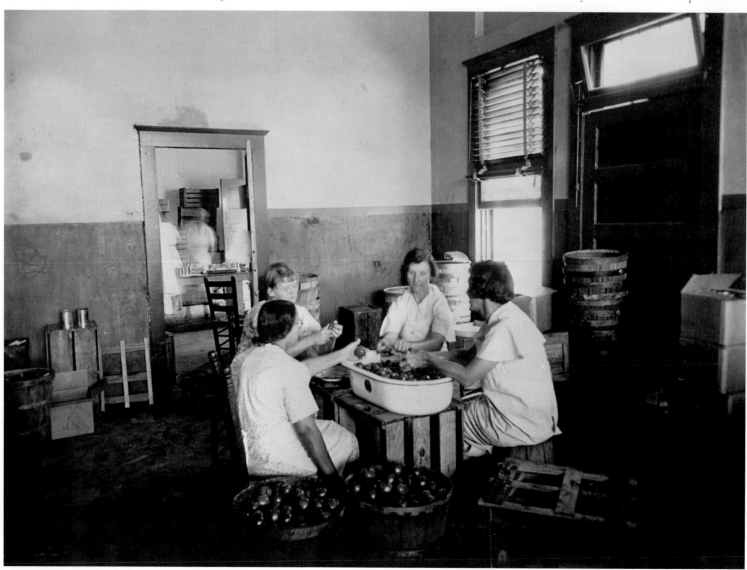

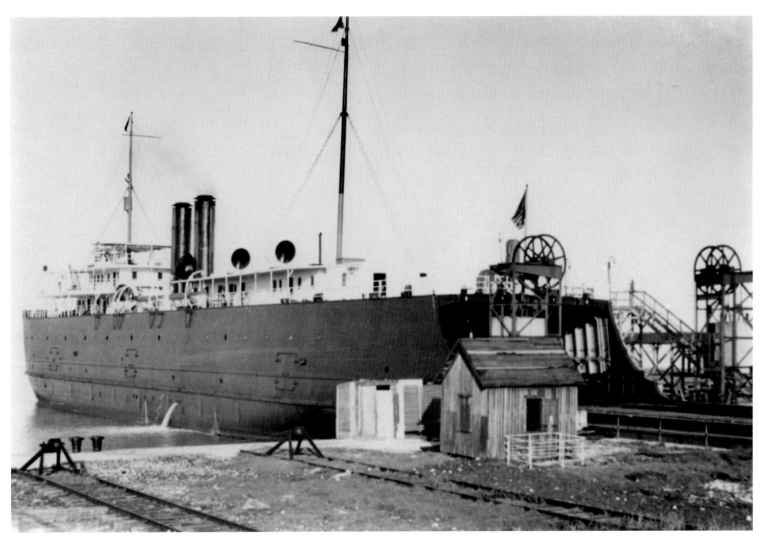

Flagler's Florida East Coast Railway originally linked not only the cities of the east coast of Florida but Cuba as well. A ferry transported railcars from Florida's southernmost point, Key West, to the nearby port of Havana on a regular basis until Fidel Castro's revolution overthrew the Cuban government in 1959. Here, a railroad ferry car takes refuge at Port Everglades after the killer 1935 hurricane which decimated Florida's Keys.

Port Everglades, Fort Lauderdale's deepwater harbor, was officially opened in 1928. The 1930s saw the maturing of the port and the arrival of the first cruise ship, the S.S. *Columbia,* which paid its first visit on January 18, 1932.

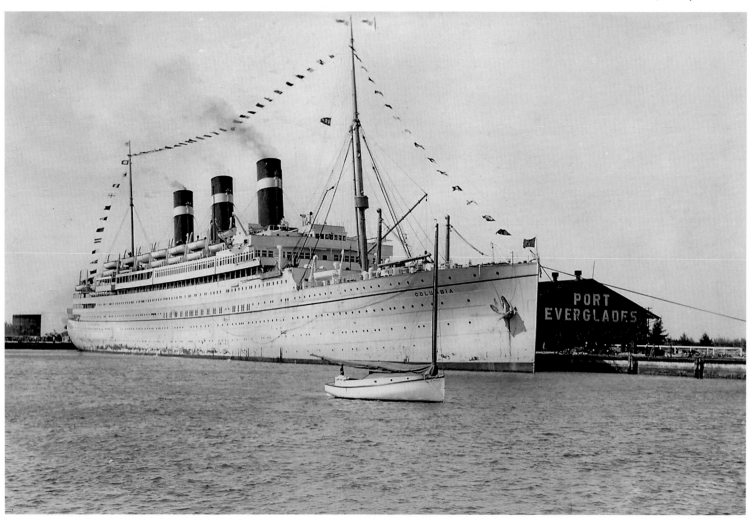

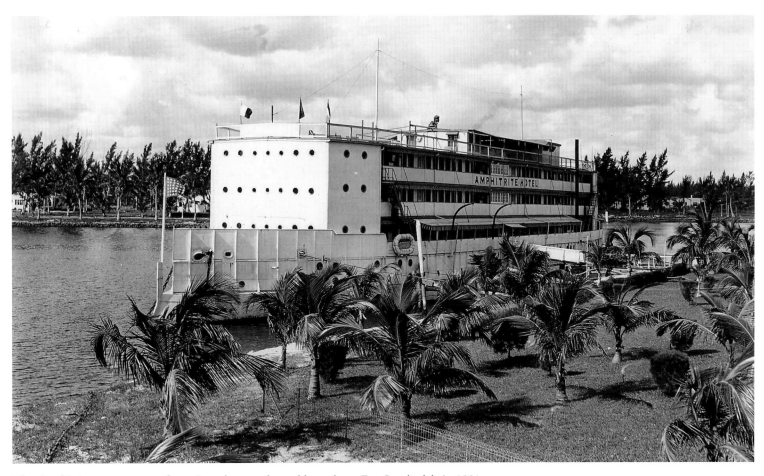

The *Amphitrite* was a converted monitor-class naval vessel brought to Fort Lauderdale in 1931 to serve as a novel floating hotel. Originally docked to the west of the Coast Guard base, it was blown to the shores of neighboring Idlewyld during the 1935 hurricane. It was then relocated to the "mole" at the center of the Las Olas Causeway, where it is shown in this image.

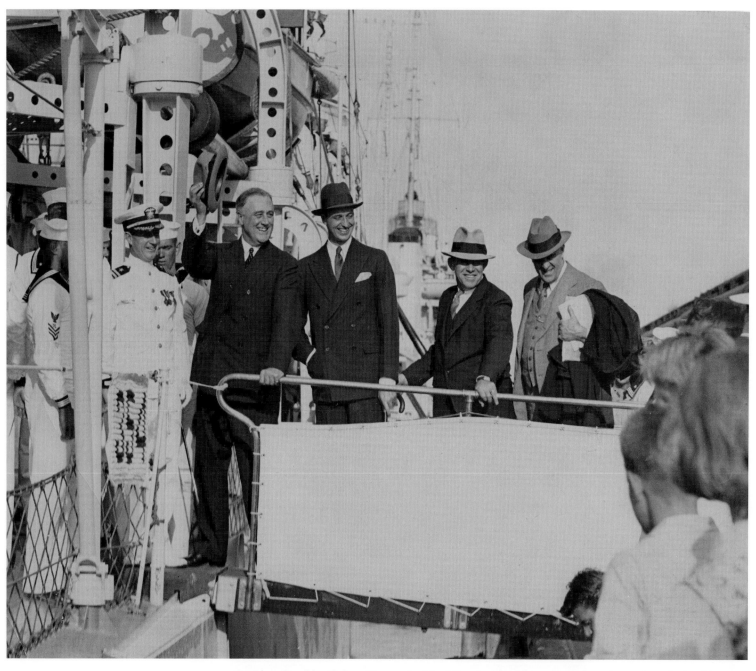

President Franklin Delano Roosevelt visited Fort Lauderdale on a number of occasions during his terms in office, generally on his way to board his yacht *Potomac* for a bit of fishing R & R. In this photo, he is boarding the Navy destroyer *Monaghan* at Port Everglades on March 23, 1936.

Leslie "Les" McNeece came to Fort Lauderdale from Indiana in 1918. Born into an athletic family, Les and his brother Doyle both played semi-pro ball with the Fort Lauderdale Tarpons. They retained their amateur status because the team paid their father, not them. Les was honored to be selected to play second base in baseball's exhibition game at the 1936 Olympics. He returned a hometown hero, having hit a home run in front of Adolph Hitler.

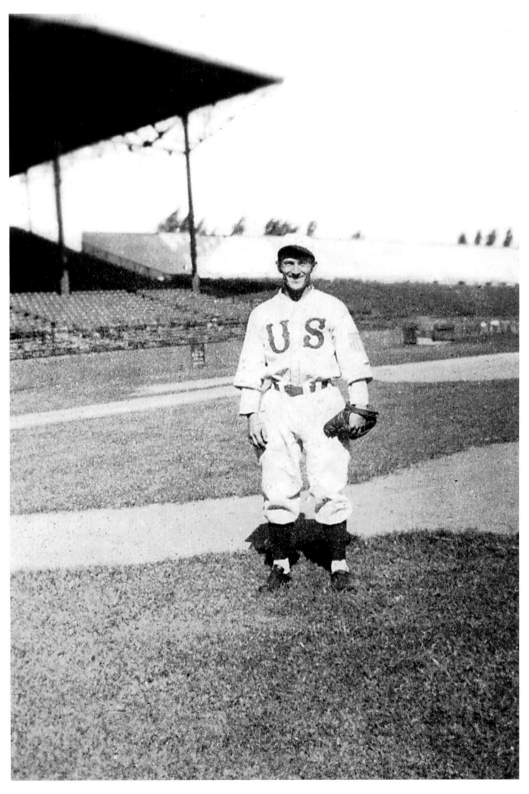

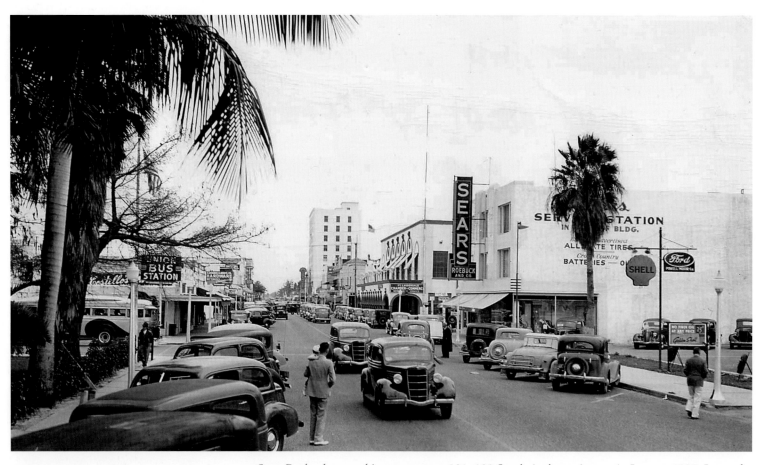

Sears Roebuck opened its new store at 101–103 South Andrews Avenue in January 1937. It was the only Sears store of its class to boast air conditioning and elevator service. Sears departed downtown for fine, new digs at "Searstown" on North Federal Highway in 1955. This view shows the Sears store and Andrews Avenue, looking south from Broward Boulevard in the late 1930s.

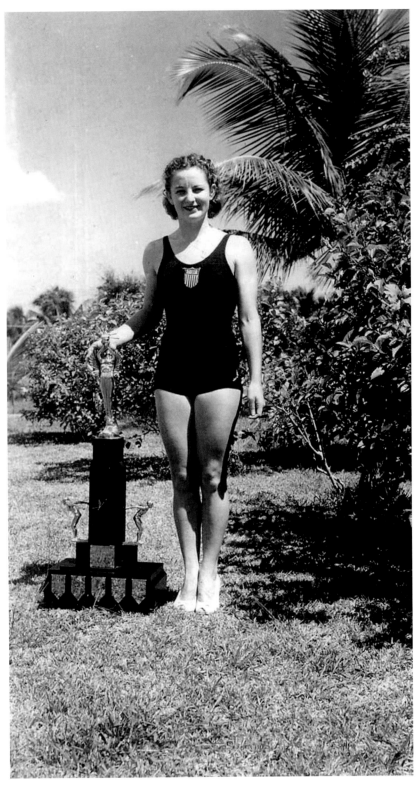

One of Fort Lauderdale's most famous citizens was Katherine "Katy" Rawls, well-known by her classmates at Fort Lauderdale High for her amazing athletic abilities. A champion swimmer and diver, she brought home silver and bronze medals in swimming and diving from the 1936 Olympics. In 1937 she was chosen Female Athlete of the Year by the Associated Press.

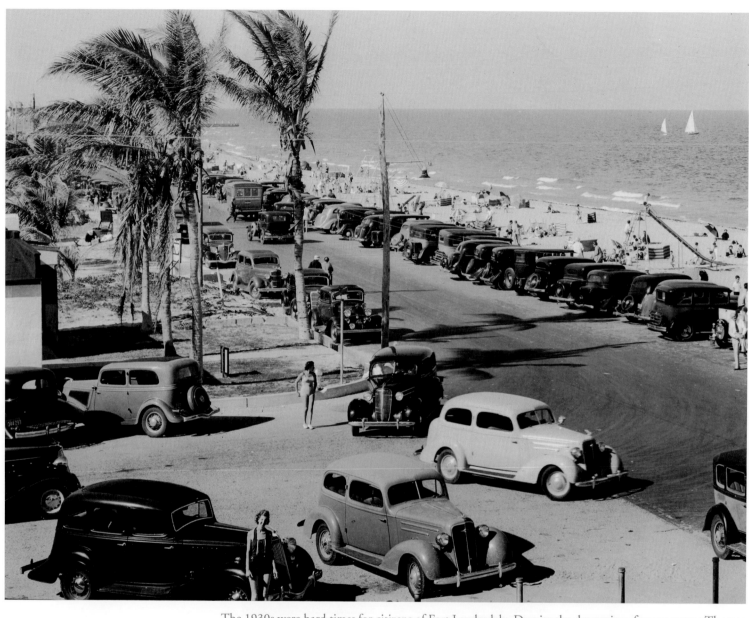

The 1930s were hard times for citizens of Fort Lauderdale. Despite the depression, former mayor Thomas Manuel recalled, "We had a great belief in the future because we knew as long as we had the sun and the ocean that people were going to come here … and they did." Here, visitors and locals alike find inexpensive recreation along Fort Lauderdales' south beach in the late 1930s.

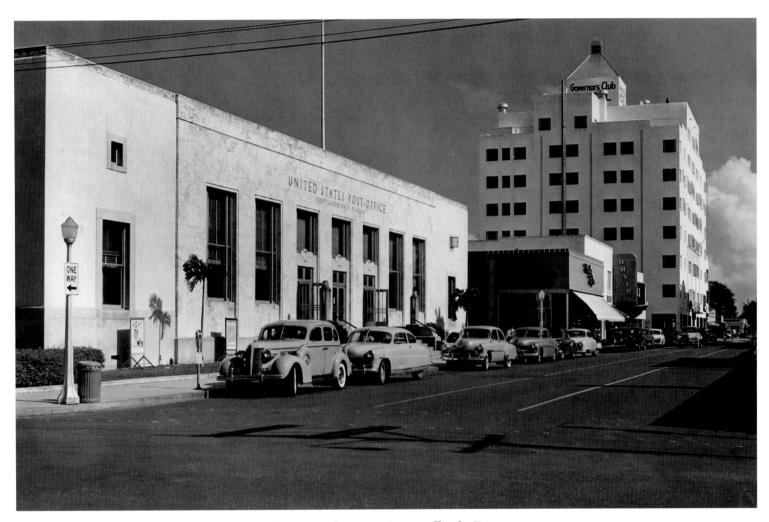

In 1936, the Works Progress Administration (WPA) constructed a new main post office for Fort Lauderdale on Southeast First Avenue at Southeast Second Street. It drew businesses and eateries to the adjacent streets, just a block away from Andrews Avenue. It was demolished in 1974, and the city's parking garage now stands on the site.

In 1933, the Prohibition amendment was finally repealed, ending an interesting era of rum-running and illicit saloons in South Florida. Repeal also encouraged the construction of legal establishments like the swanky, art deco 700 Club, shown here in 1937. The club operated at 700 East Las Olas Boulevard until 1954.

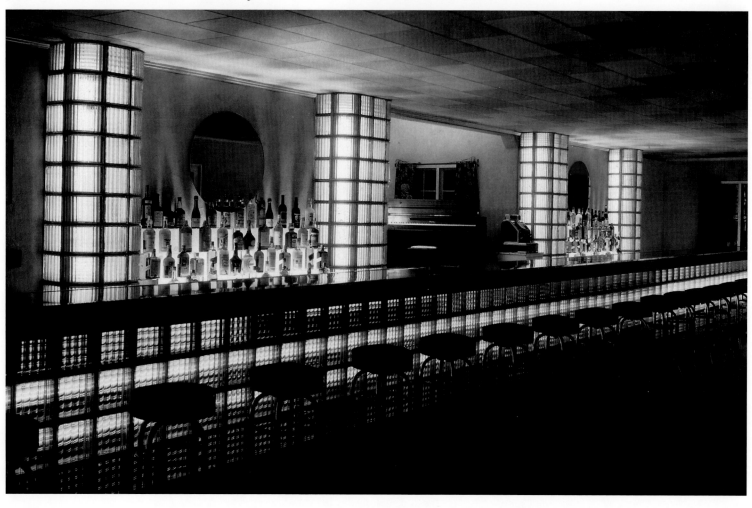

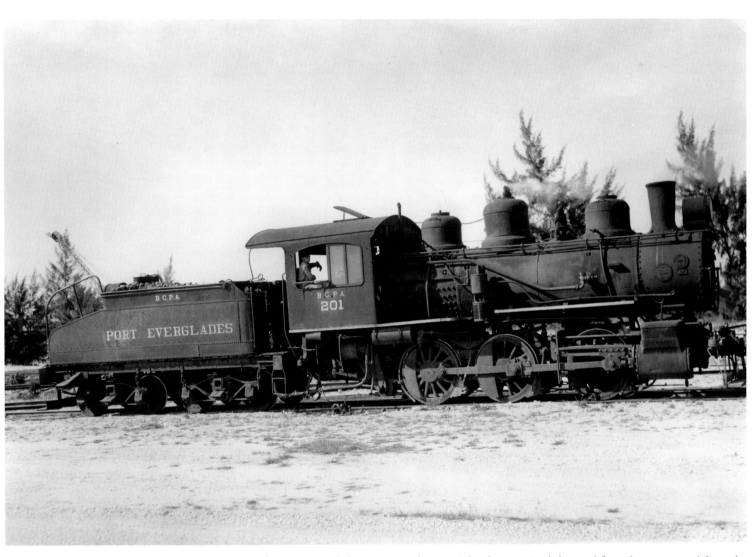

Soon after Port Everglades was opened in 1928, locals recognized the need for rail access to and from the port. In 1931, the Port Everglades Belt Railway was completed to link the port with the FEC and SAL line. This image shows belt railway engine Number 201 on February 26, 1938.

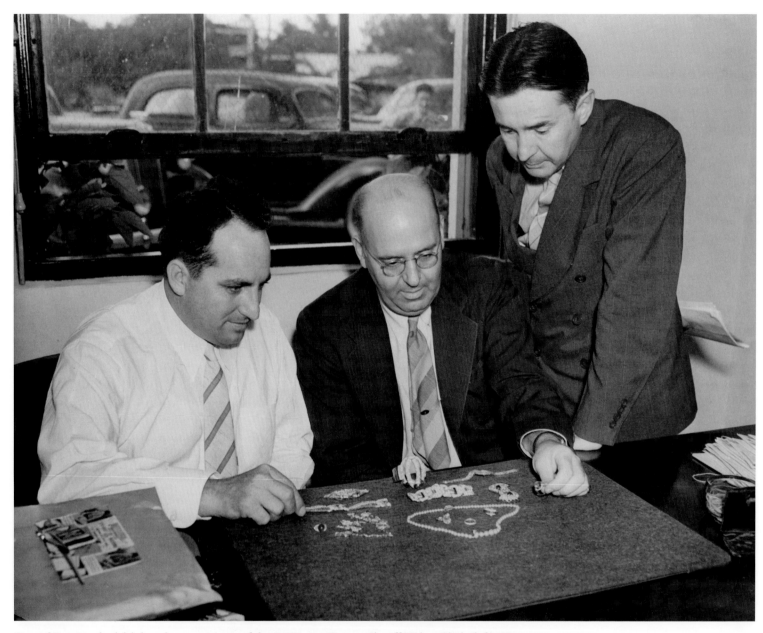

One of Fort Lauderdale's best-known citizens of the 1930s was County Sheriff Walter Clark (left). Known for his generosity and fairness in some quarters he was also hated and feared by many in the African American community. Here Clark, with FBI agents Joe Conderman (center) and R. L. Shivers (right), examine jewels recovered from a stash found in an African American cemetery in Hollywood, 1938.

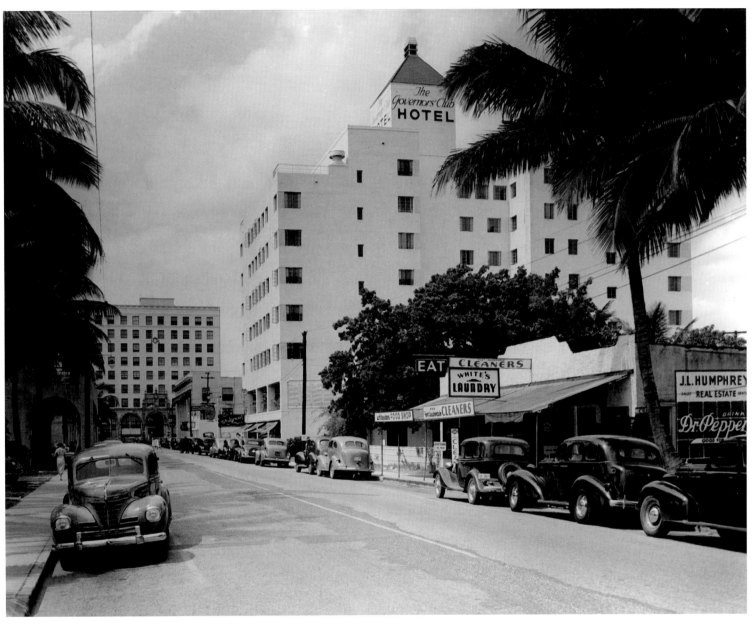

Fort Lauderdale's premier convention hotel was the Governor's Club, located on Las Olas Boulevard, a few blocks west of Andrews Avenue. Originally begun as the "Wil Mar" hotel during the boom of the 1920s, the structure sat as an uncompleted shell until finished by Fort Lauderdale *News* owner R. H. Gore in 1937. It was named in honor of Gore's brief tenure as governor of Puerto Rico.

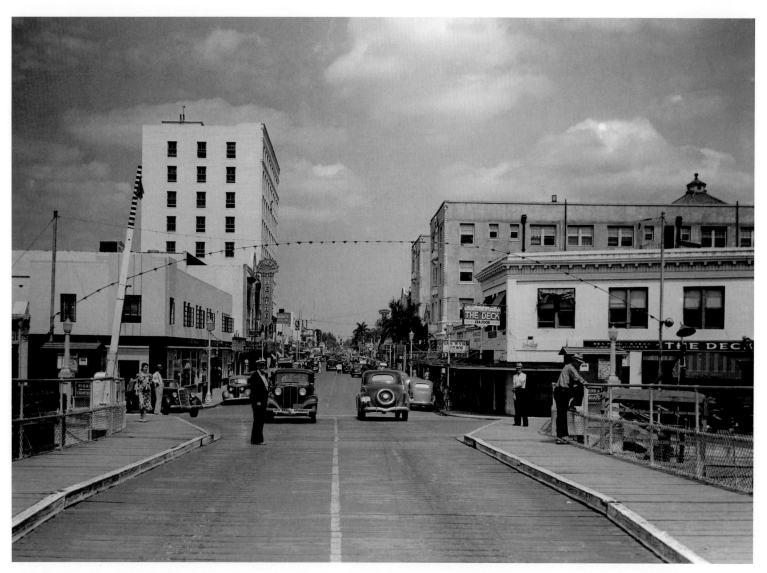

This photo, shot looking north from the Andrews Avenue bridge in March of 1939, shows the downtown remains much the same as in the 1920s, with the addition of a number of "modernizing" features like the black and white art-moderne-style tile work on the building at left. The tall building at left is the Sweet Building, which still stands as One River Plaza. All of the other structures visible in the picture are long gone today.

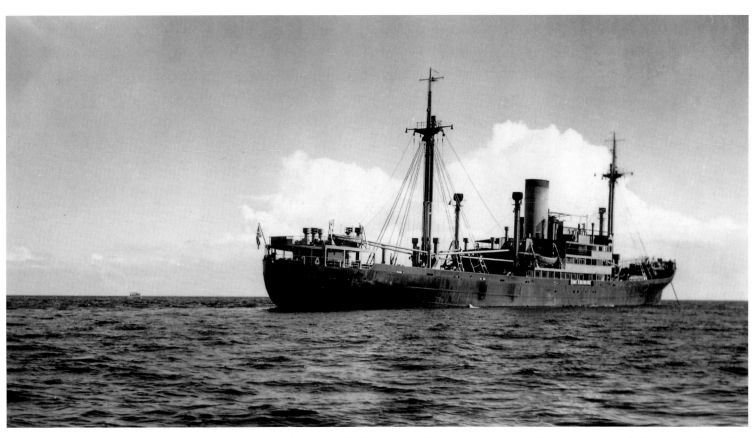

In December 1939, the German freighter *Arauca* was chased into Port Everglades by the British cruiser *Orion*. Although the U.S. had not yet entered the war, the little freighter and crew were interned in port due to liens against the Hamburg-American line. The vessel became a tourist attraction at the port until the civilian crew was eventually removed to Ellis Island for the duration of the war.

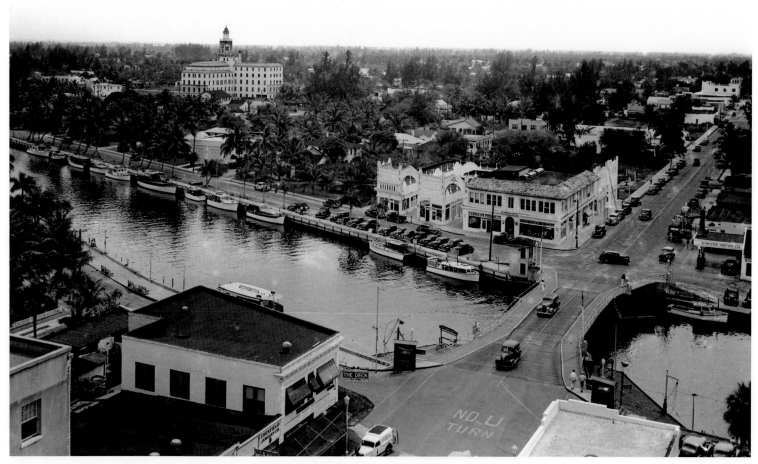

This view taken by G. W. Romer in 1939 from the Sweet Building shows Fort Lauderdale's New River and the Andrews Avenue bridge. In the left background is the rear of the 1928 Broward County Courthouse. On the opposite side of the river are the twin structures of the Maxwell Arcade, which still stand today. The 1979 bascule bridge, with its much larger drawspan, completely altered this view and made inaccessible the streets next to the river, North and South New River Drive.

THE VENICE OF AMERICA

(1940–1959)

World War II brought new prosperity to the city of Fort Lauderdale. The area's great flying weather and proximity to shipping lanes made it ideal for military training bases. A naval air station was established at the city's airfield, and the port was occupied by a sub-chasing base. The Coast Guard kept watch over the South Florida coastline on horseback. Local citizens participated in war bond drives and obeyed "blackout" orders. Fuel rationing and crammed railcars limited tourist travel but did not stop it. Wartime visitors pronounced, "Everything is terribly crowded."

After war's end, a new boom was under way. This time newcomers were not just interested in investments—they came to start a new life in America's tropics. The advent of affordable air conditioning and pesticides like DDT made this rapid growth possible. Fort Lauderdale's population grew from 35,000 to over 83,000 residents during the 1950s, as it became the state's fifth largest city.

The completion of Bahia Mar Yachting Center at the site of the former Coast Guard base encouraged the rapid growth of local marine industries. The "islands" off Las Olas Boulevard, begun in the 1920s, were finally developed, as hundreds of new residents were drawn to "ocean access" properties in the "Venice of America." New schools, churches, and other facilities sprang up to meet the growing population. The former naval air station became a new county airport, welcoming international flights by the end of the decade. Florida's new turnpike opened in 1957, creating an easy access for visitors to South Florida. In 1958, construction began on one of the city's most controversial projects, a tunnel under New River at Federal Highway.

The 1950s brought many cultural changes to the community as well. A new innovation, television, gained ground in the home of Fort Lauderdalians during the 1950s. Drive-in movie theaters were all the rage; there were four in the central part of the county by mid-decade. War Memorial Auditorium, completed in 1950, served as the city's new principal cultural facility and host to performances and meetings for decades to come. Festivals like the 1950 Tropicanza helped foster a sense of community, as well as draw in the tourists. Few citizens realized the real changes were yet to come …

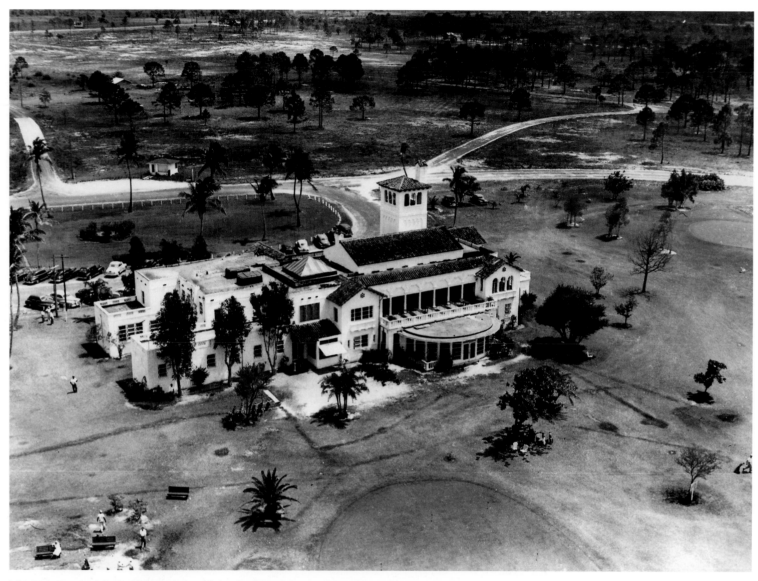

The Fort Lauderdale Golf & Country Club, also known as the "Westside Golf Course," was constructed in 1926 west of State Road 7 on Broward Boulevard, well west of town. The beautiful Mediterranean-style structure was designed by local architect Francis Abreu. Westside served as the city's only course until 1957, when the city commission put the club up for sale rather than face integration. This image shows the clubhouse about 1940.

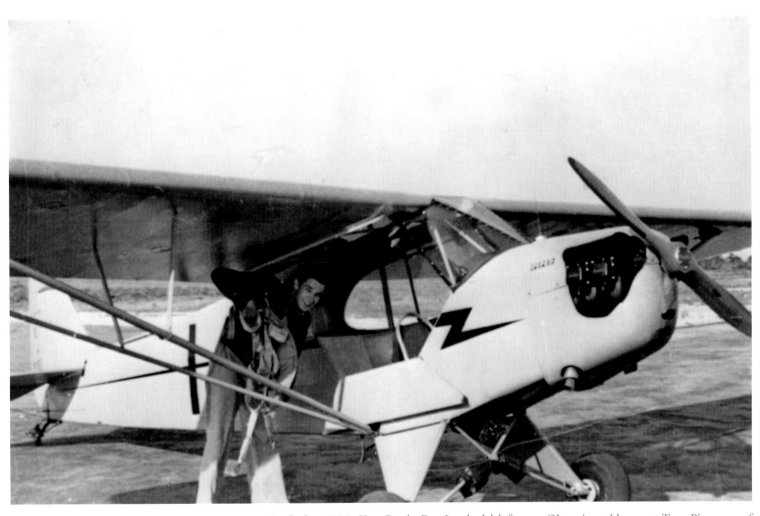

In the late 1930s Katy Rawls, Fort Lauderdale's famous Olympian athlete, met Tony Piper, son of the producer of the Piper airplane. She spent most of her allowance on flying lessons and married her instructor, Ted Thompson. Ted and Katy soon established the Thompson School of Aviation at Fogg Field. Here, Alorson W. Fussell boards one of the Thompson School planes in May 1941.

Walter Reid Clark, one of the first people born in the city of Fort Lauderdale, served as Broward County sheriff from 1933 through 1950. Clark tolerated the illegal casinos and gambling operations within the county during his tenure; in return he controlled bolita and the local slot machines. In 1950, he was indicted by the Kefauver Commission on national television for his knowledge of illegal activities. Clark died in 1951, soon after his acquittal for possession of slot machines.

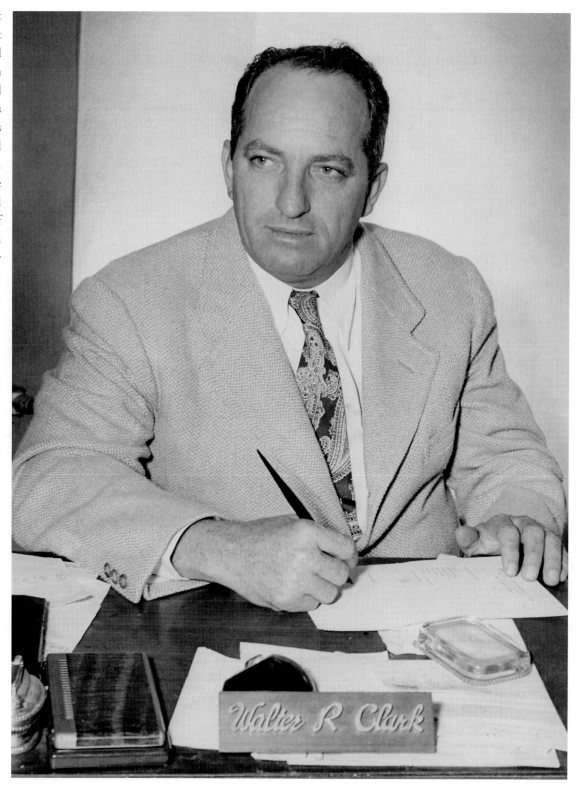

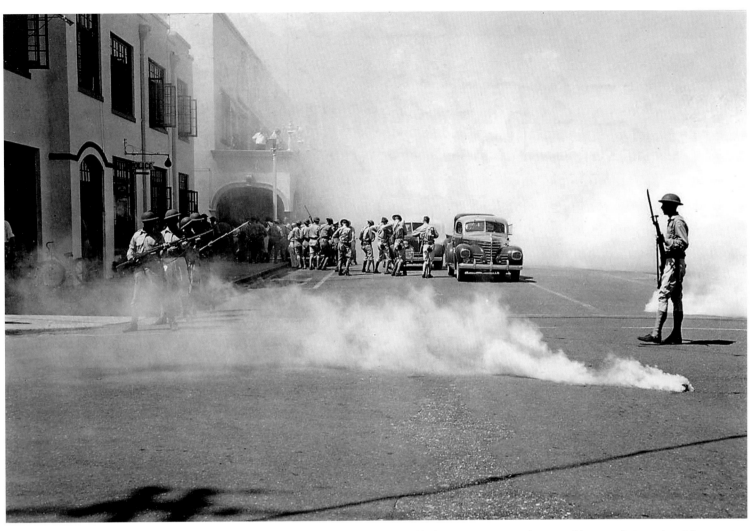

By 1942, Fort Lauderdale was quickly becoming an armed camp with a naval air station, Navy section base, Coast Artillery, and Coast Guard installations opening for business. In this photo, the Fort Lauderdale Home Guard drills outside the Fort Lauderdale City Hall and fire station, located on South Andrews Avenue just north of Second Street. Today, this is the site of the Broward Government Center. Note the guardsmen are wearing M1917/M1917A1 helmets; the soon-to-be famous M1 "steel pot" replacement design had only been adopted for U.S. troops the previous year.

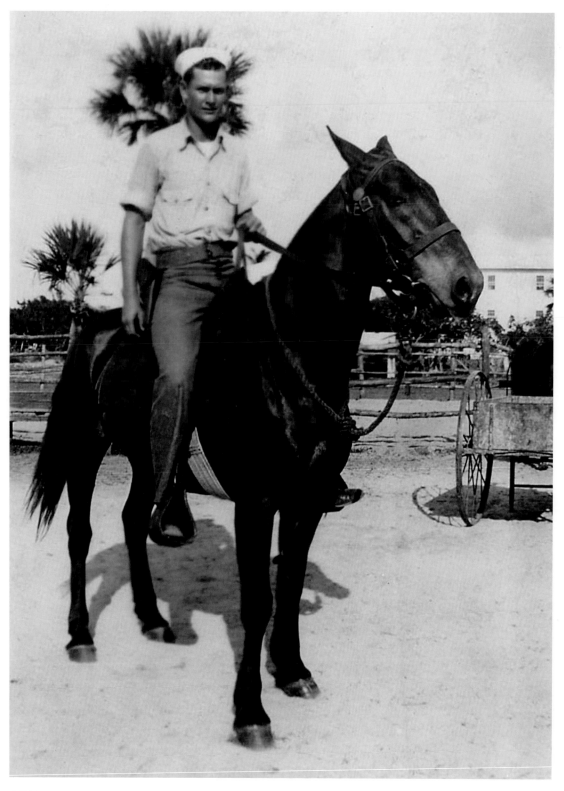

The Coast Guard took on a new importance for beach-town residents like those in Fort Lauderdale during World War II. German submarines played havoc with shipping off Florida's shoreline in 1942. Guardsmen like R. L. Landers, shown here, patrolled the beach from Dade to Martin Counties on horseback. Landers was one of many servicemen who met and married a local girl—and still calls Fort Lauderdale home.

During the war, the Fort Lauderdale's Service Men's Center, a recreation center sponsored by the local community, brought together thousands of visiting servicemen with local girls. Here, future husband and wife R. L. Landers and Helen Herriott, at right, escape the beach crowds by finding a spot on the private Bonnet House beach, just south of today's Sunrise Boulevard.

The war bond program provided not only economic support for the war effort but a patriotic rallying point as well. War bonds were sold at all sorts of local establishments like area theaters, shown here. In this image, the "Bond Belle" urges people to remember Sandy Nininger, Fort Lauderdale's first Congressional Medal of Honor winner, who was killed at Bataan early in 1942.

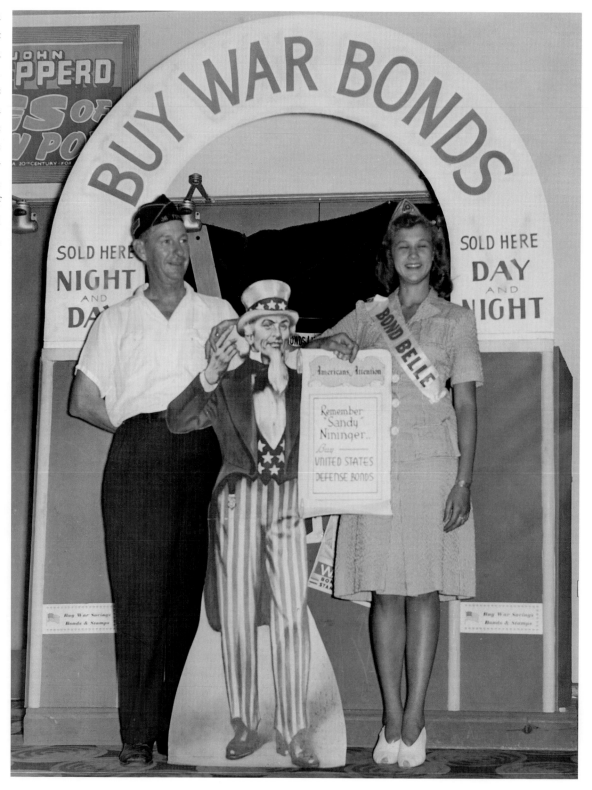

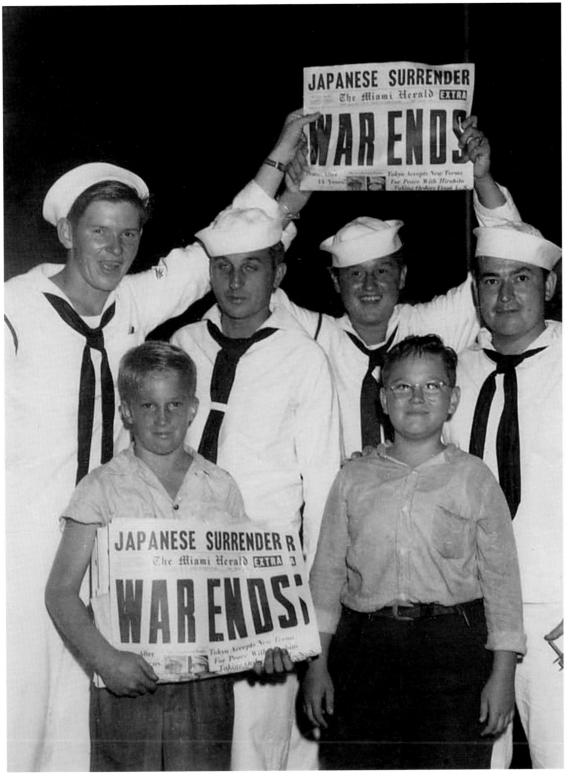

The Japanese surrender in August 1945 brought spontaneous celebrations throughout the city of Fort Lauderdale. Local citizens awaited the return of friends and family, while the thousands of servicemen in residence realized they would soon be returning home. Here, a group of sailors and a couple of newsboys enjoy one of the Miami *Herald*'s most impressive headlines.

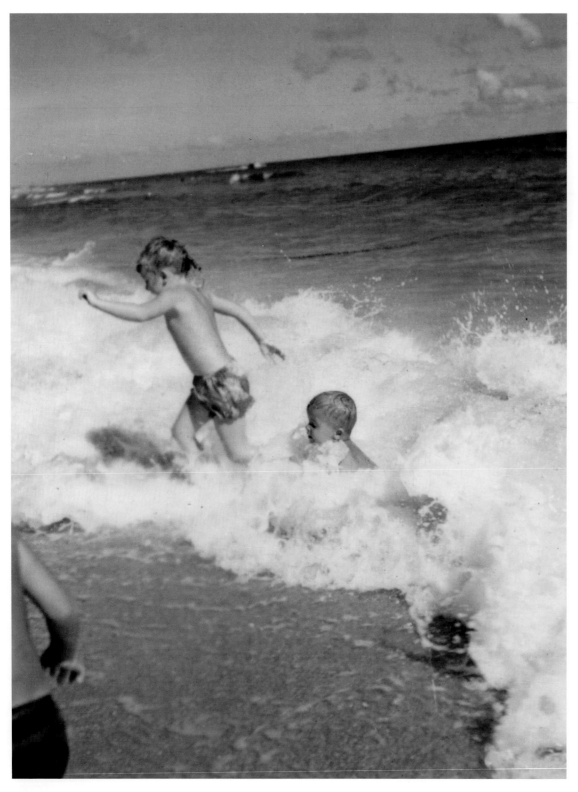

After the close of World War II, Fort Lauderdale experienced a new boom as thousands of servicemen stationed in Florida during the war returned with their families in tow. These youngsters are enjoying the Gulfstream-warmed waters of Fort Lauderdale's shores in 1946.

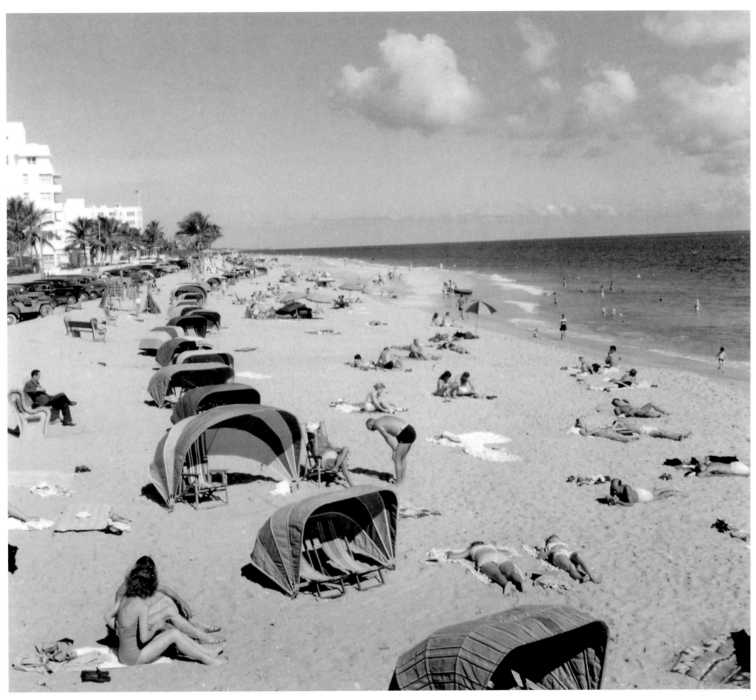

The winter of 1945–46 proved to be the city's most successful tourist season to date as travel restrictions were lifted, blackouts ended, and rationing forgotten. This classic scene shows visitors on Fort Lauderdale's beach in 1946.

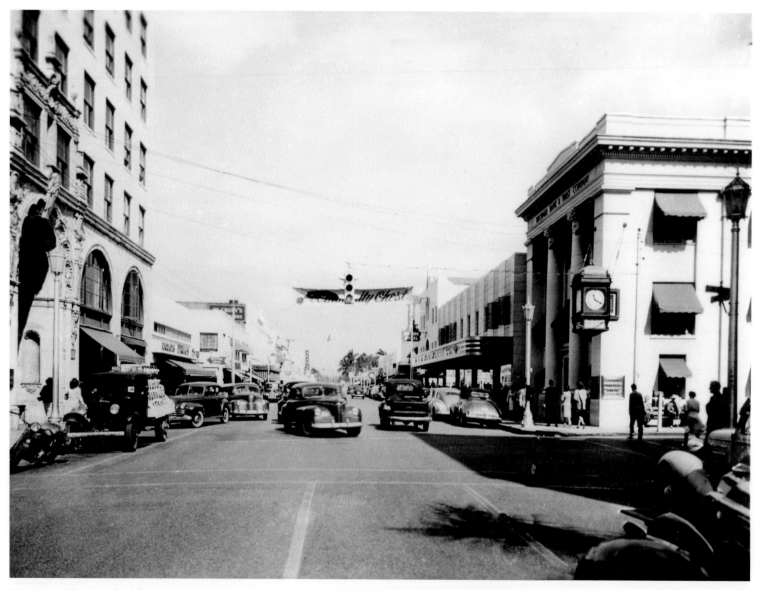

Downtown Fort Lauderdale is booming in this view looking north from Las Olas Boulevard on Andrews Avenue in the 1940s. In the 1980s, the intersection of East Las Olas Boulevard and Andrews, shown at right, was jogged to the north to accommodate the wider approach of the current bridge over New River.

Rationing of items like tires and fuel made travel difficult during World War II; this, combined with the heavy servicemen-laden train cars, obviously curtailed Fort Lauderdale's tourist trade during the era. But sun-seekers still found a way; the city was filled to capacity. Here, visitors Carl and Bernard Schuster join Abraham Fox and Joy Fox at the beach in 1945.

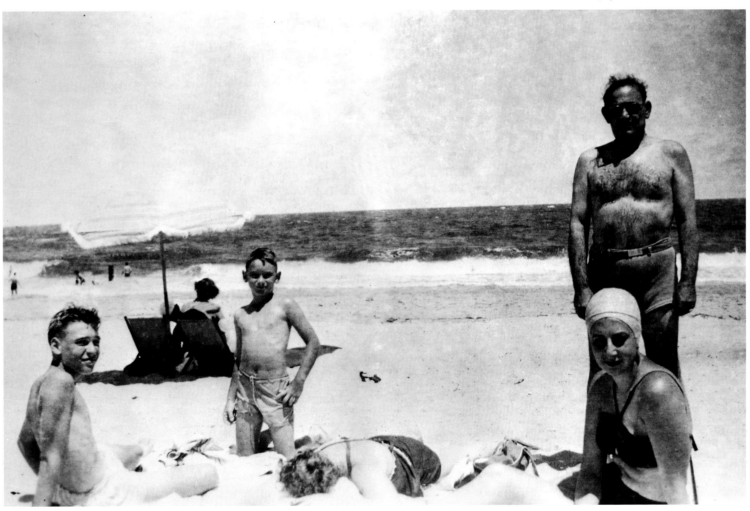

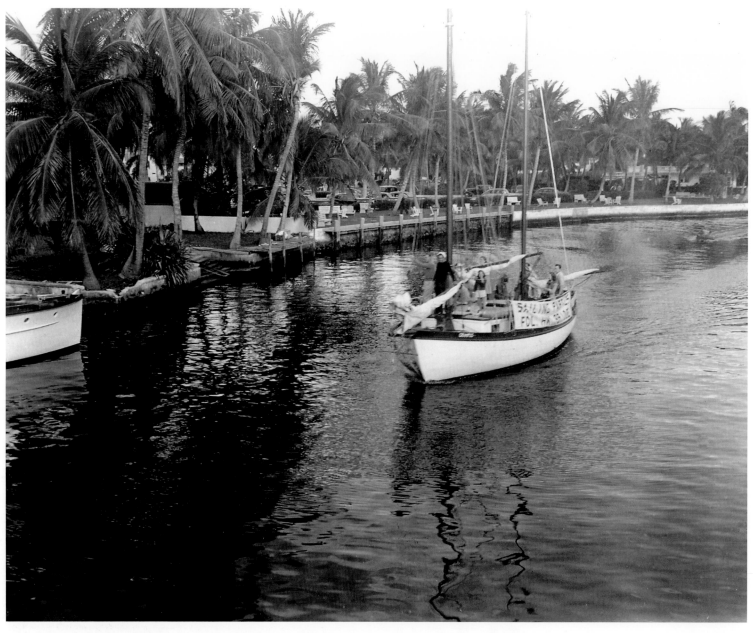

Boat parades and regattas have been a staple of Fort Lauderdale life since its earliest days. This ketch on New River seems to advertise such an event in 1946.

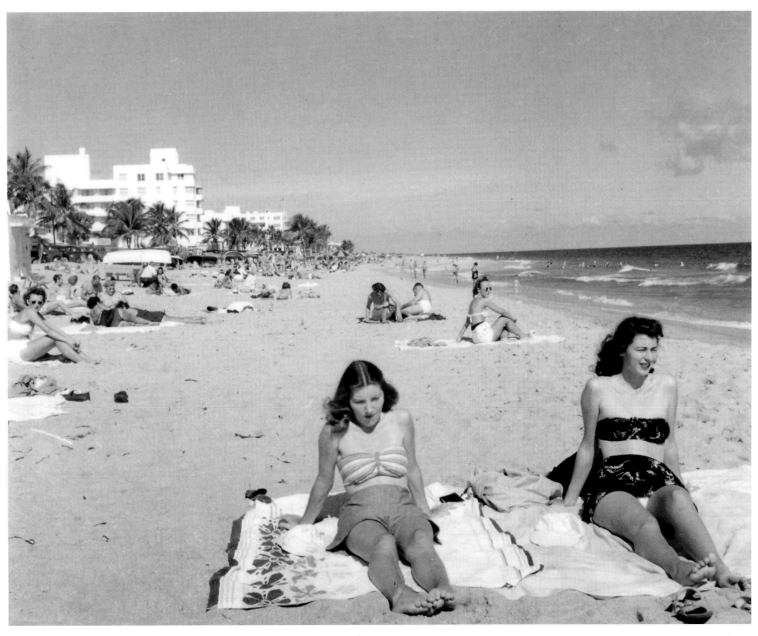

Two young ladies, displaying the latest in '40s resort wear, do a bit of sun bathing on Fort Lauderdale's beach in 1946. The grande dame of the beach, the Lauderdale Beach Hotel, appears in the background at left.

Tourists, like the indolent sun worshipers shown here, arrived in Fort Lauderdale by the thousands in the winter of 1946. One newspaper headline claimed, "Fort Lauderdale swamped by 65,000." Historians August Burghard and Phil Weidling recalled, "Never had so many people with so much money descended upon Fort Lauderdale."

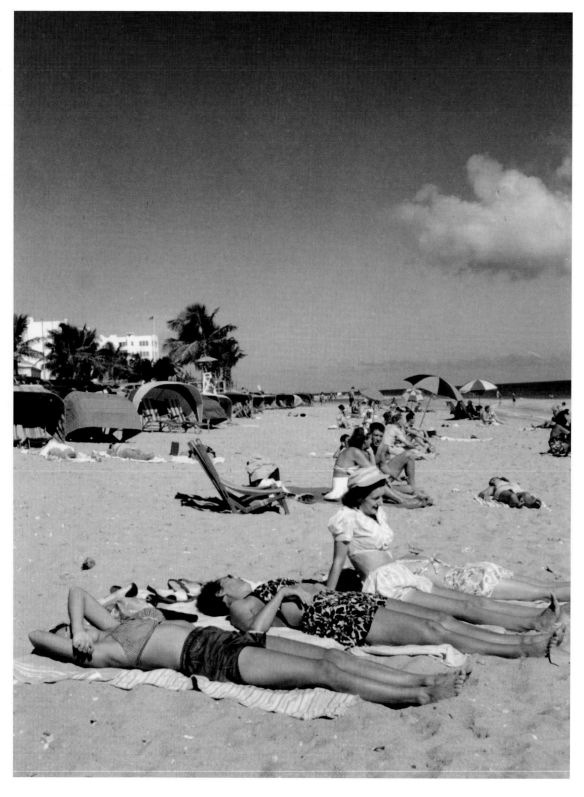

In 1947, a year of heavy rainfall was followed by hurricanes, one in September and the second in October. On October 13, local residents awoke to the story "Broward County from the air today is one vast lake." The area later known as Hacienda Village, just west of Fort Lauderdale, was completely under water, as shown here.

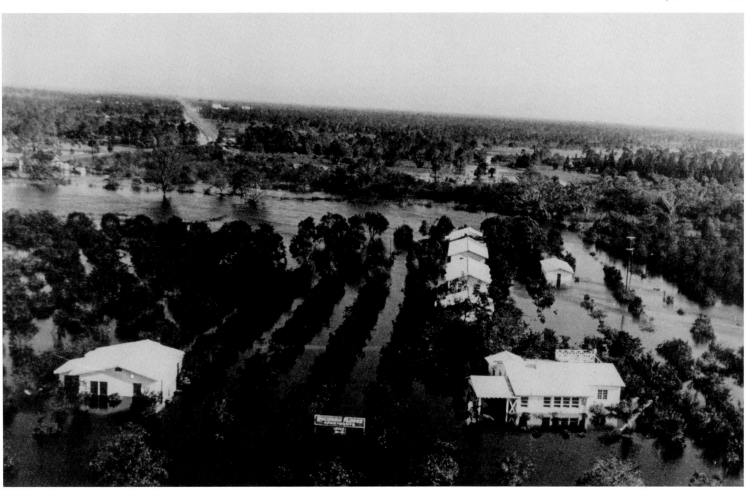

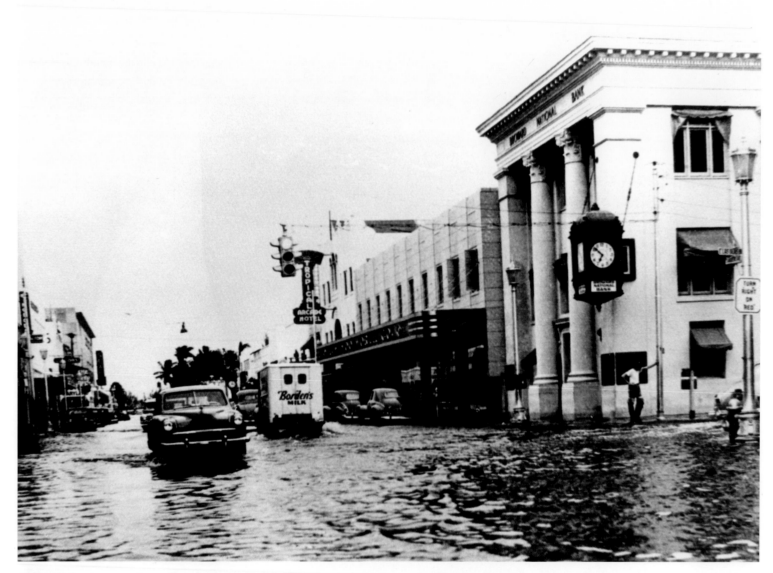

Although there were no immediate deaths in the area, the "Flood of 1947" caused millions in financial losses. Crops were ruined throughout the county. Downtown, merchandise was ruined and streets were impassable. This view shows Andrews Avenue, north from Las Olas Boulevard, shortly after the storm.

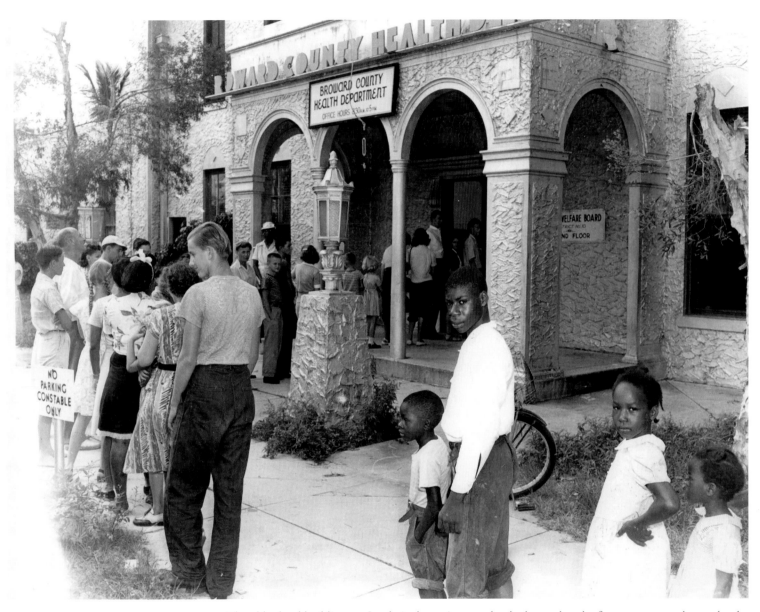

The old school building on South Andrews Avenue, that had served as the first county courthouse, by the late 1940s saw service as the home of the county health department. Citizens lined up to receive typhoid shots after the Flood of 1947 caused serious concerns about the possibility of an outbreak.

Fort Lauderdale pioneer William F. Maurer moved to Fort Lauderdale from Fostoria, Ohio, in 1925, at the height of the Florida land boom. His descendants continue to call it home. In this photo, grandson little Larry Maurer (age one year) plays in the surf on the beach on September 25, 1947, one day after a terrible hurricane struck South Florida.

Bus transportation was an important means of transport within and to and from the city in the late 1940s. The main bus terminal stood on Southeast First Street, just east of Andrews Avenue and south of Stranahan Park. The street no longer exists; today, this is the site of the campus of the Broward County Main Library.

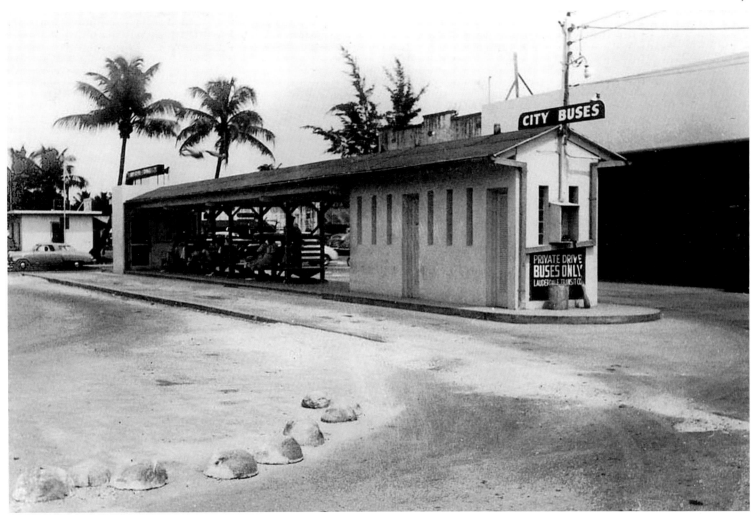

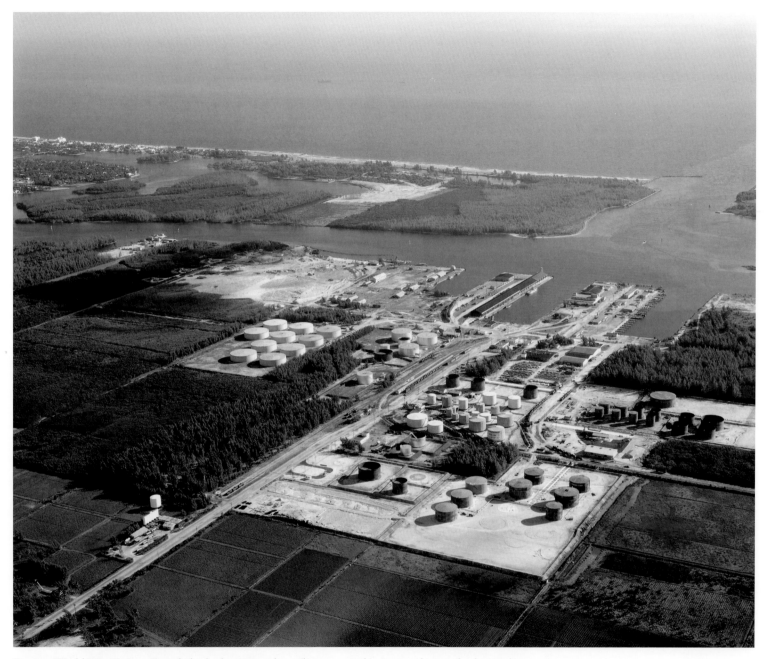

During World War II, Port Everglades had come under military control as it served as a sub-chasing base and Coast Guard headquarters. Returned to civilian control after the war, it slowly grew its reputation as a cargo port. Note the "tank farms" in this photo by aerial photographer Sherman Fairchild, taken in 1947 or '48.

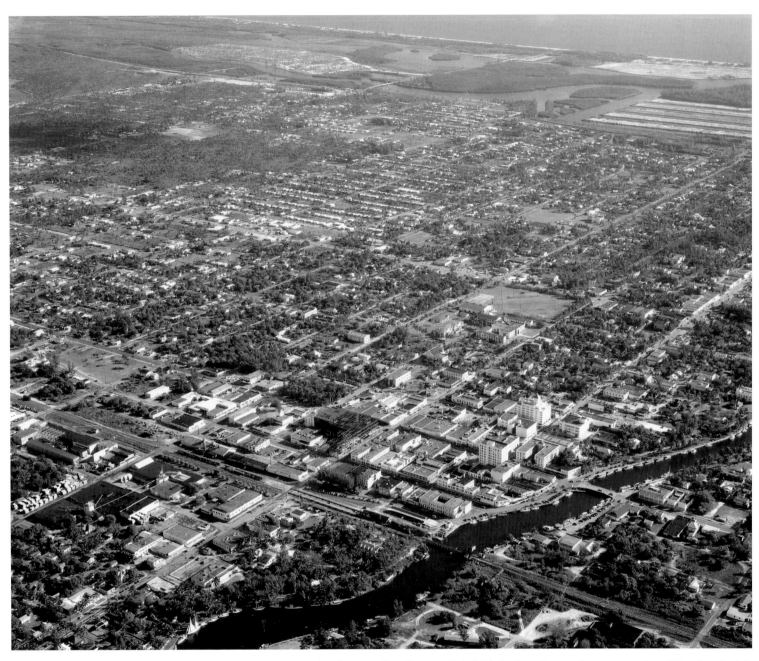

This aerial view by photographer Sherman Fairchild displays the growing community of Fort Lauderdale soon after World War II. New River can be seen at the lower right. The Florida East Coast Railway tracks are easily recognizable at the lower portion of the photo. Notice the growing neighborhood of Victoria Park at upper left and the islands off Las Olas—cleared for development—at far right.

Fulgencio Batista served as Cuba's president during the early 1940s and returned to power in a 1952 coup as a dictator friendly to the U.S. Batista, who called Daytona Beach his second home, had Broward County connections—such as mobster and gambling mogul Meyer Lansky. Batista is shown smiling, at right, next to Broward County Sheriff Clark in this photo by Steve Cresse, taken around 1950.

By the 1940s, eager tourists could travel to South Florida aboard the Seaboard Air Line's Silver Meteor, the deluxe New York-to-Miami passenger train. In 1967, the SAL merged with the Atlantic Coast Line to become the Seaboard Coast Line, or SCL. The Seaboard tracks eventually became the route of the U.S. government train service, Amtrak. Here, a train chugs south out of the Fort Lauderdale station in 1947.

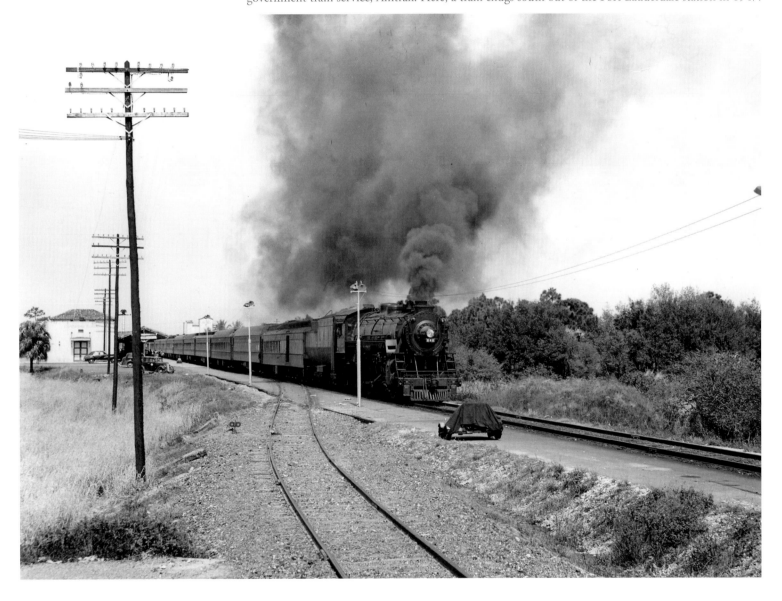

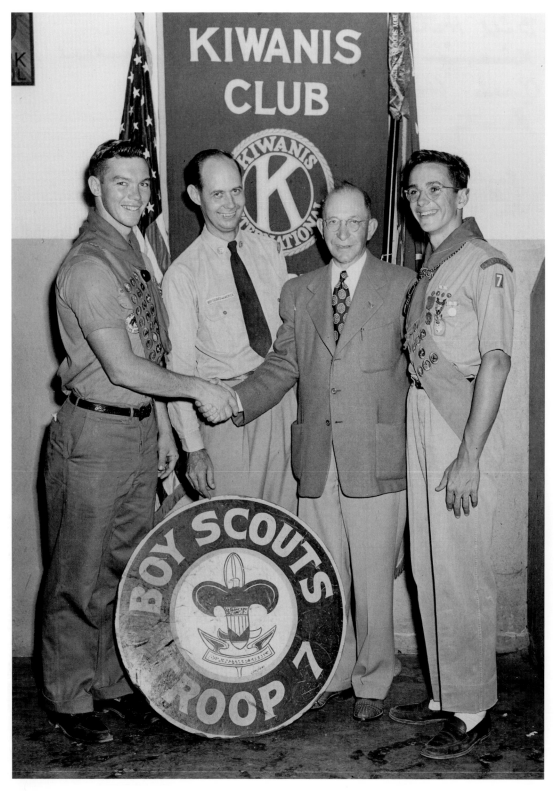

Scouting was a very popular outlet for young men at mid-century. It provided an opportunity to learn practical skills, serve the community, make friends, and of course, have fun. Fort Lauderdale Kiwanis Club president Charles Armstrong and Kiwanis Scout Master Bill Hatlem greet Boy Scouts of America Troop 7 members Oliver Lovedahl and Russell Carlisle in this 1948 photo.

Coast Guard Base 6 was commissioned on the southernmost part of Fort Lauderdale beach in 1924. After World War II, the property was acquired by the city for a new marina: Bahia Mar. This photo shows one of the buildings of the old base as construction on Bahia Mar begins in 1949.

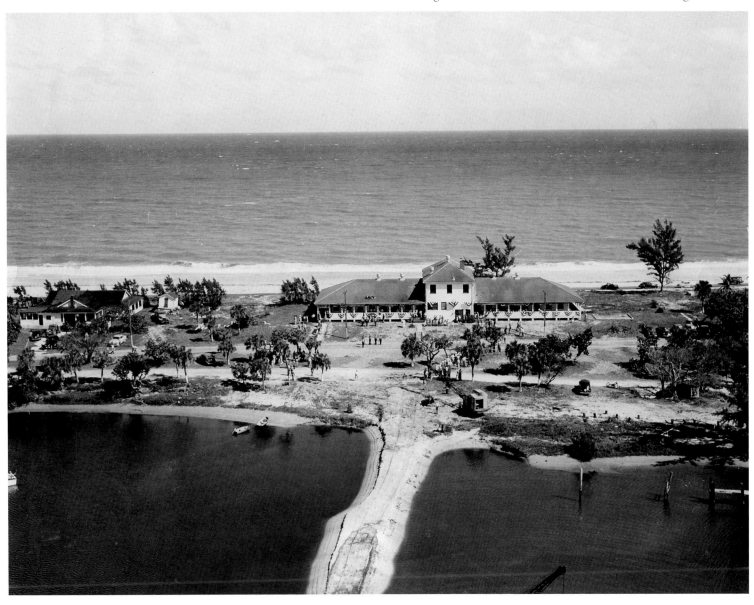

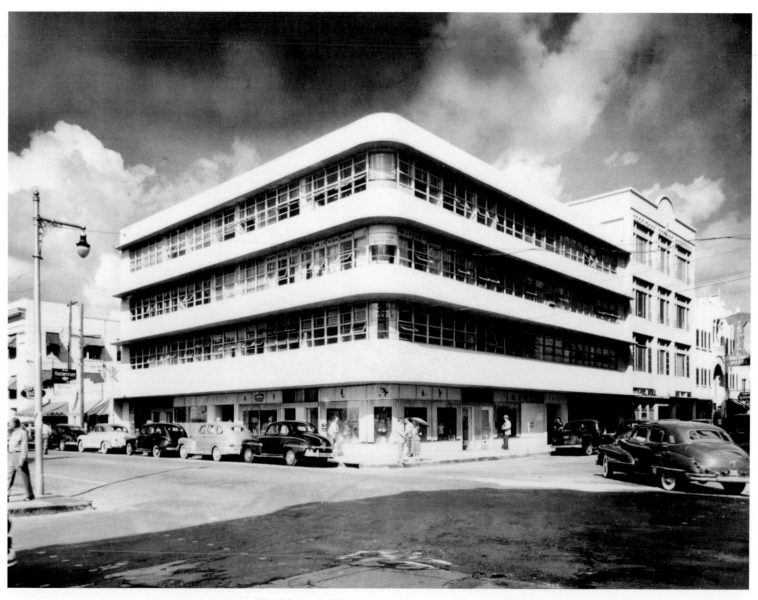

The Blount Building, with its then-trendy International Style architecture, opened in 1940 on East Las Olas at Southeast First Avenue. It was the home of many of Fort Lauderdale's physicians and other professionals. It was demolished in 1973 as part of the city's massive downtown redevelopment project.

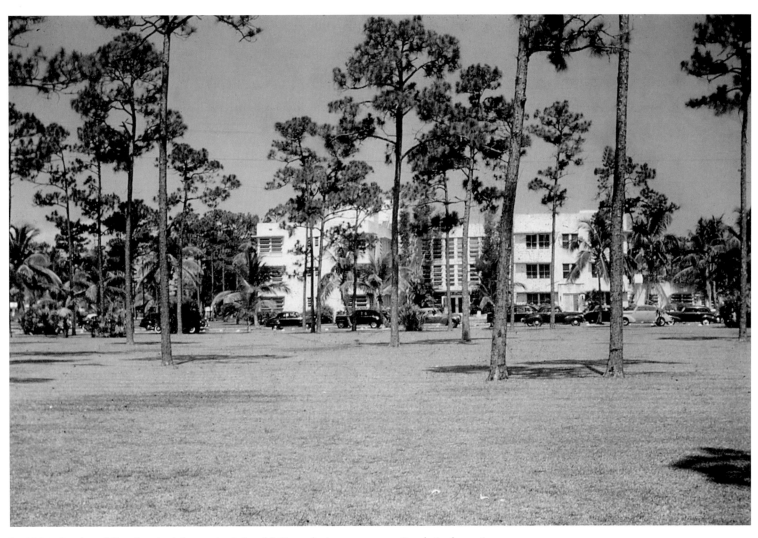

In 1937, the city of Fort Lauderdale acquired the old Granada Apartments on South Andrews Avenue; the remodeled structure opened as Broward General Hospital in 1938. This image shows the hospital in 1949. Today, this is the expansive complex known as Broward General Medical Center.

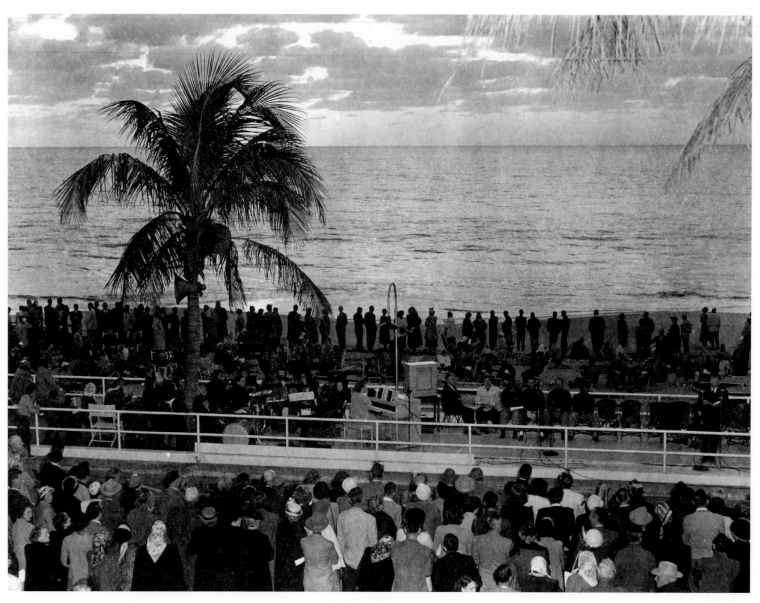

Fort Lauderdale's beautiful beach has played host to Easter Sunday services for decades. In this photo, the Salvation Army band plays before a crowd gathered for the sunrise service in 1950. The band is seated on the boardwalk, which once stood on the beach in front of the Lauderdale Beach Hotel.

Despite Fort Lauderdale's rapid urbanization at mid-century, there was still room for pleasurable rural activities like horseback riding at the edges of the city and in nearby rural towns like Davie. Here, a young equestrian takes a turn around the paddock in 1950.

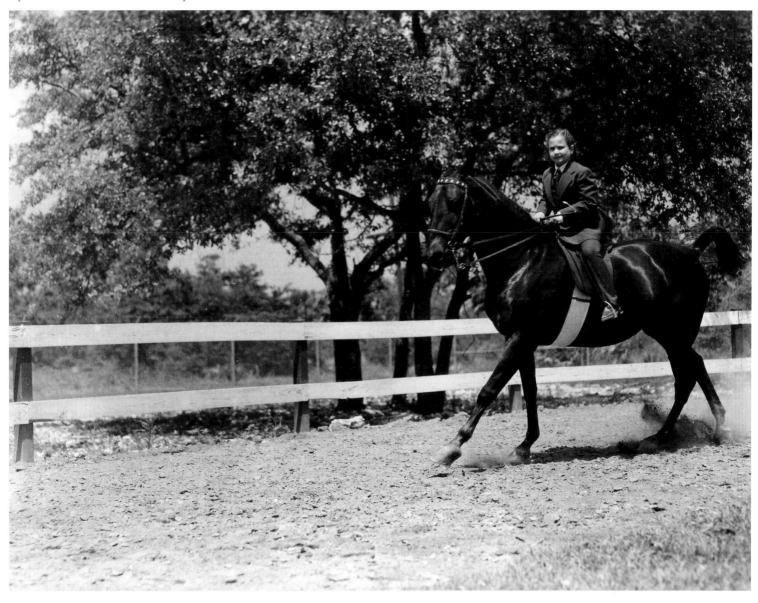

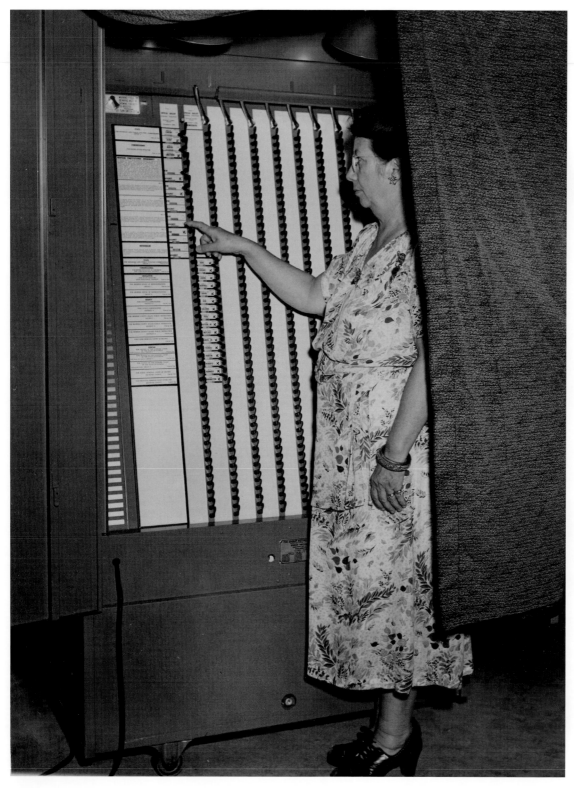

Easter Lily Gates came with her husband George to Fort Lauderdale in 1918. Her husband's infirmity led her eventually to the workplace in the 1920s. What started as "just a job" became a career—as Broward County's Supervisor of Elections—for forty years. Here, Easter Lily checks out a voting machine in 1950.

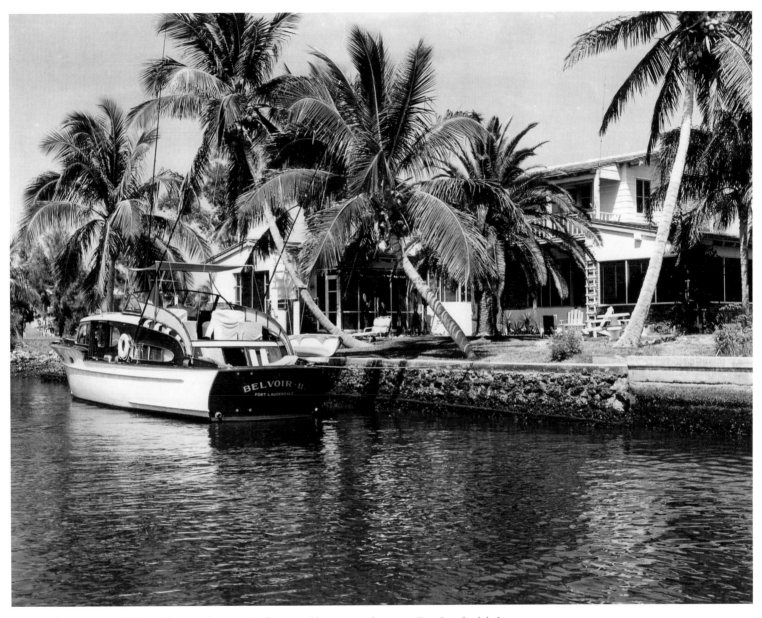

During the post–World War II boom, thousands of new residents were drawn to Fort Lauderdale by the sunny climate and economic opportunities to be had there. One of the principal draws was the extensive canal systems that provided "ocean access" for many homeowners living in relatively modest neighborhoods. This view depicts an idyllic Fort Lauderdale home (and boat) on a canal off Las Olas Boulevard in 1950.

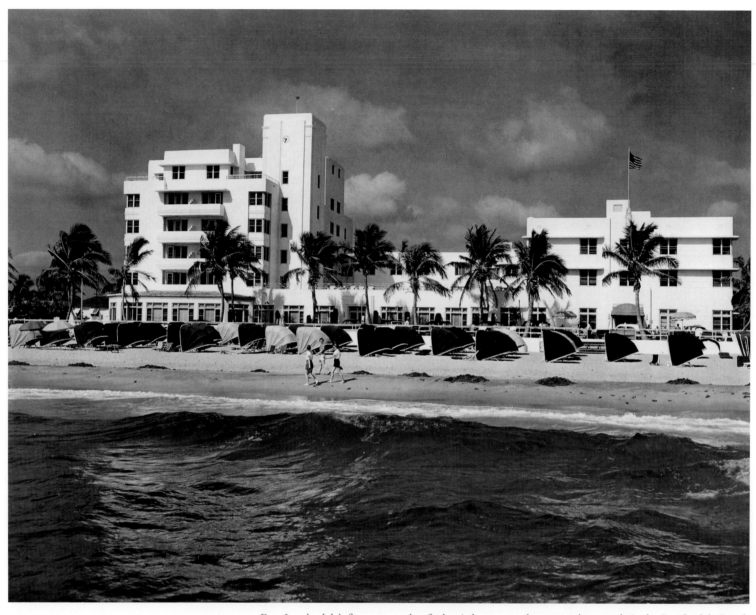

Fort Lauderdale's finest example of what is known as the art moderne style is the Lauderdale Beach Hotel, which originally opened in 1937, signaling a new era in local tourism. This view shows the hotel in 1950; a boardwalk once graced the beachfront there. Today, the building has been restored and adapted as high-end condos.

The Tropicanza Festival was a city-wide event sponsored by the Chamber of Commerce to benefit a variety of local agencies and encourage springtime tourism in 1950. The week-long festival included fishing tournaments, youth activities, a water show, a prize fight, and of course, a downtown parade. In this photo Tropicanza Queen Betty McCall poses with her court on April 10, 1950.

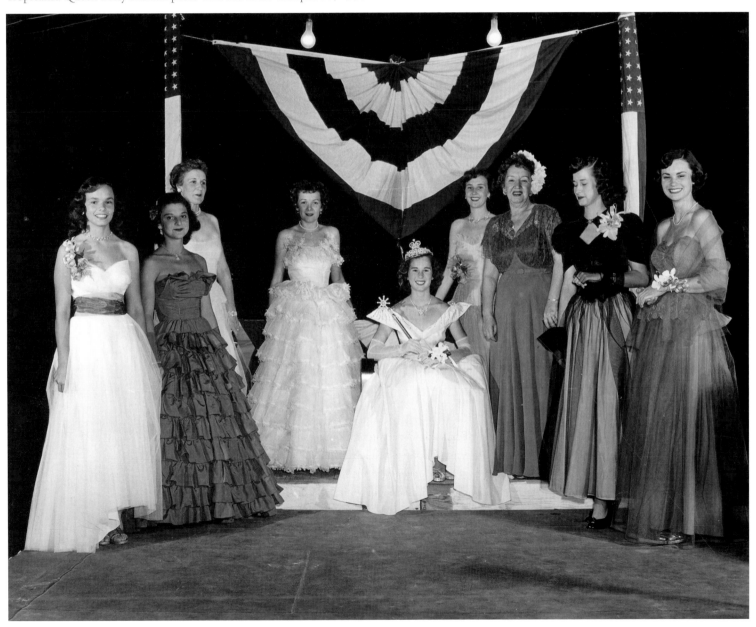

In honor of Florida's heritage, the city's Tropicanza Festival had a vaguely Spanish and Caribbean theme. Fashion shows, carnivals, parades, and dances gave ladies a chance to show off their costumes. Here, two professional models dressed as "senoritas" beckon guests to festival activities in April 1950.

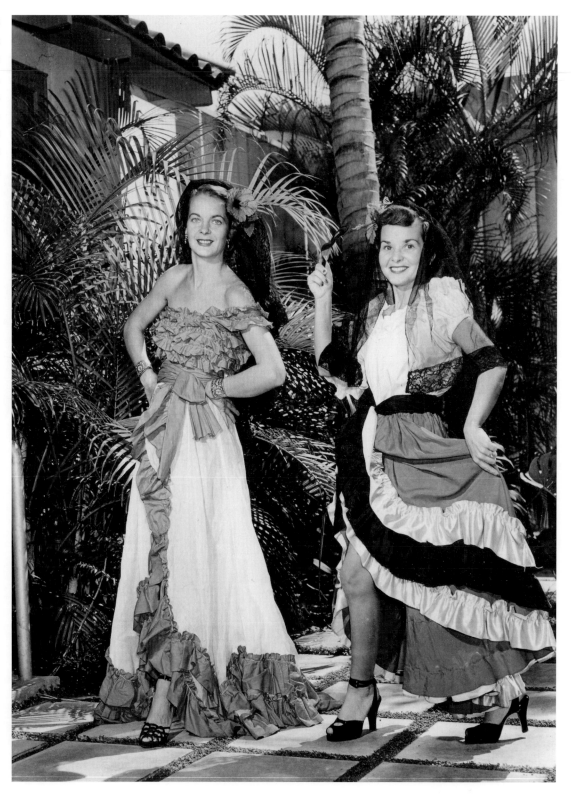

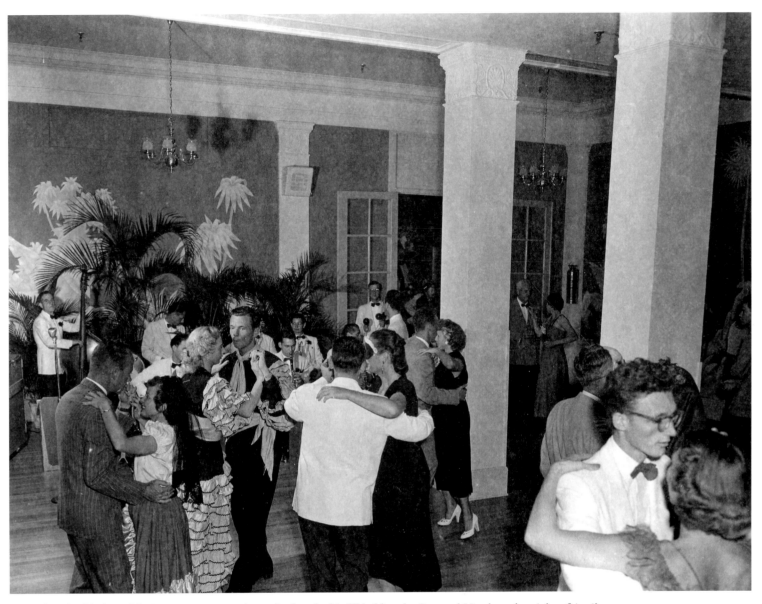

One of the highlights of the Tropicanza Festival was the "masked ball" held at the Broward Hotel on the night of April 10, 1950. "Authentic Spanish costume" was the preferred attire, but the gentlemen in this picture seem to have largely ignored the dictum.

A nighttime trip on Fort Lauderdale's waterways is still a beautiful and unique experience. Here, boats line up for the evening along New River while visitors enjoy a nighttime cruise aboard one of the many local excursion boats, at right, in the early 1950s.

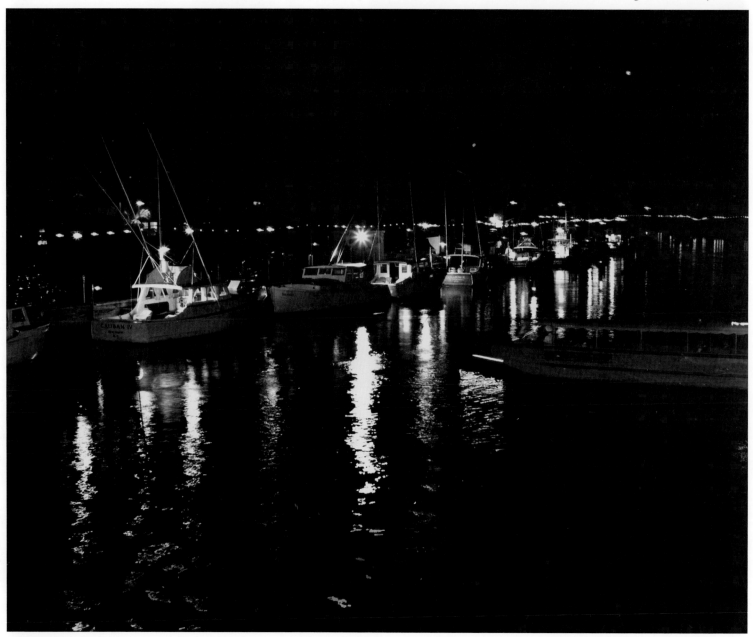

By the 1950s. Fort Lauderdale was well established as the "big city" of Broward County, but reminders of the city's agricultural heritage were not far away. In this photo, Ralph Gross wheels chicken coops at his farm located on Broward Boulevard, west of today's I-95.

This idyllic scene, part of the Florida Department of Commerce's collection, depicts a family enjoying a "typical" backyard scene, Fort Lauderdale style, in the 1950s. Mom and Dad actually have their own personal cabana, at right, and the kids enjoy what was once the *de rigueur* accessory for Florida lawns—an umbrella table.

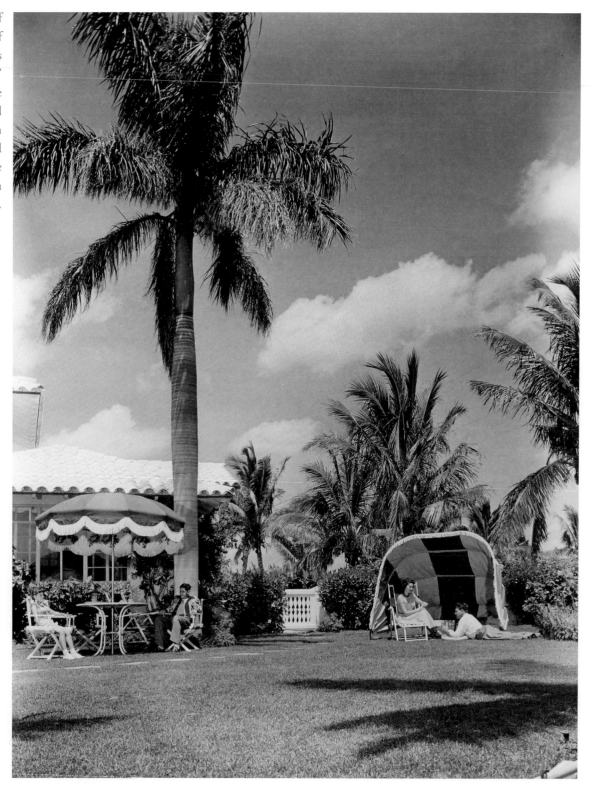

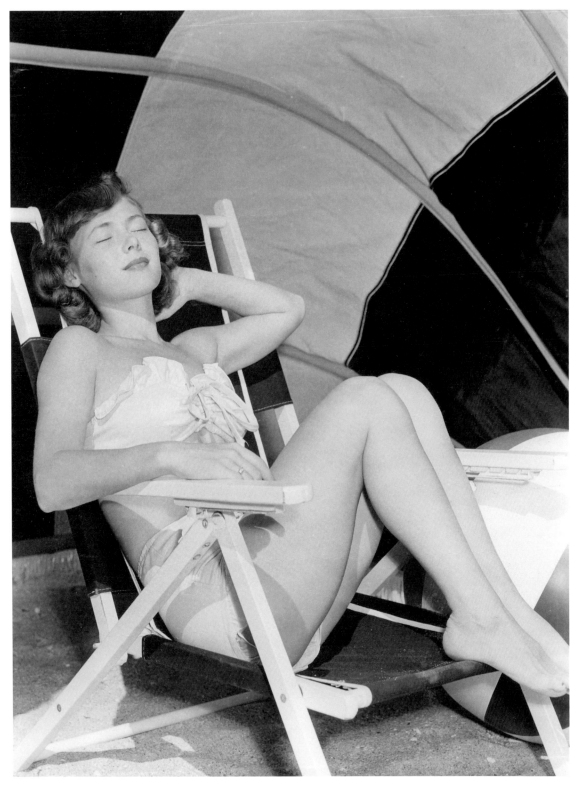

Ms. Donna Stallings appears to be napping under a rented cabana in this glamour shot taken on Fort Lauderdale's beach in the 1950s. Notice her stylish, two-piece bathing suit; bikinis were new and generally had not been accepted yet in the U.S. This photo was likely taken on the beach near the Lauderdale Beach Hotel.

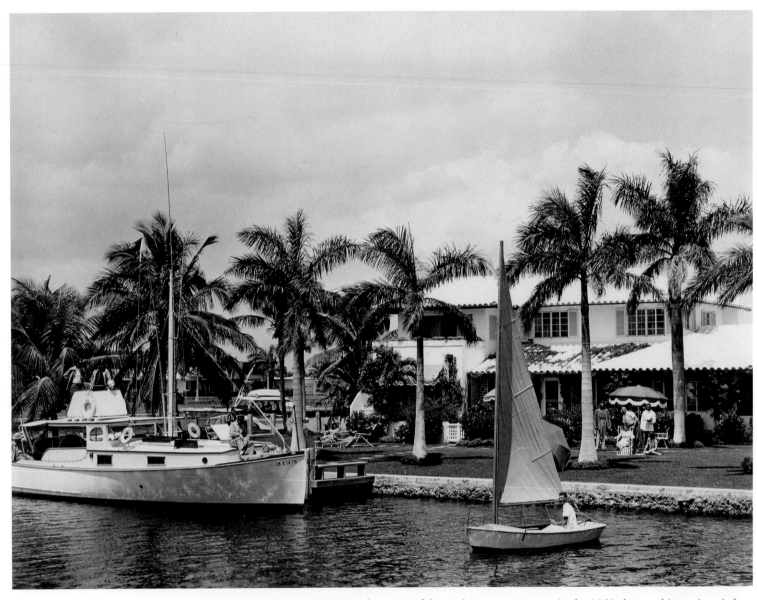

The family residing in this home along one of the city's many waterways in the 1950s has a cabin cruiser tied up to their dock. In addition to personal boats, waterfront owners often rented dock space to seasonal visitors. A friend in a small sailboat, just the right size for getting around the canals and river, is departing, at right.

One of Fort Lauderdale's best-known citizens at mid-century was Dwight L. Rogers. As a state representative, he sponsored the Homestead Exemption Act, from which all Florida homeowners benefit today. He was the first Fort Lauderdale resident to serve as a U.S. Congressman, elected in 1944. In this photo, he speaks at the dedication of Pepper Park in Fort Pierce, 1950.

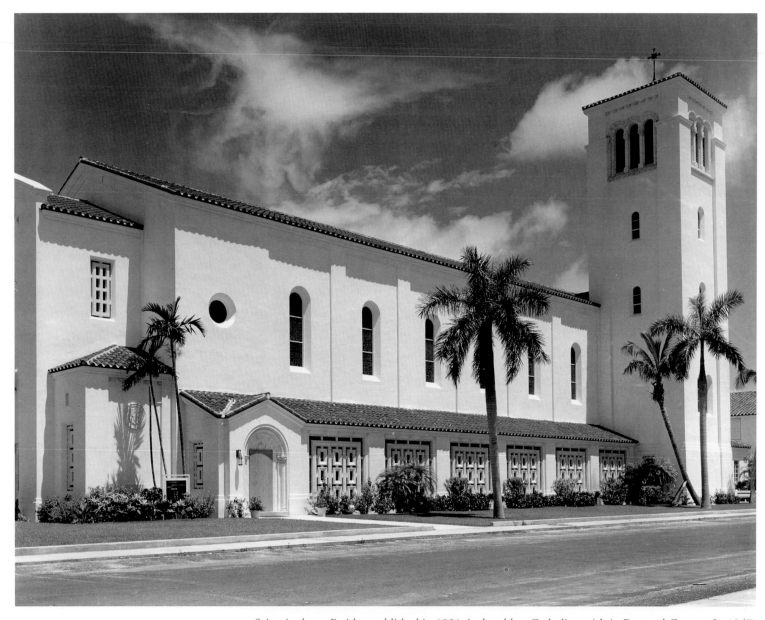

Saint Anthony Parish, established in 1921, is the oldest Catholic parish in Broward County. In 1947, Chicago architects Barry and Kay designed a new church for Saint Anthony in a Romanesque Revival style. The church featured traditional details like the bell tower, mixed with modern elements such as the brise-soleil screens over the windows on the first floor. This photo was taken in 1950.

In 1919, Fort Lauderdale charter captain Jimmy Vreeland and his guests reeled in six sailfish. The story goes that pioneer resident M. A. Hortt tied them to his car and drove to Biscayne Park in Miami, attracting an admiring crowd, and sports fishing became all the rage in Fort Lauderdale. In this image, the *Lucky Lady* carries on this historic tradition in the 1950s.

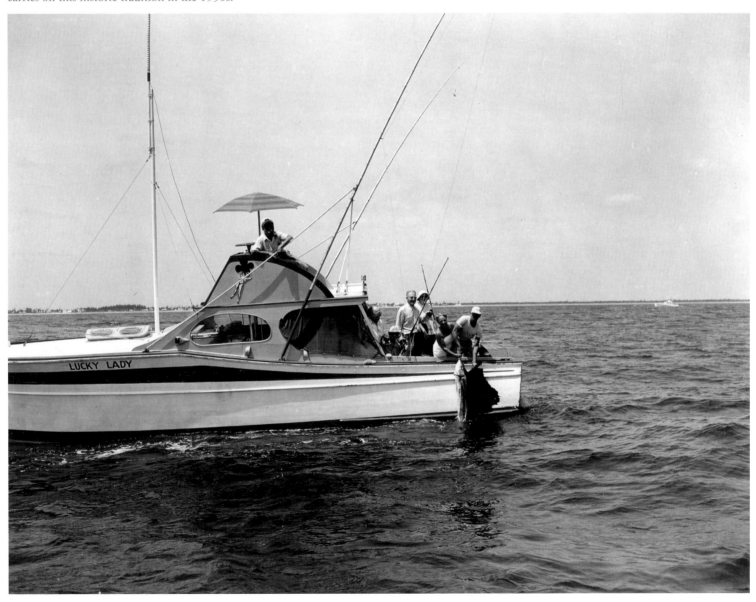

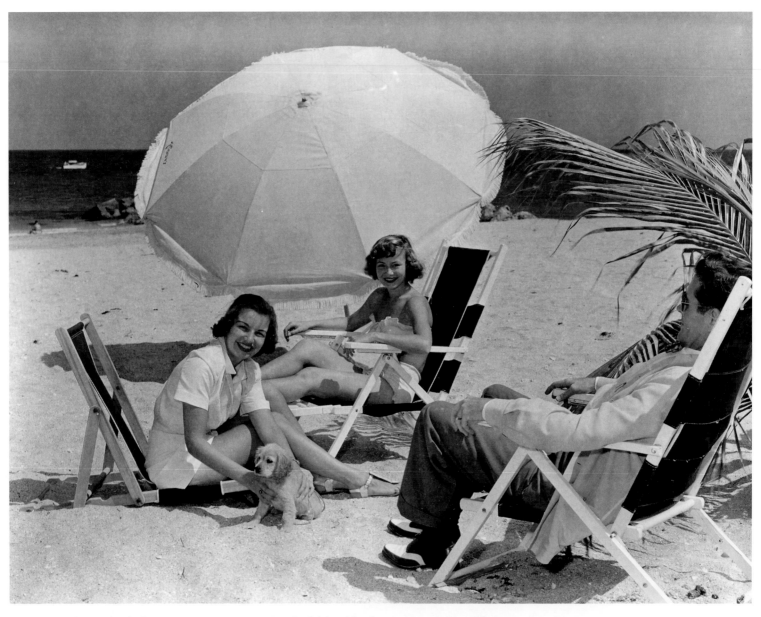

On a sunny day in April of 1950, visitors enjoy Fort Lauderdale's golden beach. From left to right are Jean Hubert, Donna Stallings, and Bob Hess, at the time manger of the local chamber of commerce.

Two youngsters enjoy a timeless entertainment on the docks along one of Fort Lauderdale's 165 miles of navigable waterways in 1953. The boy waits for a fish to bite; the young lady seems to be taking a break from playing grown-up (notice the pocketbook).

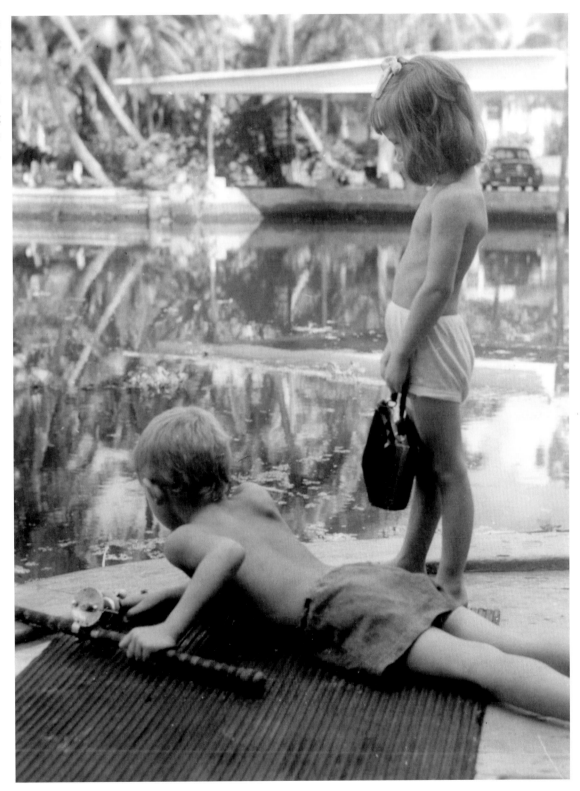

This interesting aerial view shows three slips at Port Everglades in 1953. In the background a collection of storage tanks can be seen; the port still was known primarily as a cargo port in those days. The nearby international airport, visible in the background at left, and the proximity to the islands of the Caribbean would within decades make Port Everglades one of the world's busiest cruise ports.

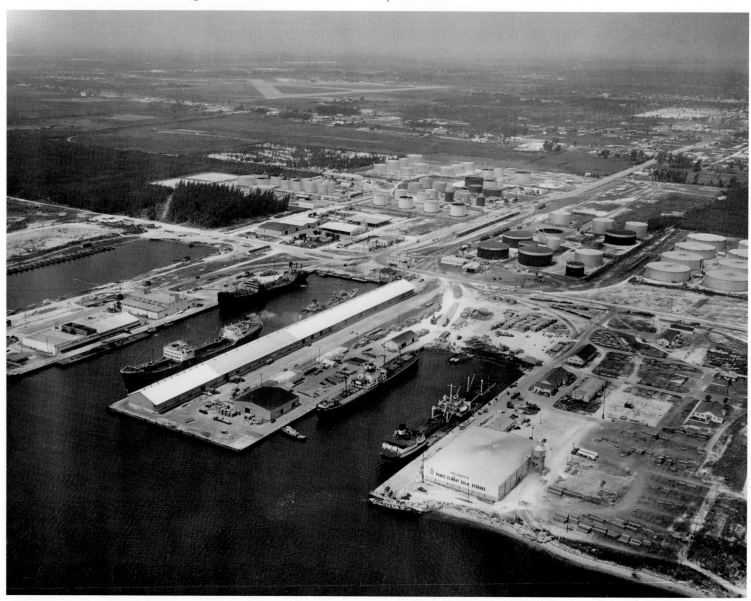

After World War II, the city of Fort Lauderdale acquired the former Coast Guard Base 6, located at the south end of the beach. In December 1949 a new marina, Bahia Mar, opened on the site. Bahia Mar put the city on the map in the boating business, as it brought tremendous publicity and cachet to potential investors and new residents. This view shows the shopping center at Bahia Mar about 1950.

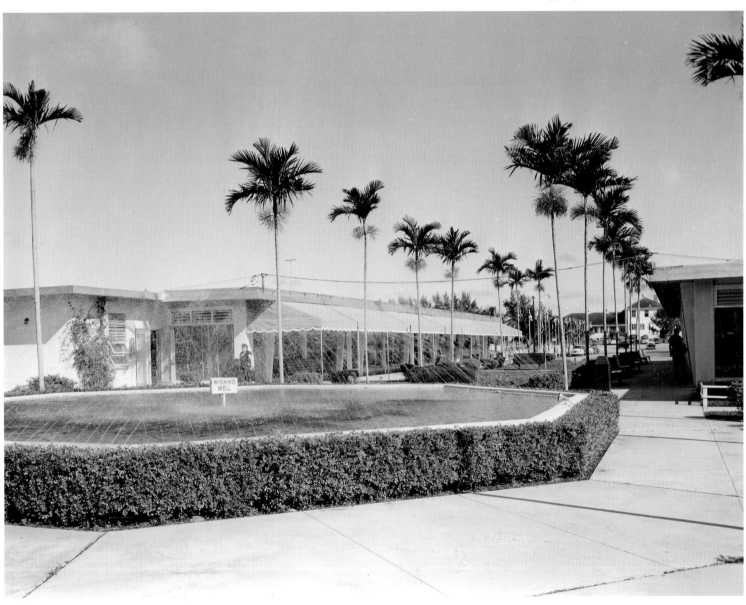

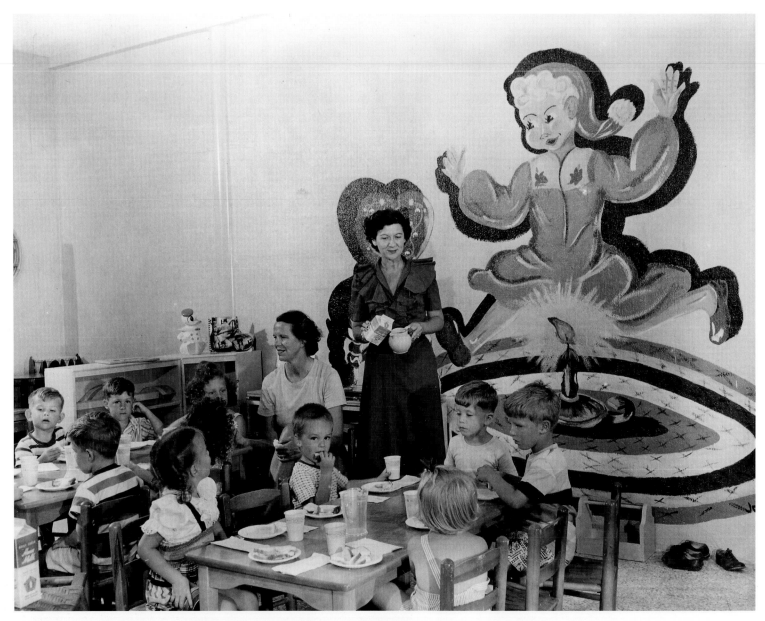

Bahia Mar became one of the country's most glamorous yachting marinas, a title it can still claim today. It featured a number of amenities for its guests, many of whom were seasonal visitors (aka "snowbirds"). This is the nursery school at Bahia Mar in the early 1950s.

This photograph by Charles Barron shows Fort Lauderdale's "strip," viewed south from the Lauderdale Beach Hotel in 1955. The empty lawn at far right in the background is the lawn of the old Las Olas Inn—formerly located at East Las Olas and Atlantic Boulevard (A1A)—demolished in 1954. Tourists and locals could easily find beachside parking for free back in the '50s.

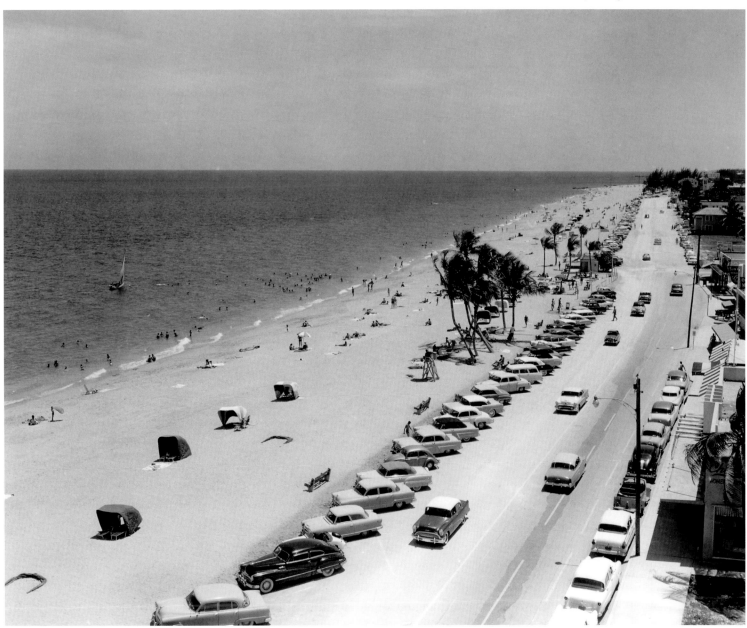

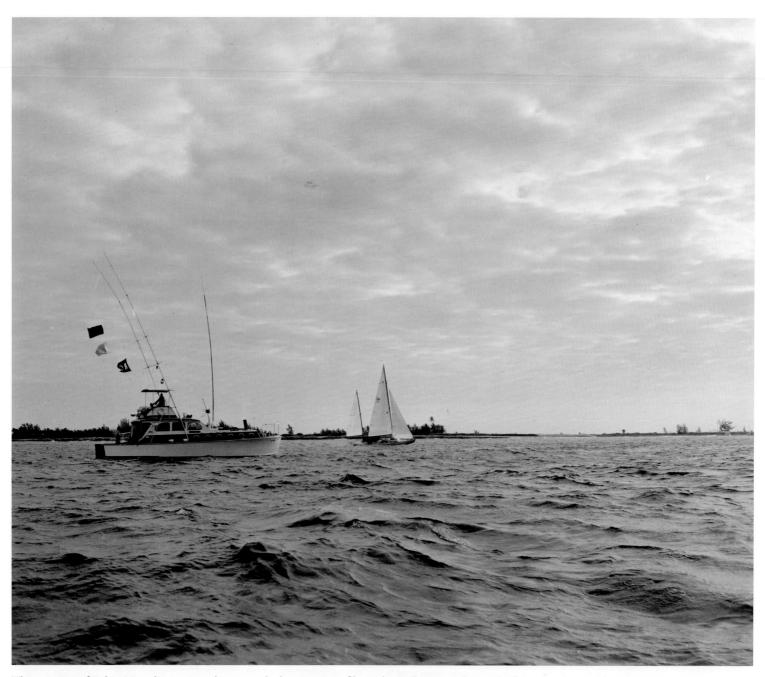

The opening of Bahia Mar, the post-war boom, and a burgeoning of boat shows, boat parades, and other maritime attractions fueled the amazing growth of the marine industries in Fort Lauderdale in the 1950s and 1960s. In this photo, a cabin cruiser shares the water with two sailboats on their way to nearby islands, 1955.

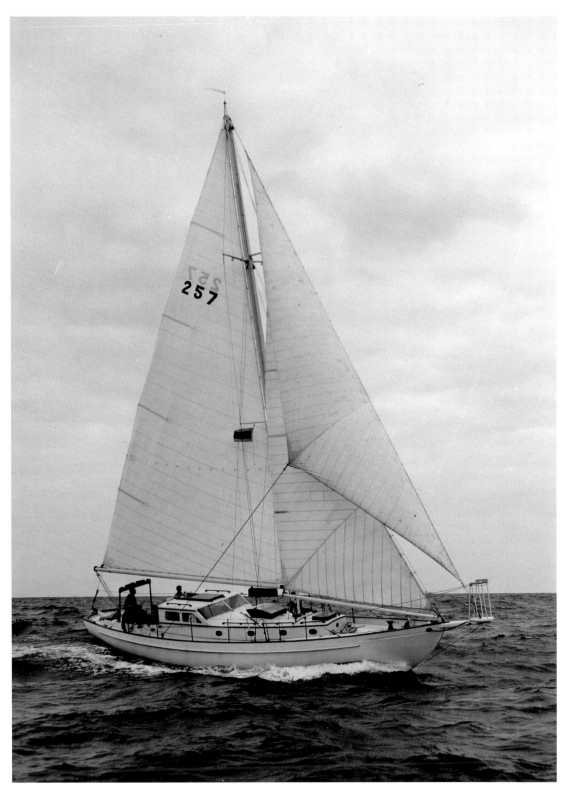

A beautiful sloop sets sail from Fort Lauderdale to Bimini, about a twelve-hour sail away, in the mid-1950s. The small island chain is the nearest to Florida of the Bahamas. Fort Lauderdale residents have long sailed to Bimini for fishing or a quiet respite; Biminians come to Fort Lauderdale for business, schooling, and shopping.

In 1957, Phillips Petroleum built a private yacht club on the northeast side of the recently constructed Seventeenth Street Causeway. They named it Pier 66. By the 1960s, the twenty-acre complex boasted two golf courses and two pools in addition to the hotel and marina. In 1965, Phillips added a seventeen-story tower topped off by a flying-saucer-like revolving lounge, still one of the city's most recognizable landmarks.

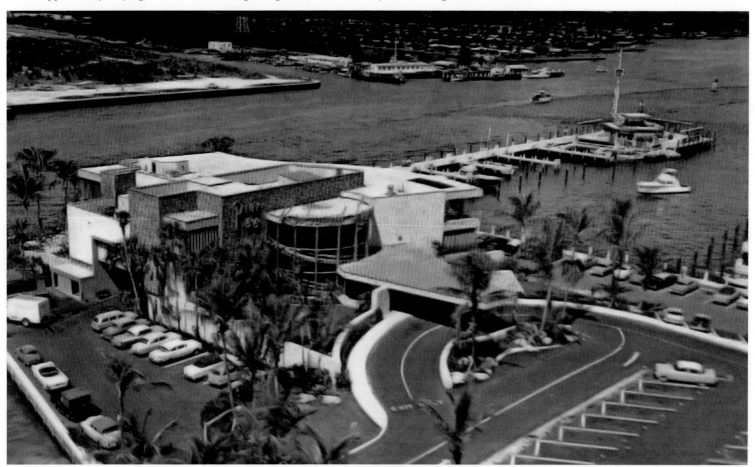

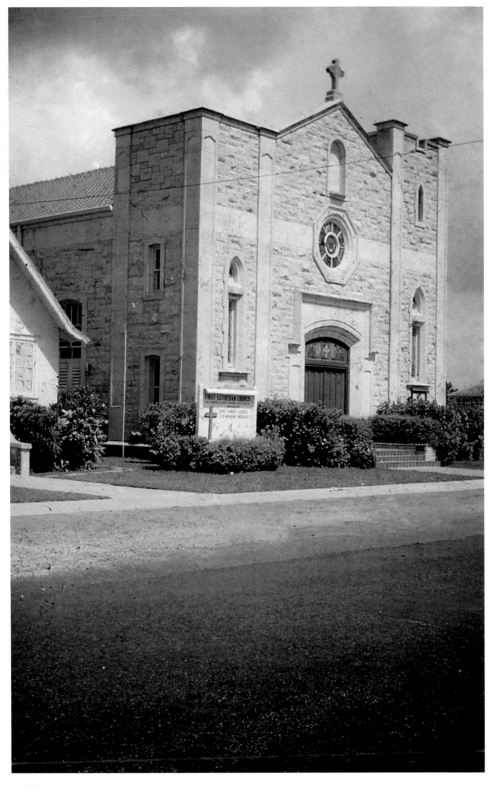

This church, Fort Lauderdale's only example of "Richardsonian Romanesque" architecture, originally served as Saint Anthony's Catholic Church and stood on East Las Olas Boulevard. After the construction of the new Saint Anthony church in the late 1940s, it was disassembled and reassembled on Northeast Fourth Avenue, where it still serves as the sanctuary of the First Lutheran Church.

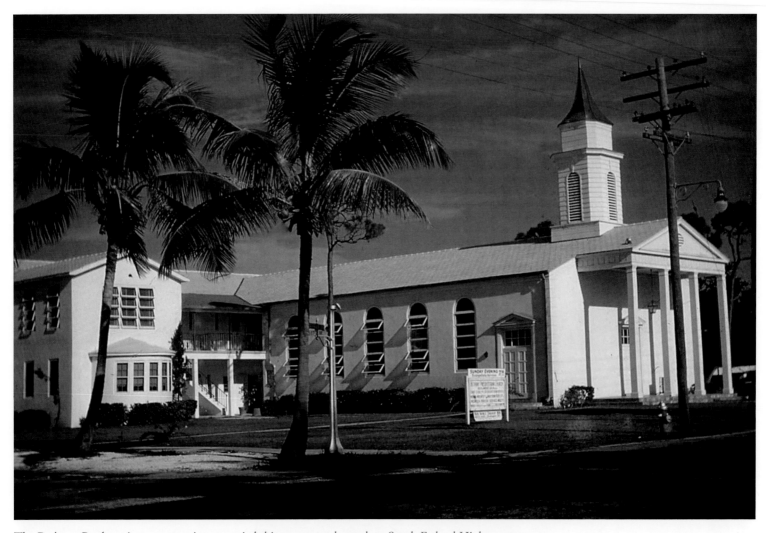

The Bethany Presbyterian congregation occupied this sanctuary, located on South Federal Highway at Southeast Ninth Street in the Rio Vista neighborhood, during the 1950s. The building was briefly the private home of a local antiques dealer in the 1970s when the church moved to new quarters across the street. Today, it is home to Bethany Christian School and the Rio Vista Community Church.

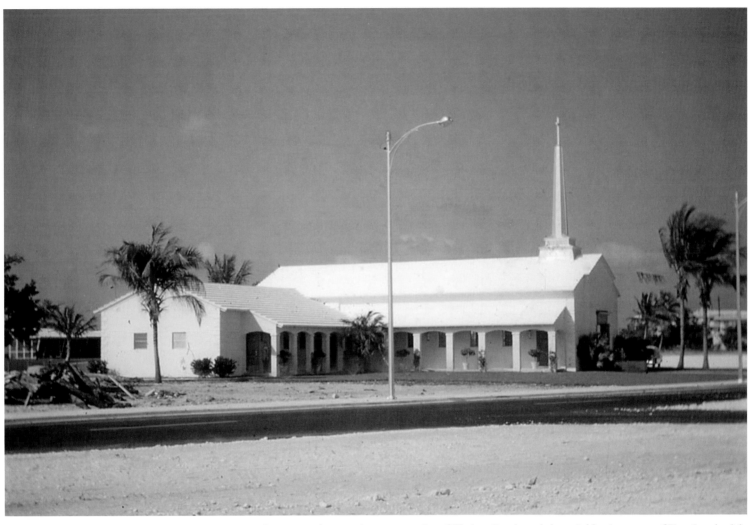

In the 1950s, the growing community of Harbor Beach and the neighboring areas of Fort Lauderdale beach lacked a convenient nearby place of worship. In 1956, the Church by the Sea, designed by local architect Robert Jahelka, opened as a Presbyterian congregation. Today it is non-denominational and serves as a popular site for weddings.

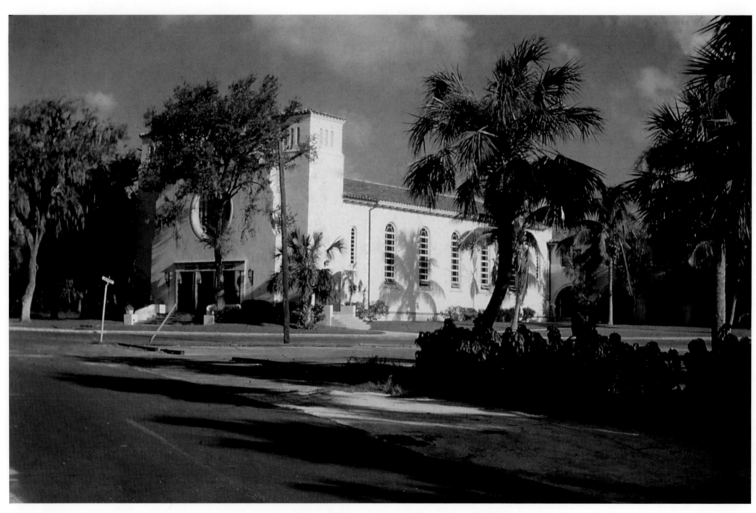

The First Presbyterian Church of Fort Lauderdale, originally founded in 1912, built a new sanctuary at 401 Southeast Fifteenth Avenue on the New River at Tarpon Bend in 1942. This image shows the handsome structure in its setting in the Colee Hammock neighborhood in the 1950s.

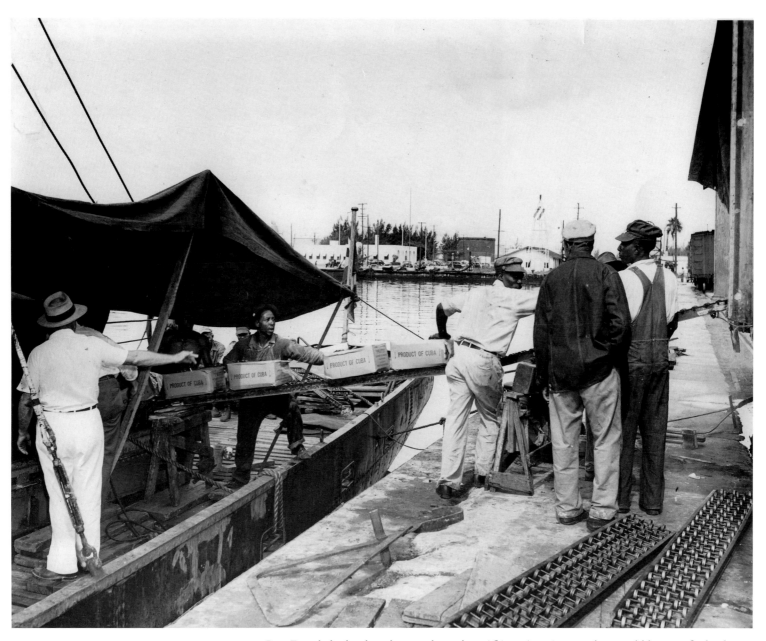

Port Everglades has long been a place where African American workers could hope to find a decent wage, even in the days of Jim Crow and Southern prejudices. Here, longshoremen unload cargo from Cuba in this early 1950s image. The common scene of handling shipments from Cuba disappeared after the U.S. severed diplomatic ties in 1961, following Castro's 1950s revolution that established a communist government on the island.

The "Philip Morris bellhop" was a popular American advertising icon of the 1930s, '40s, and '50s. The original character, Johnny Roventini, served as an ambassador at countless parades and celebrations throughout the county. The diminutive Johnny, already over twenty in the 1930s, was backed up by a corps of young imitators. In this photo, one of the "junior Johnnies" visits Fort Lauderdale for a parade or festival in the 1950s.

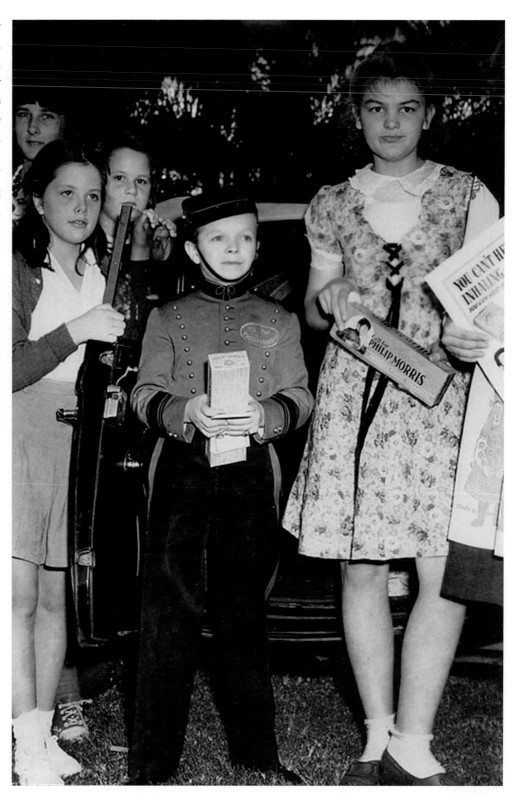

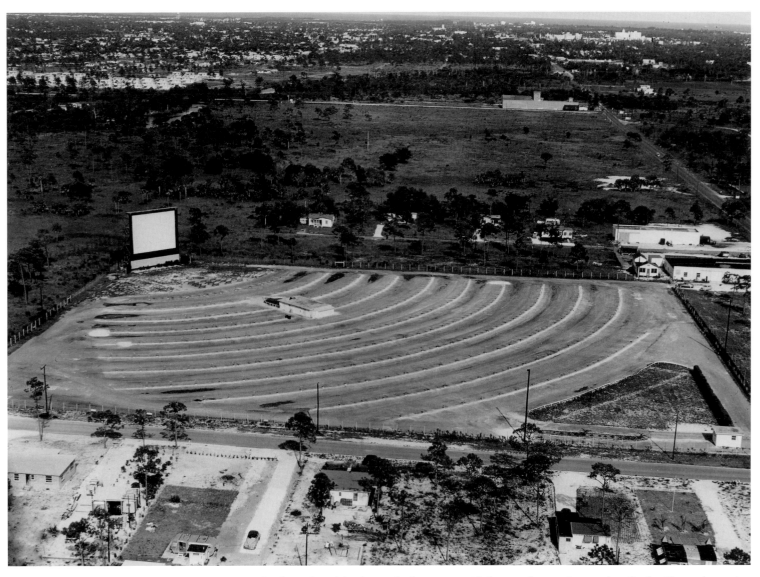

In the 1950s, drive-in movie theaters provided a popular evening pastime for families and courting couples throughout America. Fort Lauderdale's first drive-in was located at West Broward Boulevard and Northwest Twenty-Seventh Avenue. This east-facing aerial view by local photographer Tony Kozla shows the drive-in, with Broward Boulevard at upper right.

Fort Lauderdale became the state's fifth largest city as its population grew from around 35,000 to 83,648 in the 1950s. New homes and housing developments sprang up through every corner of the community. This image features a "cool" ranch house with "mid-century modern" detailing (once considered old-fashioned but now trendy again) at Davie Boulevard and Southwest Seventeenth Avenue. Students pass by on their way to school, some carrying what appear to be paper-sack lunches.

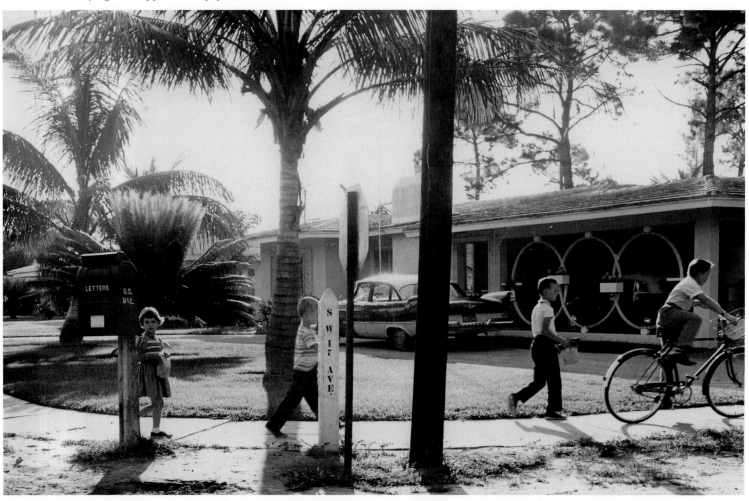

In 1956, longtime residents said farewell to the aging wooden station that had served the Florida East Coast Railway since the beginning of the twentieth century. The new station, opened in June of that year, was located on Southwest Seventeenth Street. It did not serve the public for long; by 1968 the FEC ceased passenger service.

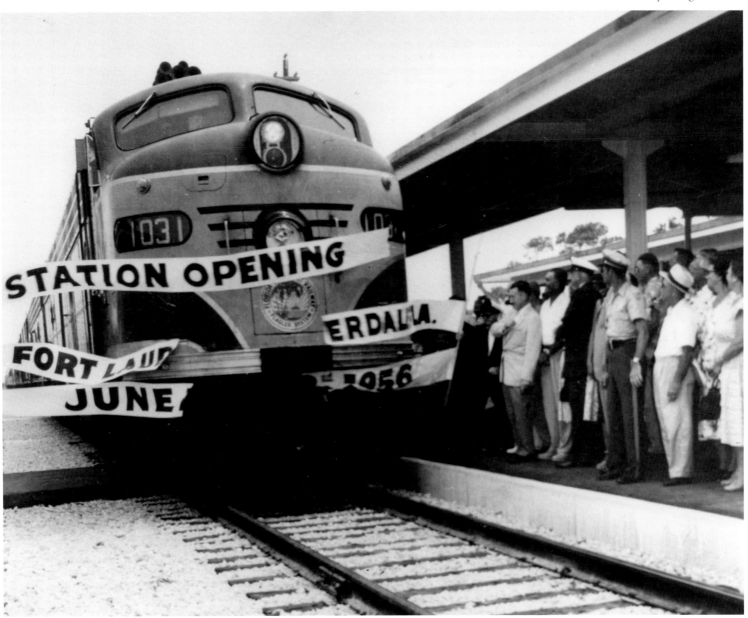

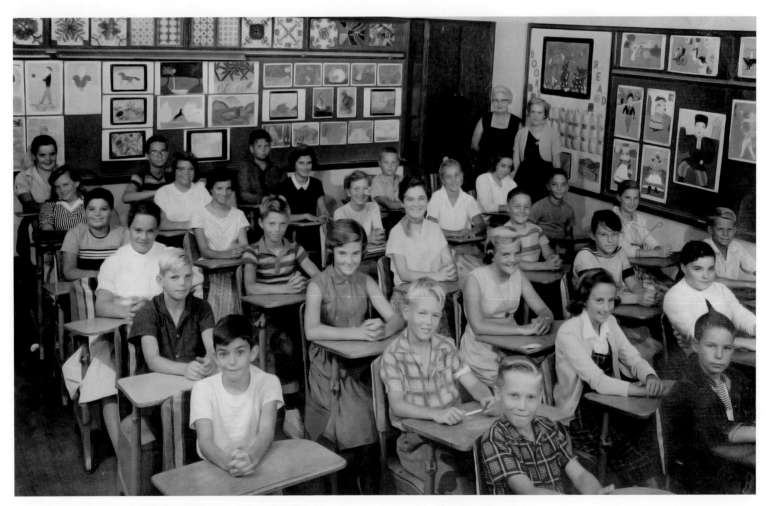

Bennett Elementary was constructed at 1755 Northeast Fourteenth Street in 1951, and named for Ulric Bennett, longtime superintendent of county schools. This photo features the students of Mrs. Margaret Morris' sixth-grade classroom in the 1956–57 school year.

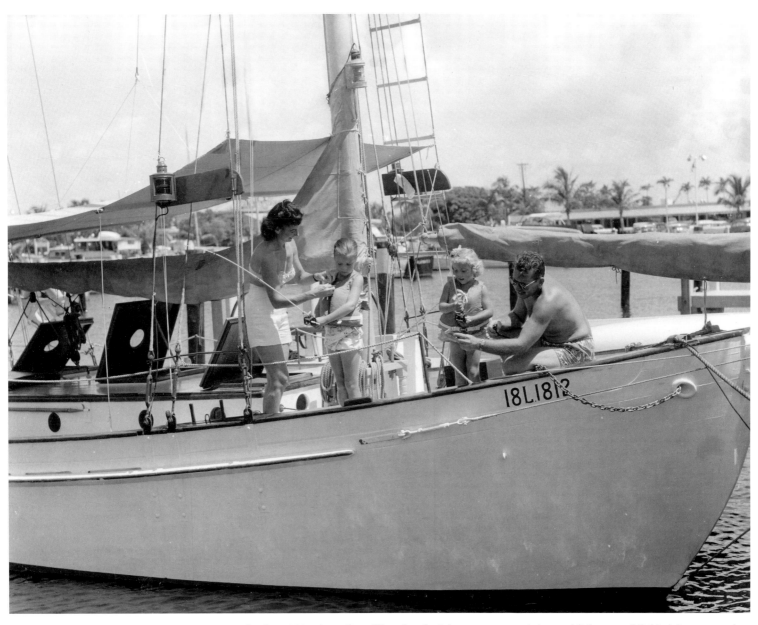

In the 1950s, the miles of Fort Lauderdale waterways and the establishment of Bahia Mar attracted an increasing number of "live-aboard" residents like the family shown in this 1957 photo. The community was once known for its houseboats and easy accessibility for pleasure boaters, but city policies have become increasingly restrictive to combat water pollution.

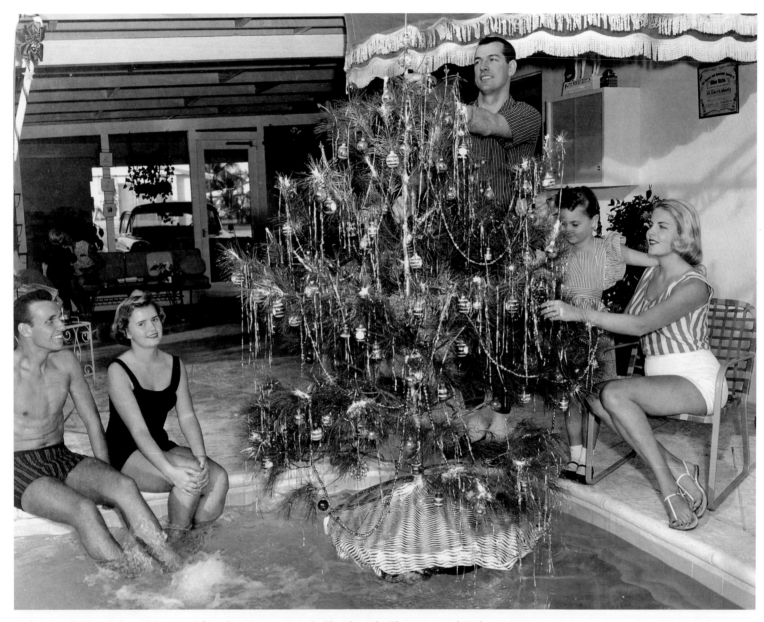

Colonel and Mrs. Robert Wheat and friends enjoy an entirely Florida-style Christmas at their home in 1957. The Wheats lived in a house designed by Fort Lauderdale "environmental" architect Bill Bigoney. Bigoney's house designs focused on the link between exterior and interior spaces, to take advantage of Florida's natural breezes in the days before air conditioning.

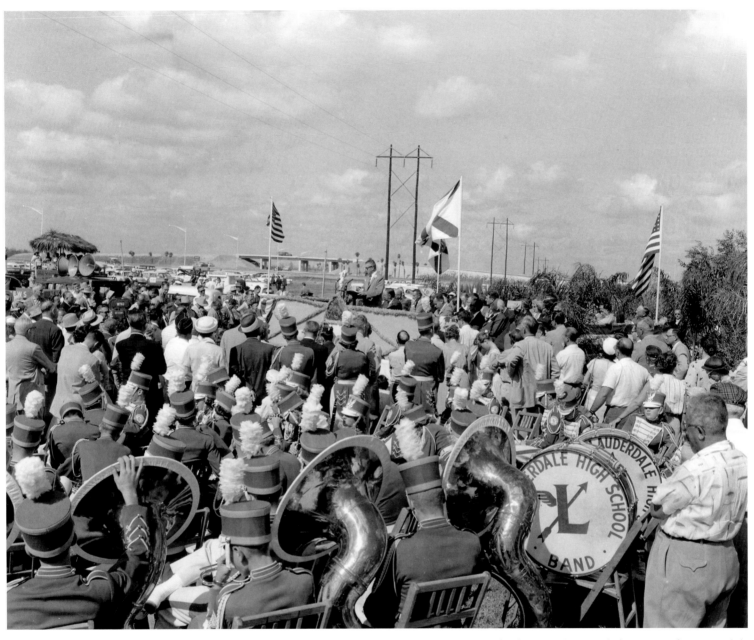

In 1957, the completion of the Sunshine State Parkway, aka the turnpike, signaled a new era for automobile travel in Florida. Originally, the highway linked North Miami with Fort Pierce and had only occasional exits. Here, the "Flying L" band of Fort Lauderdale High School performs during dedication ceremonies at the headquarters, located at the Sunrise Boulevard entrance. The speaker is Governor LeRoy Collins.

Although the southern half of the county had largely abandoned farming for real estate and tourism, winter vegetables were still the focus of north Broward's economy in the 1950s. In this photo, workers near Fort Lauderdale sort the latest pick of bell peppers, 1957.

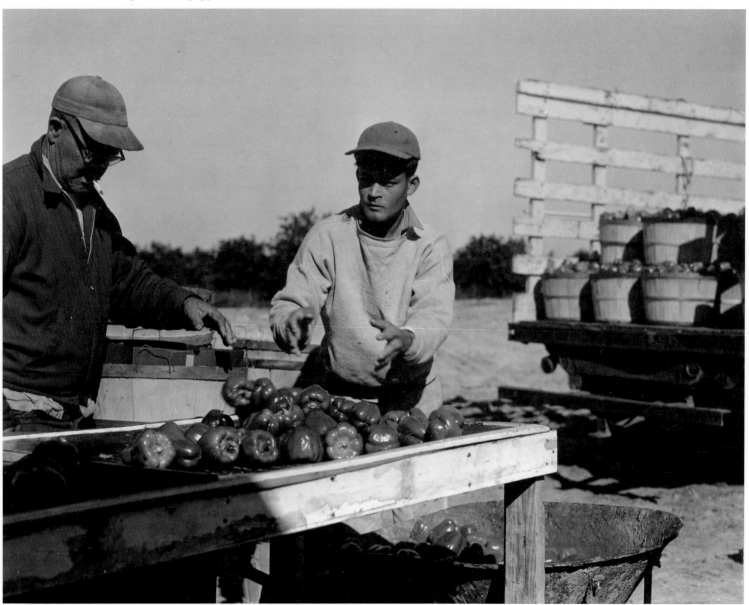

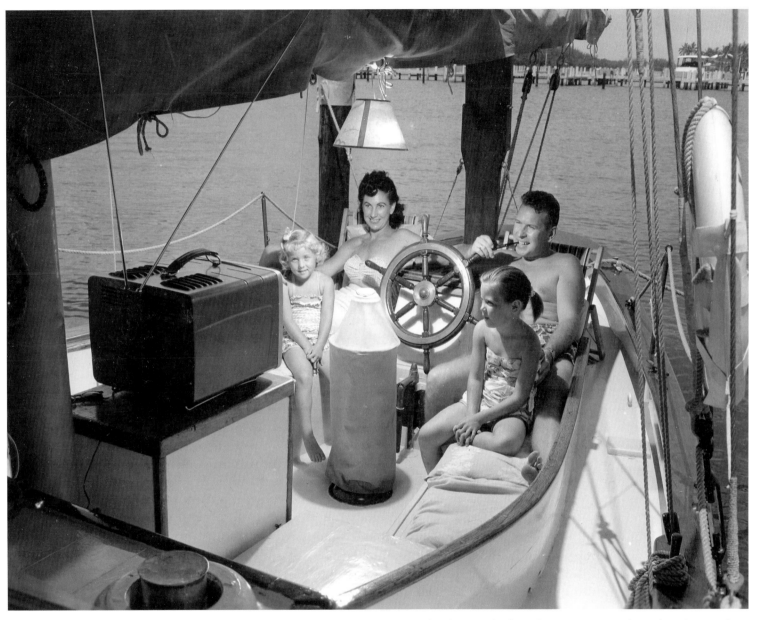

In March 1949, WTVJ (then Channel 4) became the first television station to begin broadcasting from Miami. By the end of the 1950s, a number of others had joined the new industry in South Florida, with limited hours and offerings. Here, a live-aboard family enjoys a show on their small set aboard their sailboat, probably berthed at Bahia Mar, in 1957.

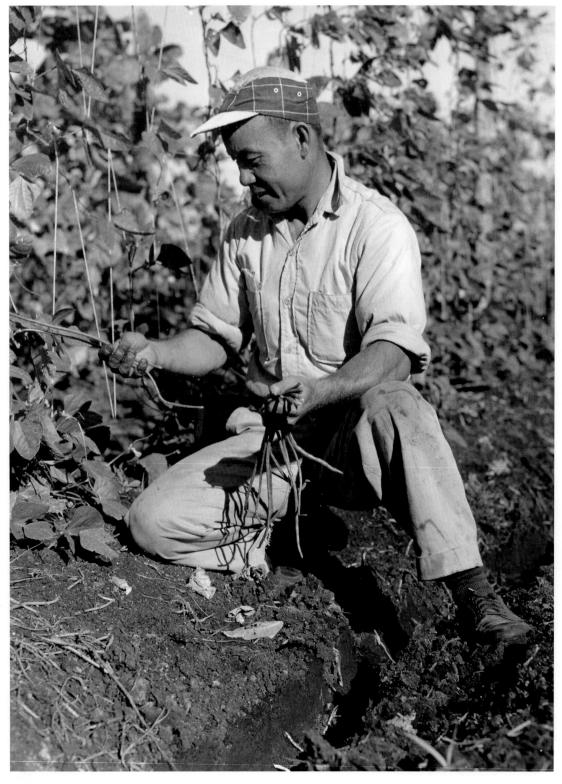

One of Broward County's main crops in the 1950s was beans. In this photo, Fort Lauderdale farmer Lee Eng harvests string beans in 1957. The white strings visible in the background helped support the vines.

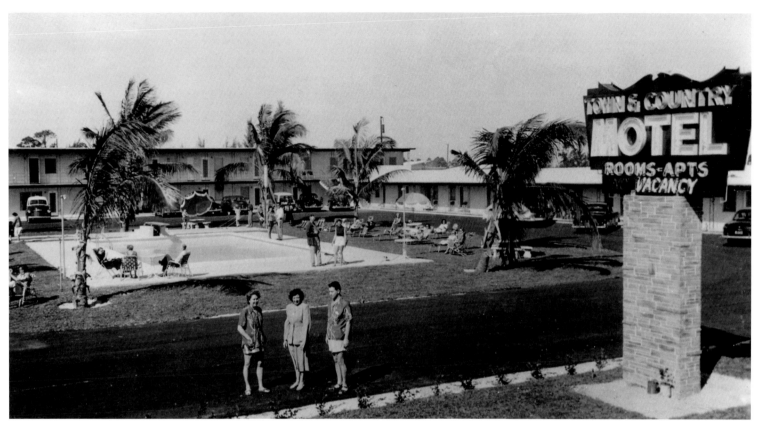

The Towne and Country Motel was typical of the "mom and pop" hostelries that once dominated the landscape of the tourist town of Fort Lauderdale. The motel opened in the early 1950s on Federal Highway just north of the "gateway," where the highway jogs north from East Sunrise Boulevard. The Towne and Country featured apartments as well as motel rooms, a swimming pool, and a great luxury at the time—air conditioning.

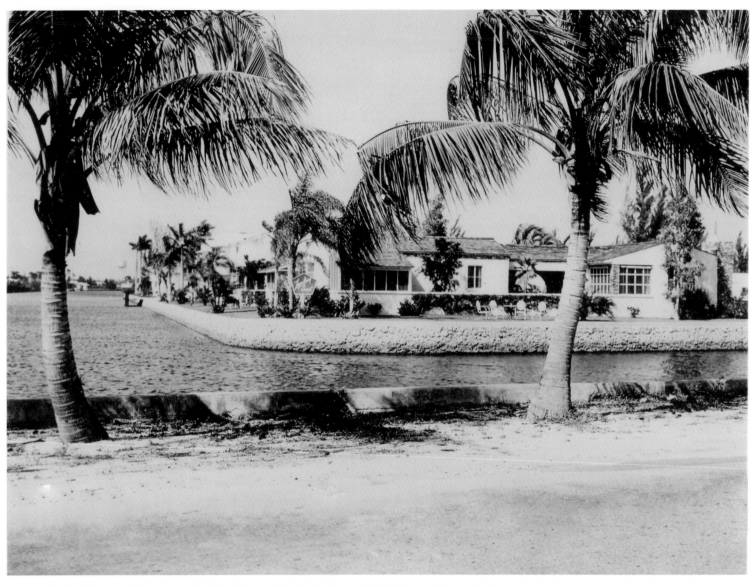

During the land boom of the 1920s, local developers Charley Rodes and W. F. Morang began the ambitious task of developing the swampy lands surrounding East Las Olas Boulevard as "islands." Few were finished until after World War II. "Hendricks Isle," Northeast Eighteenth Avenue, was one of the first to be completed north of Las Olas. This view shows the neighborhood, looking north from Las Olas Boulevard in the 1950s.

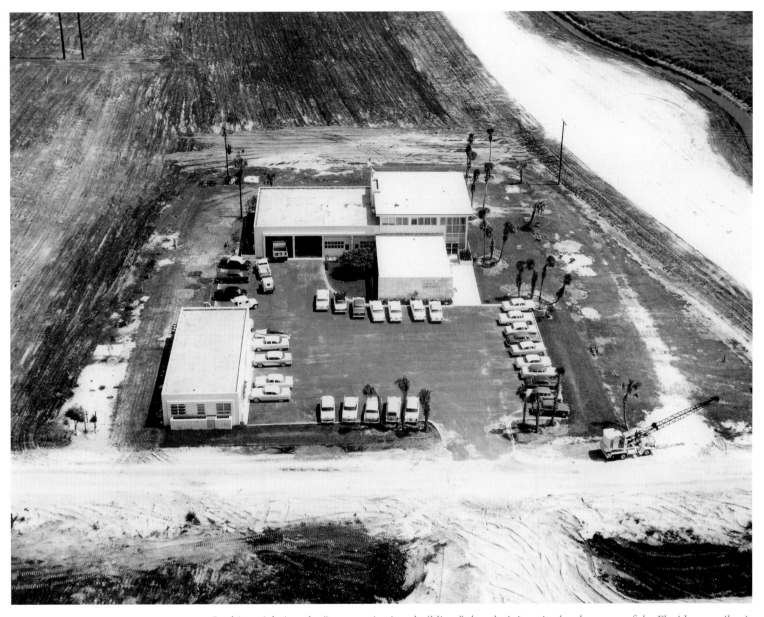

In this aerial view the "communications building," the administrative headquarters of the Florida turnpike, is shown near completion in 1956 in what is now the city of Plantation. The headquarters stands at the Sunrise Boulevard entrance named the McArthur Toll Plaza after J. N. McArthur, one of Broward's best known dairymen, who donated the land for the exchange.

In the late 1940s the old Federal Highway bridge over New River was deemed to be "The worst bottleneck on U.S. One from Maine to Florida." After a controversial political campaign, Fort Lauderdale residents slimly approved the construction of a tunnel under the river—Florida's only vehicular tunnel. Construction began in 1958, and the tunnel was dedicated in December of 1960.

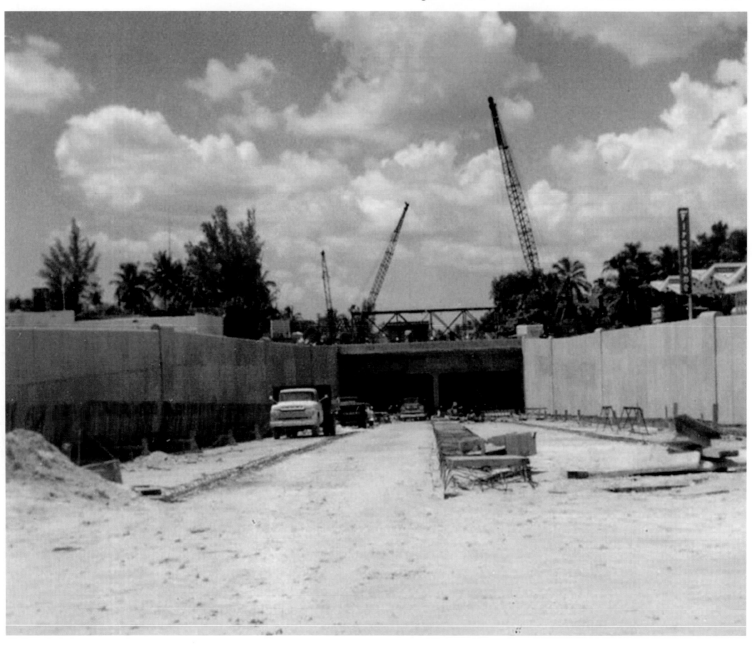

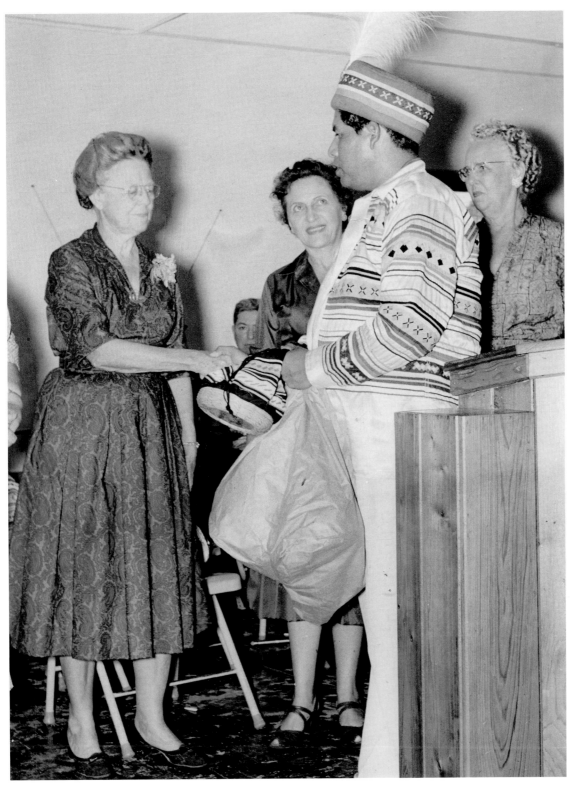

In 1934, Indian activist and Fort Lauderdale pioneer Ivy Stranahan founded the Friends of the Seminoles as a support organization dedicated to the native peoples who once called the Fort Lauderdale area home. Education was a key program of the Friends, and many Seminole children were sent to receive an education at Cherokee School in North Carolina. In this photo Mrs. Stranahan, Mrs. N. Ritchie Johnson, and Mrs. O. H. Abby receive thanks from Reverend Billy Osceola in 1959.

The *Ina B*, out of Cleveland, Ohio, pays a sun-drenched visit to Fort Lauderdale's Intracoastal Waterway in this 1959 scene. Left to right are Lynn Genaria and Mr. and Mrs. T. Warren Smith.

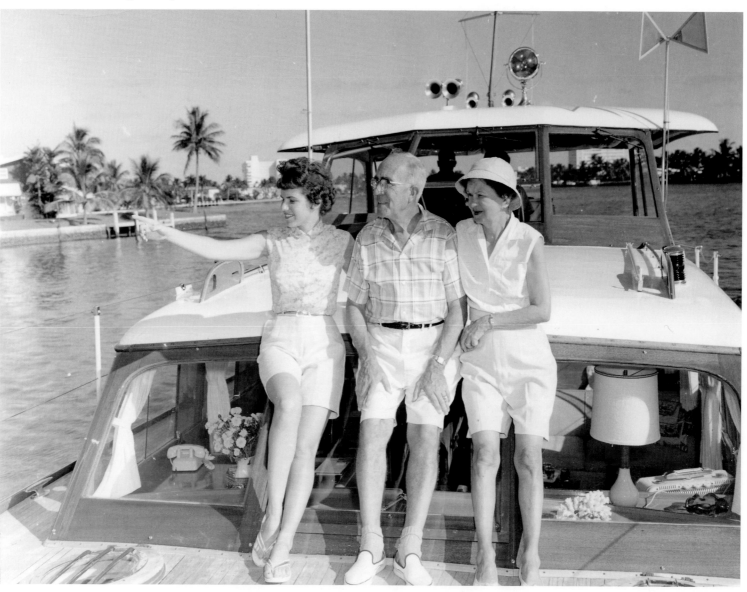

DECADES OF CHANGES

(1960–1979)

On December 21, 1960, a "beach blanket" movie premiered at the Gateway Theatre in Fort Lauderdale. It was called *Where the Boys Are,* and it documented the local tradition of a springtime collegiate invasion. Residents were amazed when the usual Spring Break crowd of 10,000 grew to 50,000 three months later. The Spring Break phenomenon would dominate Fort Lauderdale's public image for decades to come.

The beach was also the subject of more serious matters in 1961. African American citizens were not welcome at the local public beaches; instead, they used the "black beach" south of Port Everglades, which lacked facilities or even a causeway for access. In 1961, the local NAACP staged a series of "wade-ins" at Fort Lauderdale's beach to draw attention to the situation. Desegregation was a long, slow process in what was still in many ways just a small Southern town.

Three hurricanes struck South Florida during the decade, primarily causing financial damage rather than extensive loss of life. Fort Lauderdale residents were also occupied with Cold War fears, with the Soviet-friendly island of Cuba so close to the south. During the Cuban Missile Crisis in October 1962, Port Everglades served as a staging area for troops poised for an invasion of Cuba that, thankfully, did not materialize.

The real story of the era was growth—the city's population grew by seventy-five per cent in the 1960s. Neighborhoods to the northeast, northwest, and southwest of the city's core were annexed. A new type of residence, the condominium high-rise, sprang up like mushrooms on Fort Lauderdale's beach areas, forever changing the skyline. The population increase generated an incredible era of economic growth. It also led to growing traffic congestion and rising crime rates—all of the burdens of a growing metropolitan area.

By the 1970s, the city of Fort Lauderdale itself was almost at "build out." New communities continued to arise in the county itself, where there was still plenty of land and more reasonable housing. Downtown Fort Lauderdale was suffering from decline, as stores moved by the droves to the new suburban shopping malls. The Downtown Development Agency was created to completely alter the face of the urban core, and Fort Lauderdale continued to serve as the cultural, governmental, and business center of what is now Florida's second-largest county in terms of population.

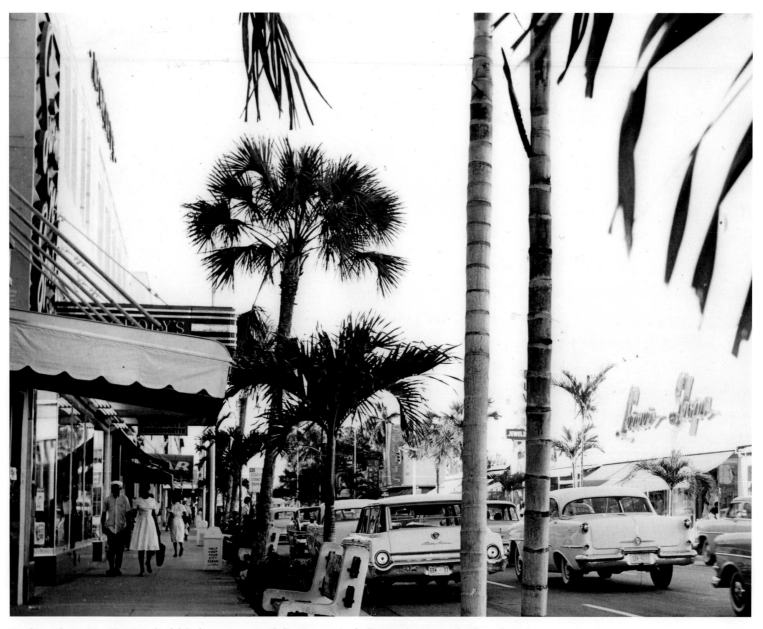

By the early 1960s, Fort Lauderdale's downtown retail district was in decline as the new, suburban shopping centers arose, away from the center of town. This photo features former shopping mecca Andrews Avenue, then still host to many retail establishments. The view is looking north from just north of Wall Street (today known as the eastern entrance to Las Olas Riverfront) on the west side of the street.

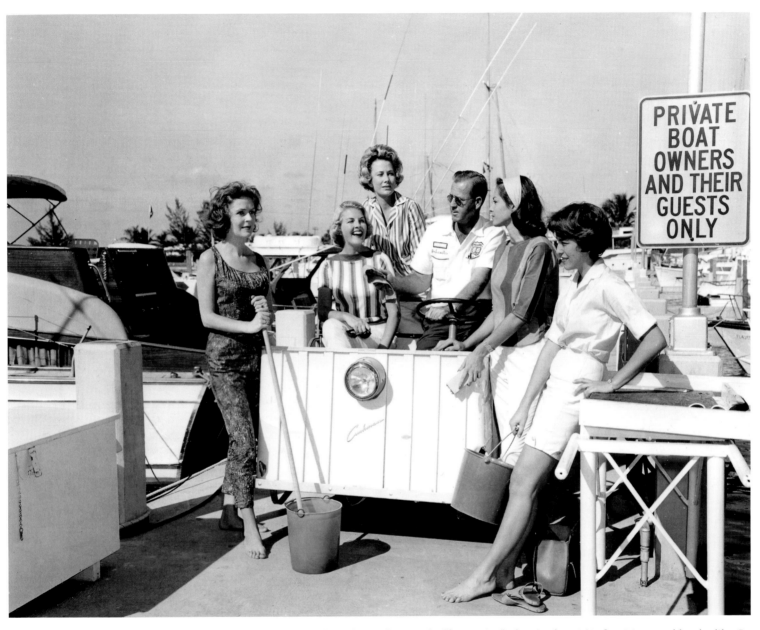

The Pier 66 marina and hotel complex was the "happening" place in the 1960s for visitors and locals alike. Its beautiful views of the local waterways have long made it a premier meeting facility and convention hotel. It has also employed a goodly number of local residents, including the cleaning crew shown gathered around a cart on the docks in this photo by Johnny Johnson, 1961.

War Memorial Auditorium opened in Fort Lauderdale's Holiday Park in 1950. It served for many years as the city's only large public venue, home to opera, prize fights, and graduations. In this scene, it plays host to a Democratic Party rally for the 1960 election. Supporters hold placards supporting Dorr Davis for juvenile court judge and Danian A. J. "Red" Ryan, who was reelected to the state legislature in November of that year.

Democrats rally at the War Memorial Auditorium in this October 1960 photo. The posters on the stage showcase the Democratic hopefuls for the presidential campaign, John F. Kennedy and his running-mate, Lyndon B. Johnson. Ironically, Broward County went Republican during the November election, casting 68,294 votes for Richard Nixon versus 47,811 for JFK.

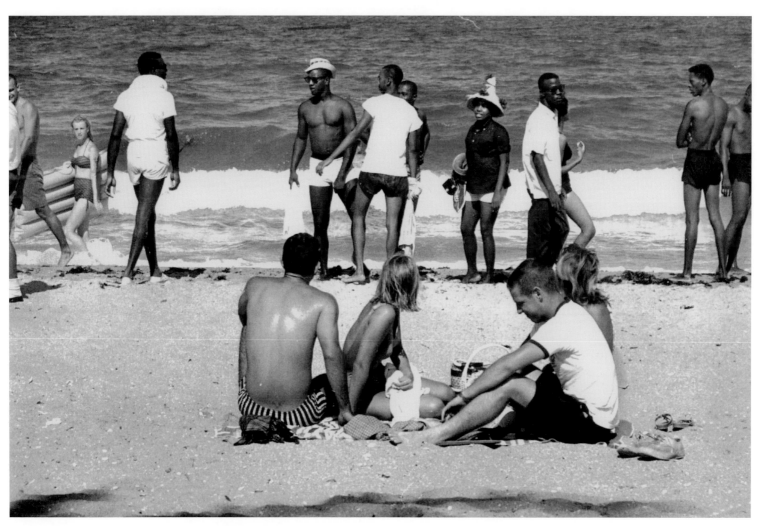

In the summer of 1961, the Fort Lauderdale NAACP staged a series of "wade-ins" on Fort Lauderdale beach to force county commissioners to construct a causeway and provide adequate facilities for African American citizens at the "Negro beach" just south of Port Everglades. The wade-ins definitely captured the attention of the local citizenry, long accustomed to segregated beaches.

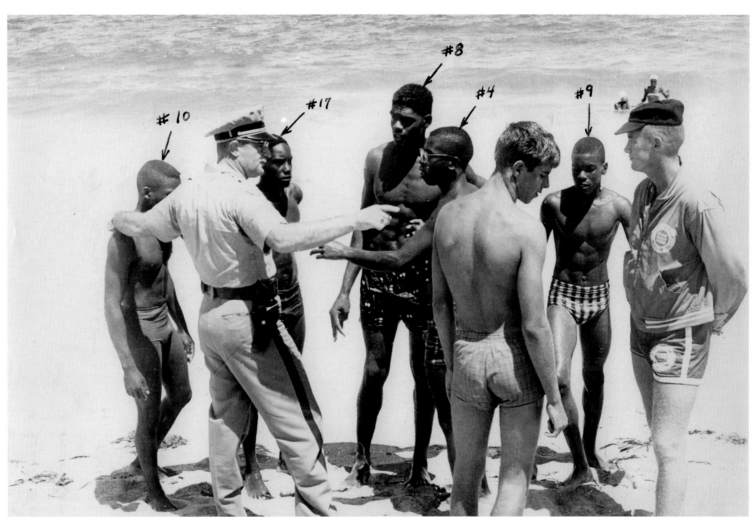

Fort Lauderdale police office Lt. Franza confronts young activists of the NAACP at the beach at Atlantic Boulevard (A1A) and Riomar August 7, 1961. From the left they are Norris Turner (#10); Henry Bentley (#17); Alfred Brown (#8); Mathew McCray (#4); and Willie Sharp (#9).

Members of the National Association for the Advancement of Colored People are escorted to the Fort Lauderdale Police Department's paddy wagon at East Las Olas and Almond Avenue during a beach "wade-in" in July 1961. Eula Johnson, NAACP president and wade-in organizer, is visible at right, in the floral hat.

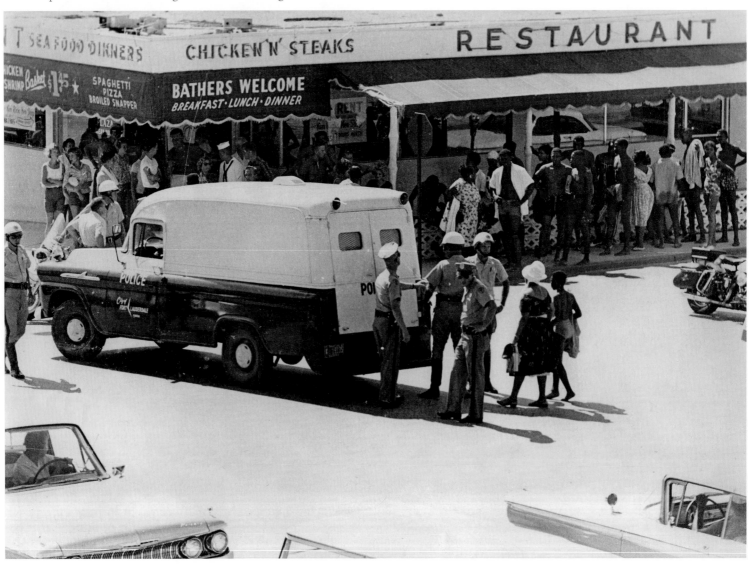

This photo features a panoramic view of New River, looking east from just west of the Andrews Avenue bridge, in the early 1960s. The bridge, shown in operation, is the third version of the span, completed in 1949. In 1979 the current bridge was built, with much longer and higher proportions. The "new" bridge is much more serviceable, but it made North and South New River Drive obsolete and forever altered the view at this historic spot.

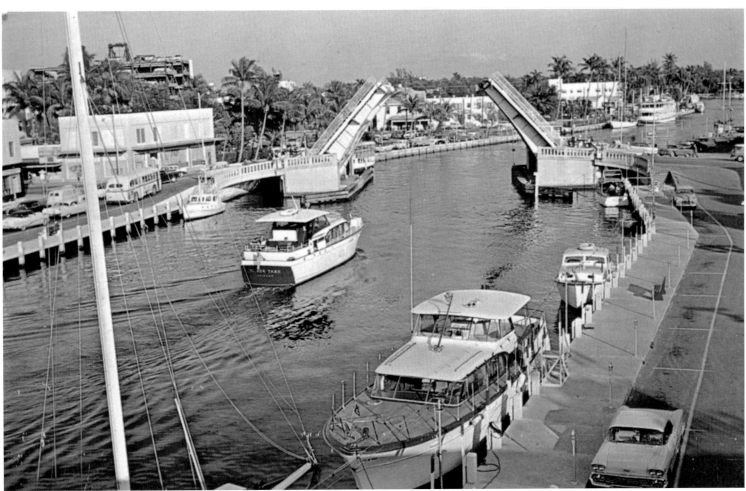

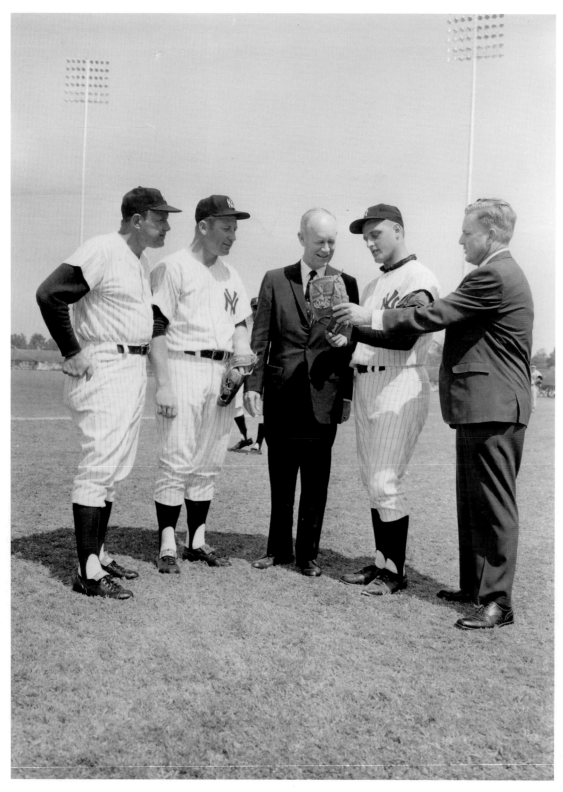

The New York Yankees, baseball's most famous team, brought their spring training camp to Fort Lauderdale in 1962 for a thirty-three-year stint. Locals enjoyed watching the Yanks at the newly constructed Fort Lauderdale Stadium (aka Yankee Stadium) near Executive Airport. Left to right are manager Ralph Houk, Mickey Mantle, Governor Farris Bryant, Roger Maris, and Wendell Jarrad, chair of the Florida Development Commission.

In the 1950s, city leaders actually invited students at colleges throughout the U.S. to make Fort Lauderdale their destination for Easter vacation. Ten thousand students appeared on an annual basis. In December of 1960, the movie which fictionalized this phenomenon, *Where the Boys Are*, premiered in Fort Lauderdale. The next spring, locals were aghast when 50,000 students invaded town. Here is a classic Spring Break scene from 1962.

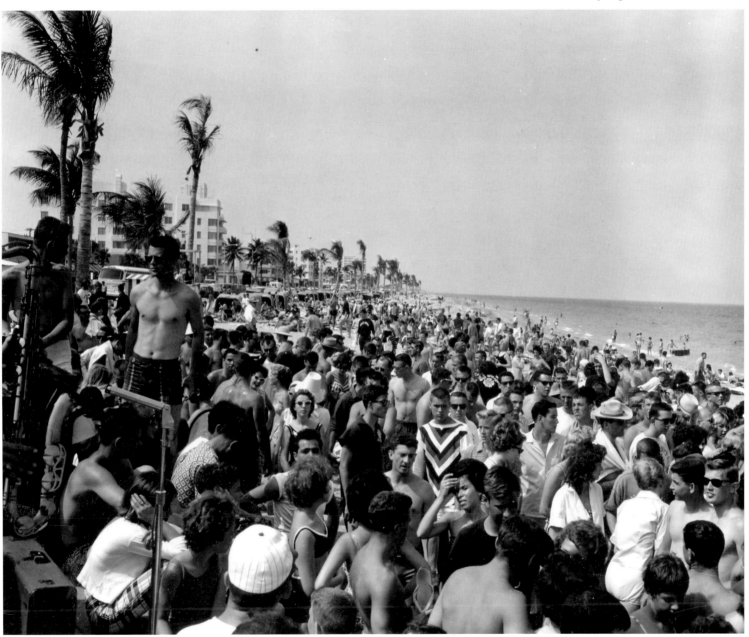

The mild waves of Florida's southeast coast have never been known as a surfing mecca—but the locals are always willing to give it a try, particularly before or after a hurricane. Here, an intrepid surfer takes on a wave at Fort Lauderdale's beach in the 1970s.

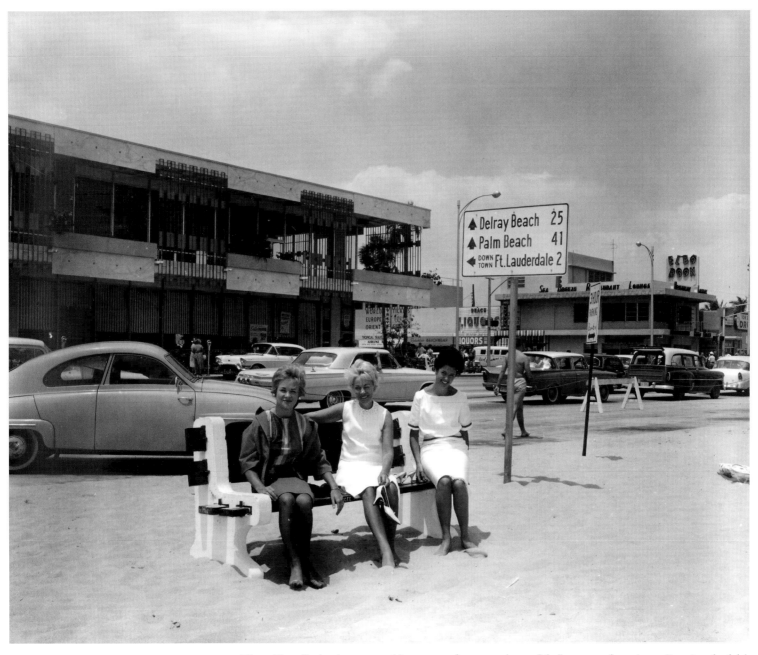

Three New Zealanders on world tour stop for a snapshot at "the" spot on the strip on Fort Lauderdale's beach in spring of 1962. At left is the Las Olas Plaza, which replaced the old Las Olas Inn in 1959. At far right, the world-famous Elbo Room, epicenter for Spring Break activities, is visible at the corner of A1A and East Las Olas Boulevard.

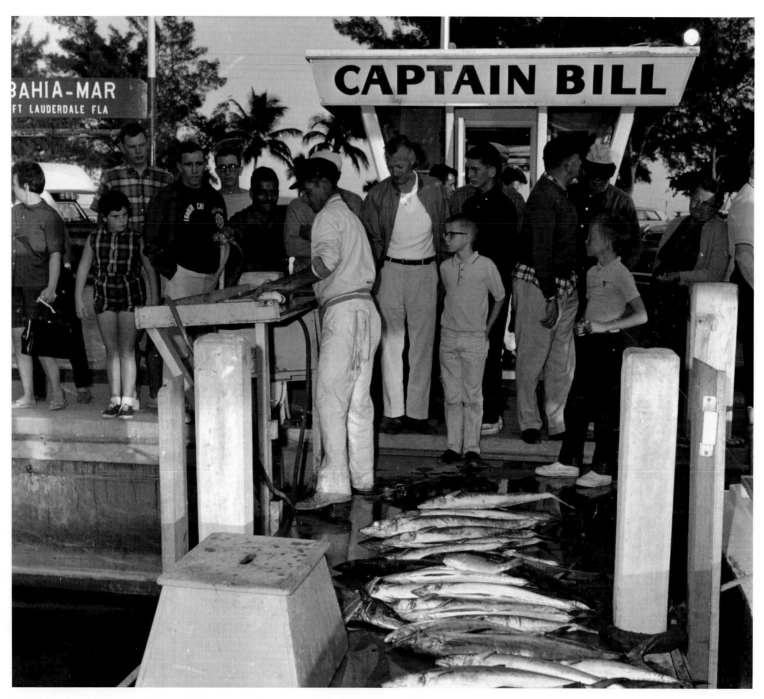

By the 1960s, the growth of the city's downtown discouraged the charters' use of their traditional docks on New River—the smell of fish was no longer acceptable there. The increased population also began to seriously affect the game fish environment as more boaters impacted more reefs. "Captain Bill" still attracted customers from his berth at Bahia Mar, as shown in this photo taken in 1963.

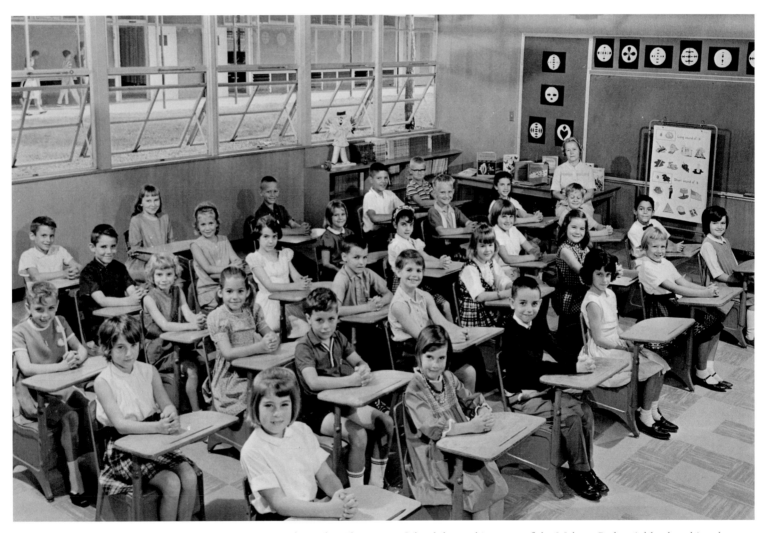

Westwood Heights Elementary School, located just east of the Melrose Park neighborhood in what was then west of the city limits, was one of many new schools constructed in the county during the late 1950s. This image shows a second grade classroom at the school in 1963. Notice the open awning-style windows, popular in the days before schools were air conditioned.

Three young ladies display the latest in (modest) beach wear on Fort Lauderdale's south beach in 1963. One of the widest beach areas in town, the south beach featured a small parking lot, tables, and barbeque grills and is still a popular spot for picnics and parties.

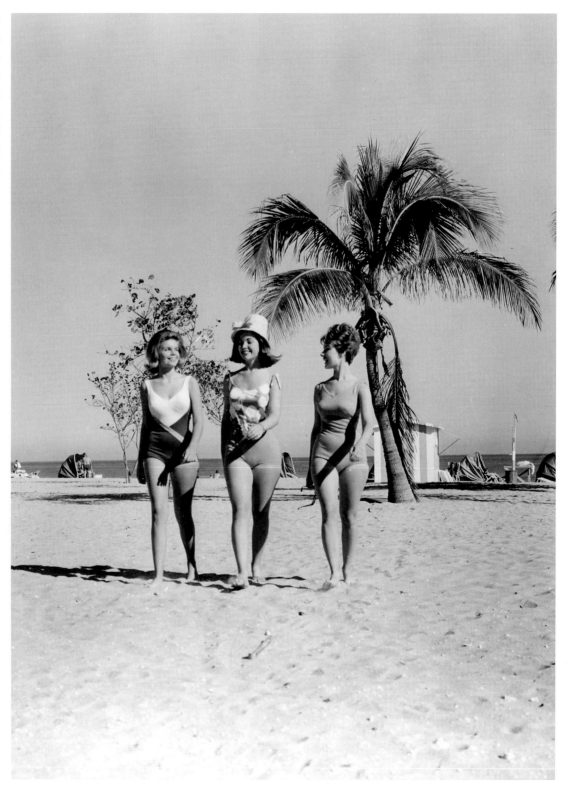

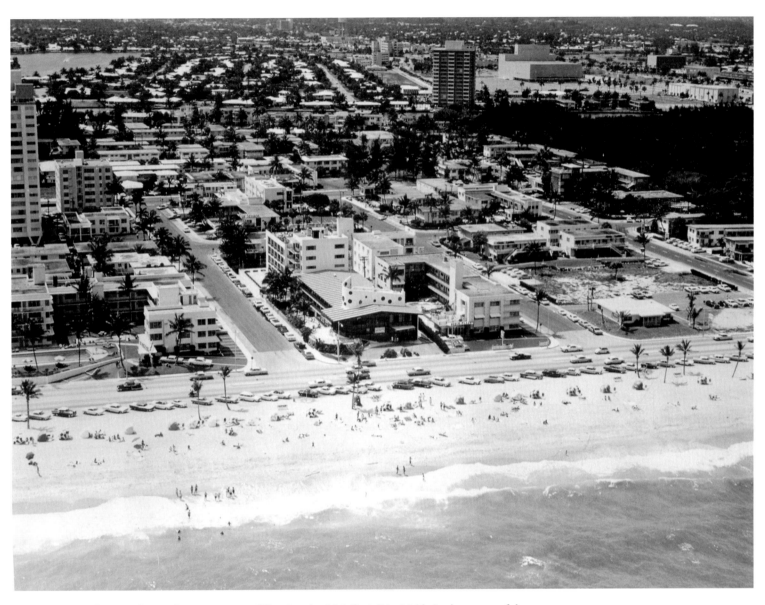

This aerial view features the northernmost part of Fort Lauderdale's "strip" in 1964. At the center of the photo is the quirky Jolly Roger Hotel. Originally constructed in 1954, it had a pirate theme that included costumed valets and waiters. It still stands, having since lost its piratic name, one of Fort Lauderdale's best examples of what is now called "mid-century modern" style.

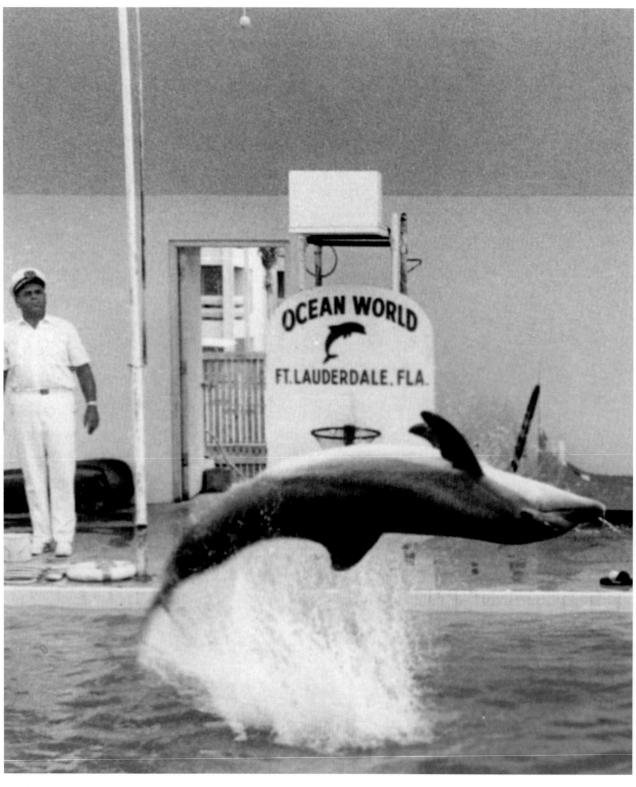

A much-needed new causeway opened in south Fort Lauderdale just north of Port Everglades on Seventeenth Street in 1956. The new link between mainland and beach encouraged a spurt of growth along what was once an insignificant roadway. Ocean World, Fort Lauderdale's marine attraction, opened on the northwest side of the span in 1965.

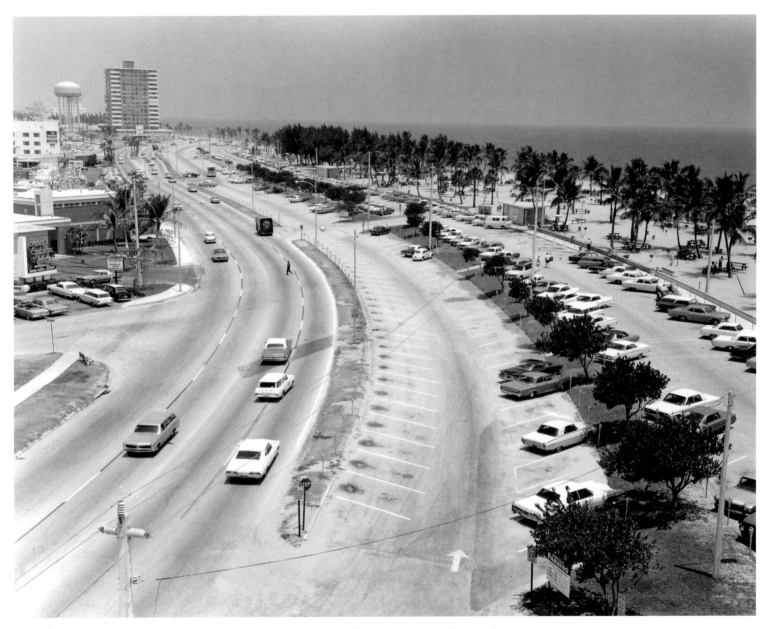

This view, north along A1A, was taken from the landmark Yankee Clipper Hotel in 1967. At right is one of Fort Lauderdale's best beaches, featuring the south beach parking lot. At left is the Bahia Mar Yachting Center.

Fort Lauderdale's first temple, Emanu-El, opened on South Andrews Avenue in 1937, the only Jewish temple between West Palm Beach and Miami. By the late 1960s the congregation had outgrown the original structure. In this photo, temple leaders gather for the symbolic groundbreaking of the new Temple Emanu-El located on West Oakland Park Boulevard in Lauderdale Lakes in May of 1967.

Las Olas Boulevard has long been known as Fort Lauderdale's "road to the beach." Immediately east of downtown, small houses and churches lined the road for many years, but in the 1950s, a series of exclusive shops arose, and the area established a reputation as the city's own "Worth Avenue," a reference to the upscale shopping area of Palm Beach. Typical of the Las Olas shops was George Horn Fine Foods, located at 825 East Las Olas Boulevard in this 1967 photo.

In December of 1965, the city of Fort Lauderdale opened a new, state-of-the-art swim center on the city's south beach, adjacent the old Fort Lauderdale Casino Pool. In 1968, the International Swimming Hall of Fame opened a new museum on the site, where educational exhibitions highlighted the accomplishments of the aquatic arts. In this photo, a diver takes the plunge off the high dive at the Hall of Fame pool in 1967.

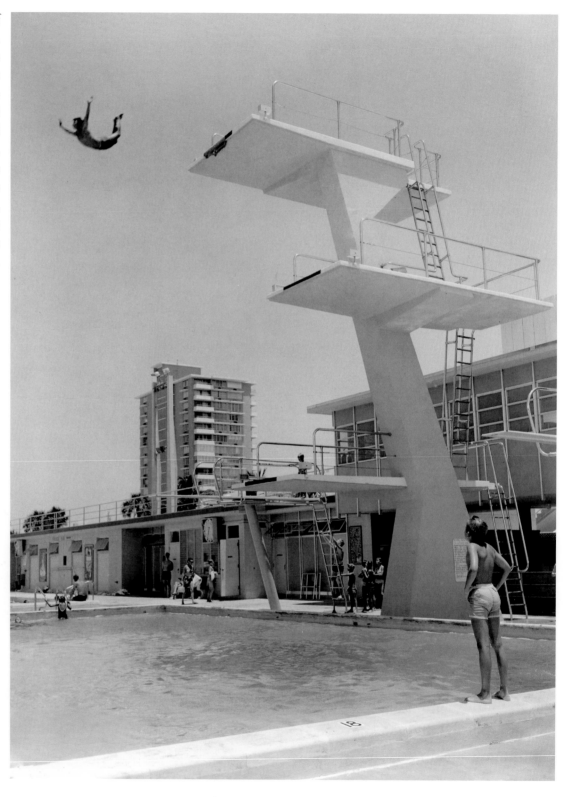

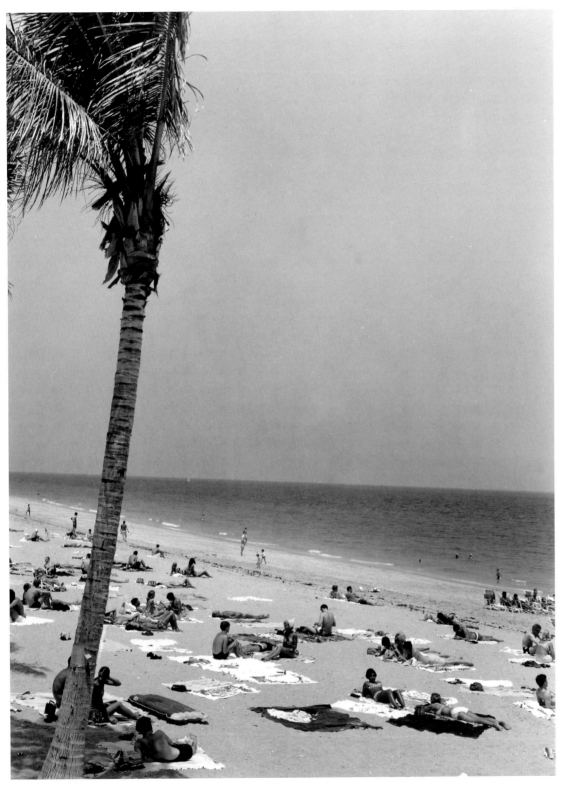

In 1967, tourism was clearly the largest single contributor to Broward County's economy, impacting every resident through the revenues it generated. The main attraction --the miles of public beach. This view reveals a typical Fort Lauderdale day under the coconut palms in 1967.

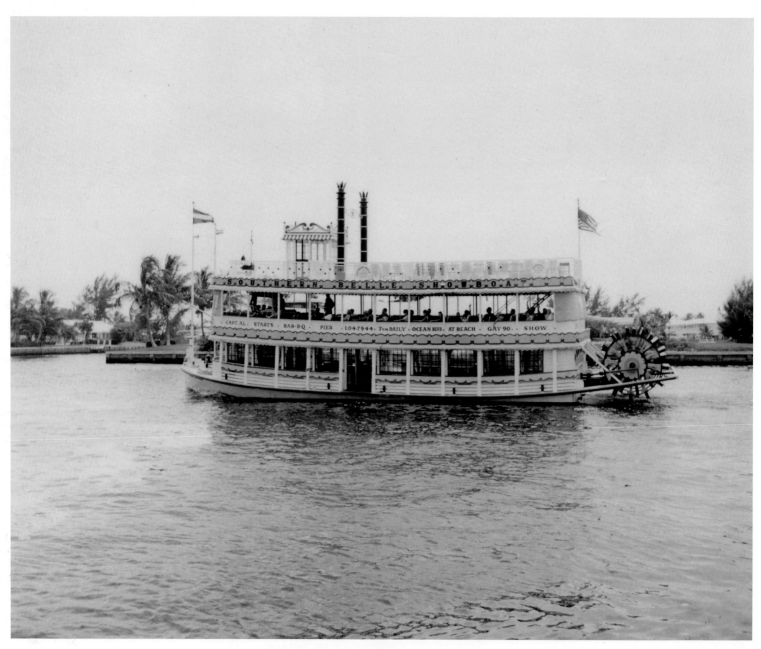

In the 1960s, the paddlewheel-style *Southern Belle* carried passengers from the Plantation Mansion House on Northeast Thirtieth Street down the Intracoastal to Port Everglades every evening. The entertainment was a wholesome, Gay Nineties-style revue, in the manner of showboats of old.

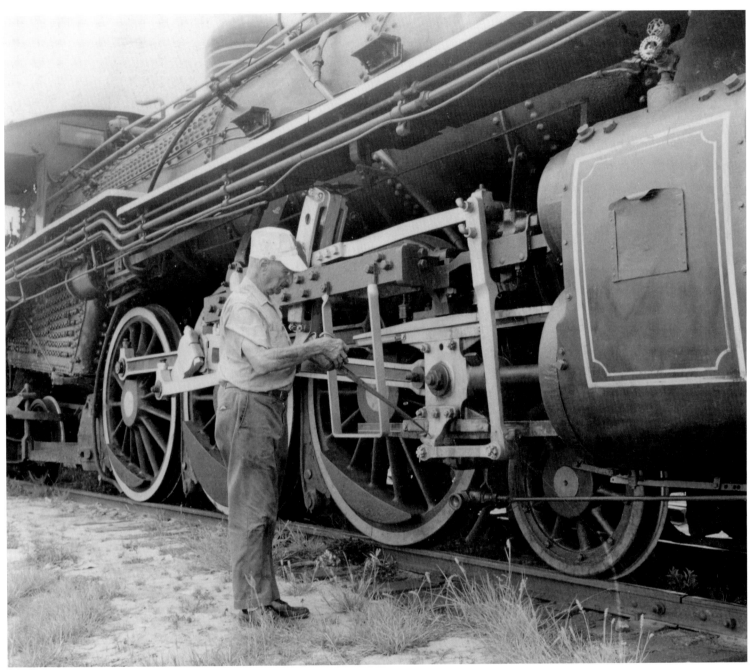

Originally founded by a group of enthusiasts at the University of Miami campus, the Gold Coast Railroad Museum opened its unique attraction in what is today Snyder Park in 1966. It featured historic rail cars and a ride on an authentic, old-time train pulled by a steam locomotive. In December 1984, the entire complex moved to south Dade County to make way for I-595.

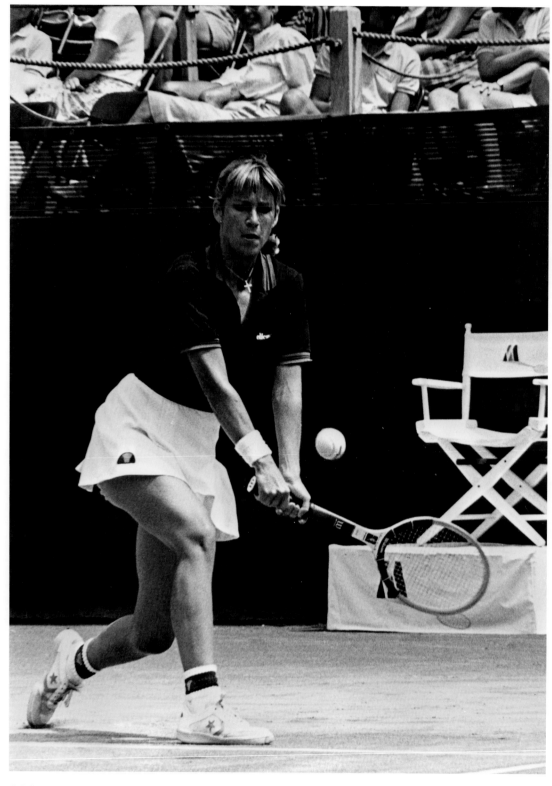

One of Fort Lauderdale's most famous citizens is Chris Evert, world renowned tennis champion who dominated women's tennis in the 1970s and '80s. Evert was born in Fort Lauderdale, the daughter of long-time city tennis pro Jimmy Evert, whose innovative programs literally put Fort Lauderdale on the tennis map. Chris won 157 singles titles and was the youngest to rank number one since Maureen Connolly.

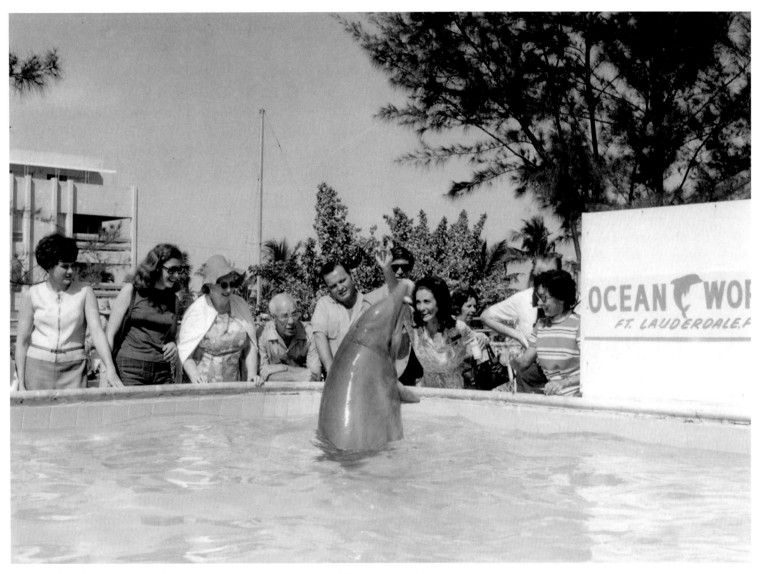

Fort Lauderdale's Ocean World marine attraction featured tropical fish, sea lions, birds, otters, and the ever-popular dolphin show, shown here in March 1970. Once surrounded by open space, by the 1990s the site was hemmed in by a new shopping center, hotel, and school. Unable to expand. It closed in 1994.

NOTES ON THE PHOTOGRAPHS

These notes, listed by page number, attempt to include all aspects known of the photographs. Each of the photographs is identified by page number, photograph's title or description, photographer and collection, and archive. Call or box numbers and identifying phrases, to a maximum of 30 characters, are added where applicable. Although every attempt was made to collect all available data, in some cases complete data was unavailable due to age and condition of some of the photographs or records.

II **BEACH, 1937**
Broward County Historical
Commission
Jack Egan Collection #92

VI **LAUDERDALE BEACH HOTEL**
Broward County Historical
Commission
Max Daughtry Collection

X **CLYDE BEATTY'S ZOO**
Fort Lauderdale Historical
Society
5-28389

2 **FLORIDA EAST COAST RAILWAY**
Broward County Historical
Commission

3 **HENRY FLAGLER**
State Library and Archives of
Florida
fps01394

4 **FIRST FORT LAUDERDALE SCHOOL**
State Library and Archives of
Florida
PR01199

5 **WILL STRANAHAN AND SEMINOLE INDIANS**
State Library and Archives of
Florida
N032163

6 **STRANAHAN RESIDENCE**
State Library and Archives of
Florida
N030850

7 **PICNICKERS AT NEW RIVER**
State Library and Archives of
Florida
Rc02883

8 **MARSHALL BROTHERS**
State Library and Archives of
Florida
PR01173

9 **SEMINOLE INDIAN VILLAGE**
State Library and Archives of
Florida
Rc02869

10 **TOMATO PICKERS**
State Library and Archives of
Florida
Rc02880

11 **PEOPLE AT THE BEACH**
State Library and Archives of
Florida
Rc02877

12 **EARLY DOWNTOWN**
Fort Lauderdale Historical
Society
5-4515

13 **BROWARD COUNTY COURTHOUSE**
Broward County Historical
Commission
Broward County Historical
Commission Collection

14 **FORT LAUDERDALE AFTER FIRE**
Broward County Historical
Commission
Broward County Historical
Commission Collection

15 **NORTH NEW RIVER CANAL**
State Library and Archives of
Florida
Rc15513

16 **BURNING OF THE OSCEOLA HOTEL**
State Library and Archives of
Florida
PR01215

17 **BURNING OF THE OSCEOLA HOTEL**
State Library and Archives of
Florida
PR01214

18 **RESIDENCE OF "COMMODORE" A. H. BROOKS**
State Library and Archives of
Florida
N030852

19 **BOAT ON NEW RIVER**
Broward County Historical
Commission
Ivan Austin Collection

20 **BROWARD COUNTY COURTHOUSE**
Broward County Historical
Commission
Broward County Historical
Commission Collection

21 **JAMES M. HOLDING**
Broward County Historical
Commission
Broward County Historical
Commission Collection

22 **FIRST SCHOOL BUS**
Broward County Historical
Commission
Broward County Historical
Commission Collection

23 **KIDS WITH FLAGS**
Broward County Historical
Commission
Marshal-Anglin-36

24 WHITE STAR BUS
Broward County Historical
Commission
Broward County Historical
Commission Collection

**25 BILLY BLITZER AND D.
W. GRIFFITH**
State Library and Archives of
Florida
PR07286

**26 BATHERS AT LAS OLAS
BEACH**
State Library and Archives of
Florida
PR01196

27 WANDERER HOUSEBOAT
State Library and Archives of
Florida
PR01187

**28 SOUTH METHODIST
CHURCH**
State Library and Archives of
Florida
PR01188

**29 LEAIRD AND PELLETT'S
BUICK GARAGE**
State Library and Archives of
Florida
PR01191

30 DRESDEN APARTMENTS
State Library and Archives of
Florida
PR01181

**31 FIRST CHURCH OF
CHRIST, SCIENTIST**
State Library and Archives of
Florida
PR01184

32 SEMINOLE INDIAN CAMP
State Library and Archives of
Florida
PR04813

**33 BROWARD COUNTY
GARAGE**
State Library and Archives of
Florida
PR01189

34 SUGAR CANE
State Library and Archives of
Florida
PR01180

35 HOME GUARD
Broward County Historical
Commission
Broward County Historical
Commission Collection

36 SIGURD DILLEVIG
Broward County Historical
Commission
Edith Lewis Collection #160

37 ARTEYEE TIGER
State Library and Archives of
Florida
N04780

38 NEW RIVER
Broward County Historical
Commission
Oleta Dunworth Collection
#14

40 BROWARD HOTEL
Broward County Historical
Commission
Broward County Historical
Commission Collection

41 BEACH GROUP
Broward County Historical
Commission
Barwick Collection #36

**42 BRYAN CHILDREN WITH
THOMAS CHARLTON**
Broward County Historical
Commission
Bryan Collection #72

43 MUNICIPAL BAND
Broward County Historical
Commission
Lewis Collection #4

44 SHIRTTAIL CHARLIE
Broward County Historical
Commission
Broward County Historical
Commission Collection,
Early 1920s

**45 ANTIONETTE SULLIVAN
AND NELLIE LEHRMAN**
State Library and Archives of
Florida
ms25335

46 SHRINE CLUB
State Library and Archives of
Florida
ms25330

47 HARDING VISIT
Broward County Historical
Commission
Ivan Austin Collection #13

48 BIRCH ESTATE
Broward County Historical
Commission
Ivan Austin Collection #16

49 BASEBALL TEAM
State Library and Archives of
Florida
Rc05186

50 TARPONS
Broward County Historical
Commission
Ruby Haberly Hamilton
Collection

51 LAS OLAS BEACH
Broward County Historical
Commission
Broward County Historical
Commission Collection

52 LAS OLAS INN
Broward County Historical
Commission
Harold Vreeland Collection

53 CAPTAIN VREELAND
Broward County Historical
Commission
Vreeland Collection #18

54 WESTSIDE SCHOOL
Broward County Historical
Commission
Helen Landers Collection

55 SOUTHSIDE SCHOOL
Broward County Historical
Commission
Gertrude Boyd Collection

56 MAYPOLE DANCE
Broward County Historical
Commission
Eastside School Collection

57 GROUP WITH FISH
State Library and Archives of
Florida
N030835

58 HOTEL TROPICAL
State Library and Archives of
Florida
FR0585

59 FIRE DEPARTMENT
Broward County Historical
Commission
Ivan Austin Collection #40

60 BATHING BEAUTIES
Fort Lauderdale Historical
Society
5-1011-14A

**61 FLORIDA POWER AND
LIGHT COMPANY**
State Library and Archives of
Florida
Rc08441

99 **ALORSON FUSSELL AT THE THOMPSON SCHOOL OF AVIATION**
State Library and Archives of Florida
N047140

100 **SHERIFF WALTER CLARK**
Broward County Historical Commission
Clark Family Collection #43

101 **WWII GUARD TRAINING**
Broward County Historical Commission
Broward County Historical Commission Collection

102 **R. L. LANDERS**
Broward County Historical Commission
R. L. Landers Collection

103 **R. L. LANDERS AND HELEN HERRIOTT ON BONNET BEACH**
Broward County Historical Commission
Helen Landers Collection

104 **WAR BOND PROGRAM**
Broward County Historical Commission
Broward County Historical Commission Collection

105 **WWII ENDS**
Broward County Historical Commission
Clark Family Collection #55

106 **CHILDREN ON BEACH**
State Library and Archives of Florida
c003645a

107 **BEACH SCENE**
State Library and Archives of Florida
c003646a

108 **NORTH ON ANDREWS AVENUE**
State Library and Archives of Florida
N046610

109 **BEACH GOERS**
State Library and Archives of Florida
ms26245

110 **SAILBOATING ON NEW RIVER**
State Library and Archives of Florida
c004121

111 **SUNBATHERS**
State Library and Archives of Florida
c003648a

112 **SUNBATHERS**
State Library and Archives of Florida
c003646b

113 **1947 FLOOD**
Broward County Historical Commission
Broward County Historical Commission Collection

114 **ANDREWS AVENUE FLOODED**
State Library and Archives of Florida
PR01197

115 **CITIZENS RECEIVING TYPHOID SHOTS**
Broward County Historical Commission
Steve Cresse Collection

116 **LARRY MAURER ON BEACH**
State Library and Archives of Florida
c007512

117 **BUS TERMINAL**
Broward County Historical Commission
Fort Lauderdale City Plan Book

118 **AERIAL VIEW**
State Library and Archives of Florida
PR15232

119 **AERIAL VIEW**
State Library and Archives of Florida
PR15230

120 **FULGENCIO BATISTA AND SHERIFF CLARK**
Broward County Historical Commission
Steve Cresse Collection #33

121 **SEABOARD AIR LINE RAILROAD**
State Library and Archives of Florida
PR09400

122 **BOY SCOUTS AT KIWANIS CLUB**
State Library and Archives of Florida
Rc16674

123 **COAST GUARD BASE**
Broward County Historical Commission
Robert Hodges Collection

124 **BLOUNT BUILDING**
State Library and Archives of Florida
N046606

125 **BROWARD GENERAL HOSPITAL**
Broward County Historical Commission
Floyd Pyles Collection #1326

126 **EASTER SERVICE ON BEACH**
State Library and Archives of Florida
c013104

127 **EQUESTRIAN**
State Library and Archives of Florida
c014838

128 **EASTER LILY GATES**
Broward County Historical Commission
Easter Lily Gates Collection

129 **HOME ON ATLANTIC INTRACOASTAL WATERWAY**
State Library and Archives of Florida
c013146

130 **LAUDERDALE BEACH HOTEL**
State Library and Archives of Florida
c013071

131 **TROPICANZA FESTIVAL QUEEN AND COURT**
State Library and Archives of Florida
c013140

132 **COSTUMES AT TROPICANZA FESTIVAL**
State Library and Archives of Florida
c013126

133 **DANCING AT TROPICANZA FESTIVAL**
State Library and Archives of Florida
c013136

134 **NIGHT ON NEW RIVER**
State Library and Archives of Florida
c013112

This view, looking south and west, shows Fort Lauderdale's south beach in 1967. In the background center, the entrance to Port Everglades is just visible. Just to the right of center is the ocean-liner-shaped Yankee Clipper Hotel, designed by Miami architect Tony Sherman. The beach at right is one of Fort Lauderdale's most historic spots. It was once the site of one of the original forts of Fort Lauderdale, and later, the House of Refuge lifesaving station.

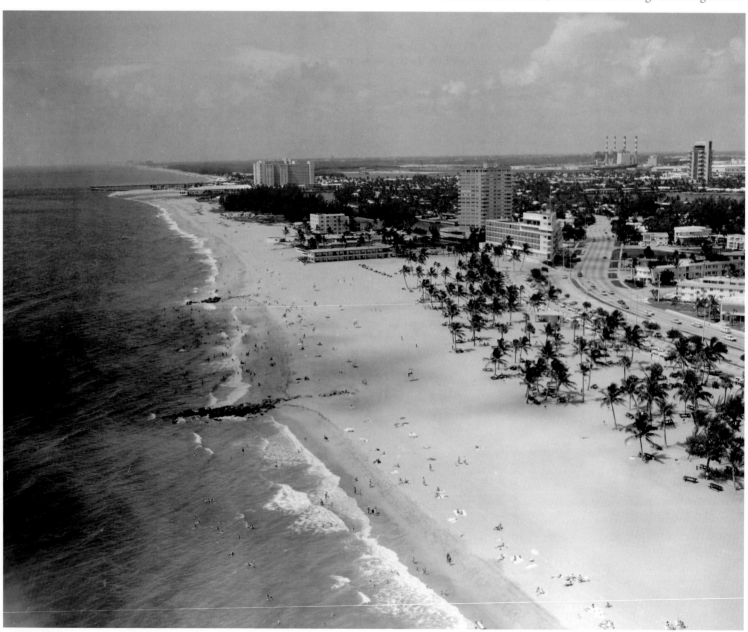